Colour

How to Use Colour in Art and Design

Colour

How to Use Colour in Art and Design

Edith Anderson Feisner

Laurence King

Colour is dedicated to Him who allowed me to fulfil my dream of having this book published and to M. Anne Chapman (1930–1986), artist, teacher and exemplar. Anne brought colour to Montclair State University and into my life. I will always be grateful for her shared knowledge but most of all for her friendship. Thank you, Anne, for never letting me assume.

Published 2000 by Laurence King Publishing
an imprint of Calmann & King Ltd
71 Great Russell Street
London WC1B 3BP
Tel: + 44 7831 6351
Fax: + 44 7831 8356
email: enquiries@calmann-king.co.uk
www.laurence-king.com

A catalogue record for this book is available from the British Library.

ISBN: 1 85669 300 7

Senior Managing Editor: Richard Mason
Development Editors: Damian Thompson, Richard Mason
Editorial Consultant: Alan Pipes
Designer: Andrew Shoolbred
Cover Design: Design Deluxe
Picture Researcher: Peter Kent
Printed in Hong Kong

Front cover: Vassily Kandinsky, *In Blue,* 1925. Oil on canvas, 31½ x 43⅓ in (80 x 110 cm). Kunstammlung Nordrhein-Westfalen, Dusseldorf. Photo: Walter Klein, Dusseldorf. © ADAGP, Paris and DACS, London 2000.
Halftitle: M. Anne Chapman, *Quadrate Blue,* 1970. Coloured pencil, 14 x 14 in (35.5 x 35.5 cm).

Contents

Preface	viii
Credits	ix

PART I
COLOR FOUNDATIONS ... 1

Chapter 1 What Is Color? ... 2
Physiology ... 3
How Light Gives Objects Color ... 4
Factors in Perception ... 4
 Media and Techniques ... 4
 Eye and Brain ... 4
 Psychology and Culture ... 5
Local, Optical, and Arbitrary Color ... 5
Concepts to Remember ... 7
Exercises ... 7

Chapter 2 Color Systems and Color Wheels ... 8
The Pigment Wheel ... 9
The Process Wheel ... 9
The Munsell Wheel ... 10
The Light Wheel ... 11
The Visual Wheel ... 11
Concepts to Remember ... 12
Exercises ... 12

Chapter 3 Color Theorists ... 13
Color Theory in the Ancient World ... 13
Leonardo da Vinci ... 13
Sir Isaac Newton ... 13
Moses Harris ... 14
Johann Wolfgang von Goethe ... 14
Philip Otto Runge ... 15
J. C. Maxwell ... 15
Michel Eugène Chevreul ... 16
Ogden Rood ... 16
Ewald Hering ... 17
Albert Munsell ... 17
Wilhelm Ostwald ... 18
C.I.E. ... 18
Johannes Itten ... 19
Alfred Hickethier ... 20
Josef Albers ... 20
Faber Birren ... 20
Frans Gerritsen ... 21

Concepts to Remember ... 22
Exercises ... 22

Chapter 4 Coloring Agents ... 23
Additive Color Mixing ... 23
Subtractive Color Mixing ... 23
 Pigments and Dyes ... 23
 Binders and Grounds ... 26
 Color Printing ... 27
 Photography ... 30
Concepts to Remember ... 31
Exercises ... 31

PART II
DIMENSIONS OF COLOR ... 33

Chapter 5 The Dimension of Hue ... 34
Mixing Hues ... 34
 Pigment Wheel ... 34
 Munsell Wheel ... 35
 Light Wheel ... 35
 Process Wheel ... 35
Broken Hues ... 37
Hues in Compositions ... 37
Concepts to Remember ... 38
Exercises ... 38

Chapter 6 The Dimension of Value ... 39
The Values of Hues ... 39
 Discords ... 40
Value and Spatial Clarity ... 40
 Shading ... 40
 Pattern and Texture ... 42
 Emotion ... 42
 Definition and Emphasis ... 43
 Contrast and Toning ... 43
Value in Compositions ... 43
 Order ... 45
Concepts to Remember ... 48
Exercises ... 48

Chapter 7 The Dimension of Intensity ... 49
Chroma ... 49
Colored Grays ... 49
Complementary Hues ... 50

Complementaries on the Different Wheels 50
False Pairs 51
Glazing 52
Intensity in Compositions 52
Balance 53
Intensity and Value 54
Effects of Depth 54
Proportion 54
Concepts to Remember 55
Exercises 55

Chapter 8 The Dimension of Temperature 56
Mixing 56
Neutrals 56
"Relative" Temperatures 57
The Effects of Backgrounds 59
Tonality 59
Proportion 60
Metals 62
Concepts to Remember 63
Exercises 63

PART III
COLOR IN COMPOSITIONS 65

Chapter 9 Color and the Principles of Design 66
Rhythm 66
Balance 68
Proportion 69
Scale 71
Emphasis 72
Harmony 74
Concepts to Remember 77
Exercises 77

Chapter 10 Color and the Elements of Design 78
Space 78
The Illusion of Transparency 80
Translucency 82
Volume Color 83
Film Color 83
Intensity and Space 84
Presentation 84
Line 84
Outlining 86
Legibility 87
Other Types of Line Formation 88
Form and Shape 88
Texture 89
Reflective Surfaces 90

Light 91
Types of Lighting 92
Concepts to Remember 93
Exercises 93

Chapter 11 Color Interactions 94
Afterimages 94
Successive Contrast 94
Simultaneous Contrast 95
Achromatic Simultaneous Contrast 95
Chromatic Simultaneous Contrast 96
Bezold Effect 96
Optical Mixing 97
Concepts to Remember 102
Exercises 102

Chapter 12 Color and the Effects of
Illumination 103
Shadows 103
Time and Weather 106
Chromatic Light 111
Structural Color 112
Luminosity 112
Iridescence 112
Luster 114
Concepts to Remember 115
Exercises 115

PART IV
THE INFLUENCE OF COLOR 117

Chapter 13 Color Symbolism 118
Color Associations in Language, Emotion 118
Black, White, and Gray 118
Red and Pink 119
Orange and Brown 119
Yellow 119
Green 120
Blue 120
Purple, Violet, and Indigo 121
Influences of the Dimensions of Color 121
Religious and Cultural Symbolism 121
Christianity 122
Judaism 122
Islam 122
Buddhism 122
Hinduism 122
Flags and Heraldry 123
Color and the Environment 126
Color and Health Care 127

Concepts to Remember 128
Exercises 128

Chapter 14 Putting Color to Use—Then and
Now 129
Color in the Fine Arts 129
Paleolithic Painting 129
Ancient Egypt 131
Ancient Greece 131
Ancient Rome 131
The Middle Ages 132
The Renaissance and the Baroque 134
Color in Non-Western Art 135
Romanticism and Impressionism 137
Modernism 139
Late Twentieth-Century Art 140
Color in the Applied Arts 141
Architecture and Interior Design 141

Furniture and Other Arts 143
Fiber Arts 144
Graphic Design and Printing 145
Computer Technology and the Internet 147
Exercises 148

Appendix 1: Coloring Agents—Dry Binders 149
Appendix 2: Coloring Agents—Liquid Binders 149
Appendix 3: Coloring Agents—Pigment Origins
and Characteristics of Common
Colors 150
Appendix 4: Hue—Various Art Media Matched to
Color-Aid Paper Pure Hues 150
Appendix 5: Color Legibility Rankings 153
Glossary 154
Bibliography 158
Index 161

Preface

This book aims to give students in all the visual arts a thorough grounding in the history, psychology, and physics of color, as well as training and tips for putting that knowledge into practice. Rather than addressing issues that pertain to specific media, this book introduces fundamental principles that should prove useful to all arts students, be they painters, interior designers, photographers, fiber artists, potters, or others who use color. The chapters unfold in teaching order: each forms the basis for the next, so that readers will be building from a sturdy foundation. Still, the technicalities of color are quite complex, so each chapter concludes with a "Concepts to Remember" section and exercises in which to try out what's been learned.

Part I outlines color fundamentals. Here the reader will be introduced to the basics of light, the eye/brain color-processing system, and the history of color theory, as well as the various color wheels available and their application to specific art media. Part II explores in detail the four dimensions of color—hue, value, intensity, and temperature. Part III pursues these dimensions further by studying the principles and practice of design, examining how colors interact and how shadows and light affect color perception and usage. Part IV focuses on the psychological and cultural aspects of color. The language, emotions, and symbolism of daily life are deeply influenced by color, as is revealed in our history of pigment use in past and present cultures, and in the fine and applied arts.

This book is the result of twelve years' teaching the subject of color to students enrolled in all the major courses offered by the Fine Arts Department at Montclair State University, New Jersey—from painting, fiber, and ceramics to jewelry, printmaking, and graphic design. The course and the book have been developed to address the common concerns about color elicited by these diverse media, whatever the readers' backgrounds and future aspirations.

Acknowledgments

No book is written by itself, and I must express my heartfelt thanks to the Fine Arts Department of Montclair State University for my education and for the opportunity to teach Color Studies for twelve years. First, thanks go to all my students, especially David Zita. Thanks also to the professors in the Fine Arts Department, especially Robert Browning (jewelry); Susi Colin (art history); Sabine Eck (art history); John Luttropp (graphic design); William McCreath (ceramics); Klaus Schnitzer (photography); Walt Swales (sculpture); Anne Betty Weinshenker (art history); and the late Michael Kendall (art education, color, and design). My gratitude to the staff of the university extends also to David Fogg, Lynda Hong, and Allison Mackenzie.

Thanks also to the reviewers of the manuscript, whose comments were very helpful. They include Ray Burgraf, Florida State University; Jean K. Dilworth, Eastern Illinois University; Beth Emmott, Moore College of Art & Design; Allen Harlow, University of Colorado at Boulder; Betty Kelly, Kirkwood Community College; Rosalie King, Western Washington University; Don Schol, University of North Texas; and Kim Varnadoe, Salem College.

I wish also to thank all those students who supplied artworks used in this book: Carol von Achen; Arna Arvidson; Michael Bailey; Melinda Beavers; Elaine Brodie; Mark Hartnett; Marianne Hauck; April Hill; Grace Kennedy; Jennifer Kievit; Elly Madavi; Tricia Malecki; Glenn Mason; James McGinnis; Jo Motyka; Pamela Muller; Jessica Niemasz; Michele Nolan; Indrani Novello; Danielle Pompeo; Dreux Sawyer; Deborah Scott; Lorraine Spontak; Xin Xu.

I wish to thank Karen Dubno and Fairchild Books for giving me the opportunity to write this book. I also want to thank Olga Kontzias, Executive Editor; Sylvia L. Weber, Production Editor; and Nataliya Gurshman, Art Director, for all their support. My sincere gratitude goes also to Damian Thompson and Richard Mason for developing and managing the project; both editors brought immense skill and patience to bear on the transformation of my manuscript into a book. Thanks also to picture researcher Peter Kent, interior designer Andrew Shoolbred, cover designers Nick and Melinda Welch, and Fakenham Phototypesetting for rendering the color charts.

My undying gratitude is extended to Dave (my husband and best friend) for his encouragement, patience, technical advice, and gofering; to my daughter Maria for keeping our household going, but mostly for her bright smile and her reassurance; and to my son Ernst for his encouragement and ability to aid a computer dummy in distress. My thanks also to my dear friends Joan Masterson, Mary Wagner, and Marianne Hauck for being there.

Edith Anderson Feisner
Montclair State University
July 2000

Credits

Calmann & King Ltd, Fairchild Publications, the picture researcher, and the author wish to thank the institutions and individuals who have kindly provided photographic materials or artwork for use in this book. Every effort has been made to contact copyright holders, but should there be any errors or omissions we would be pleased to insert the appropriate acknowledgment in the subsequent edition of this publication.

Literary Credit

1. caption for fig. 3.7: Ogden N. Rood, *Modern Chromatics*, 1879. Facsimile edition, New York; London: Van Nostrand Reinhold Co., Inc., 1973, p. 163.

Illustration Credits

1.2, 3.7, 3.9, 3.10, 3.11: *Color*, 3e, by Paul Zelanski and Mary Pat Fisher, 1999 (Laurence King/Prentice Hall, Inc.).

Picture Credits

opposite page 1 © British Museum **1.1** © Succession H. Matisse/DACS 2000 **1.4** Science Photo Library/David Parker **1.7** David Kimber/The Car Photo Library, Dorset **1.8** © British Museum **2.5** Science Museum/Science and Society Picture Library **4.1** Alan Pipes **4.3** Photo courtesy of *American Ceramics Magazine* **4.4** Werner Forman Archive, London **4.5** © Margaret Courtney Clarke/Corbis **4.6** AKG/London **5.5** Indrani Novello **5.6** Jessica Niemasz **5.7** Jennifer Kievit **6.3** © RMN, Paris/Michèle Bellot **6.11** Lorraine Spontak **6.16** Michael Bailey **7.1**, Deborah Scott **7.3**, **7.10** Melinda Beavers **7.11** Dreux Sawyer **8.2** Elly Madavi **8.4** RMN **8.5** Glenn Mason **8.8** Werner Forman Archive, London **9.1** © VAGA, New York/DACS, London 2000 **9.4** Grace Kennedy **9.6** Arna Arvidson **9.7** April Hill **9.9** Tricia Malecki **9.11** Jo Motyka **9.18** Pamela Muller **9.20** Elly Madavi **9.21** Michele Nolan **9.22** James McGinnis **9.23** Xin Xu **9.24** Arna Arvidson **9.25** Carol von Achen **10.7** Mark Hartnett **10.9** Spectrum, London **10.14** Arna Arvidson **10.15** Jane Taylor/Sonia Halliday Photographs, Western Turville, UK **10.16** By permission of the Henry Moore Foundation **11.2** Elaine Brodie **11.5** Danielle Pompeo **11.6** Deborah Scott **11.8** Elly Madavi **11.9**, **11.10** Photographs by Ellen Page Wilson/John Back, courtesy of Pace Wildenstein, New York © 2000 Chuck Close **11.11** © DACS 2000 **12.2** Marianne Hauck **12.3** RMN **12.6** © The Frick Collection, NY **12.7** © Estate of Stuart Davis/VAGA, NY/DACS, London 2000 **12.10** © ARS, NY and DACS, London 2000 **12.14** Deborah Scott **12.15** © ARS, NY and DACS, London 2000 **13.1** T. Anders/R. Harding Picture Library **13.2**, **13.8**, **13.9** Images Colour Library, London **13.3** © Succession Picasso/DACS 2000 **14.3** © Fotografica Foglia, Naples **14.4** By permission of the City of Bayeux **14.7**, **14.8** RMN **14.9** © ADAGP, Paris and DACS, London 2000 **14.12** Norman McGrath **14.14** Jacqueline Guille/Norwich School of Art and Design, David Whitworth/Crafts Council **14.15** Alan Pipes.

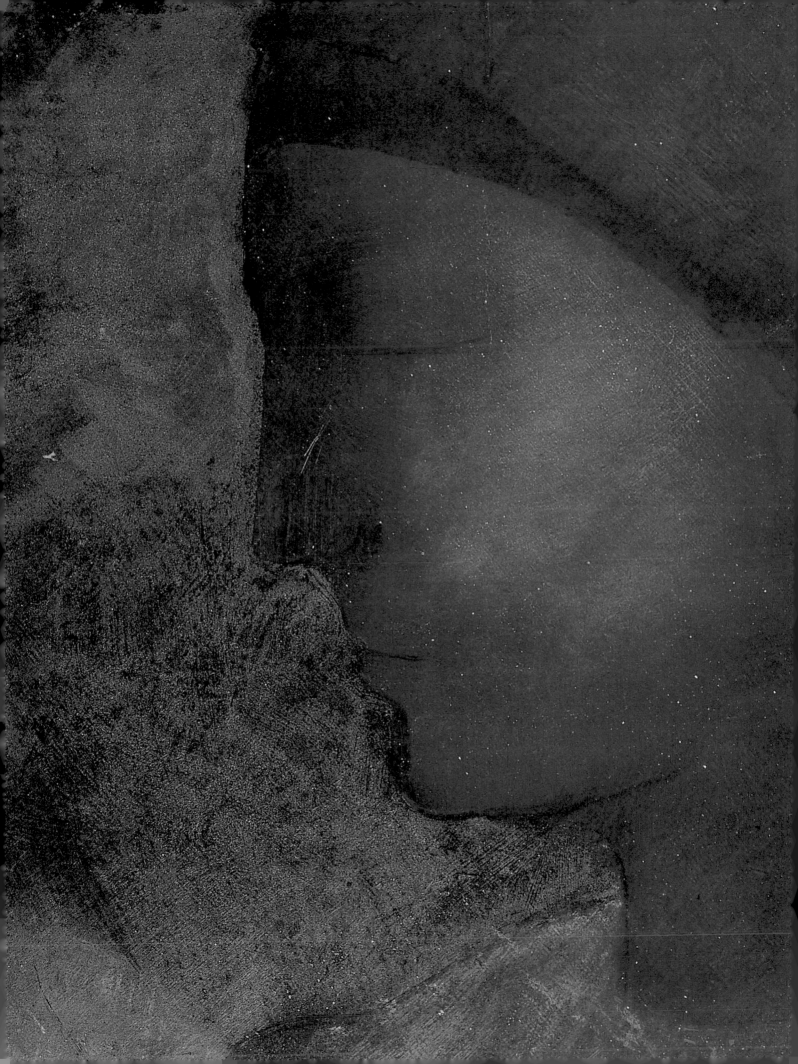

Part I Color Foundations

Three basic elements are required for an appreciation of color: a light source, an object, and a viewer. This part begins with the fundamentals of color observation. We describe the physiology of the eye and how light imparts color to objects, as well as the psychological and cultural factors involved in perception. These factors in turn affect whether an artist chooses to use local, optical, or arbitrary color. Next we examine the different color systems and "wheels," along with their application to different media.

The science and psychology of color have fascinated thinkers for centuries. On our historical journey, we meet such individuals as Leonardo da Vinci, Sir Isaac Newton, and Josef Albers. Their influence on the discipline of color today remains strong.

Finally, we look at coloring agents— additive and subtractive color mixing, pigments, dyes, binders, grounds—and discover how color is employed in the art of four-color printing and photography.

Opposite: Odilon Redon, *The Golden Cell (Blue Profile)* detail, 1892 (see also fig. 1.8).

CHAPTER 1
What Is Color?

More than any other element of design, color has the ability to make us aware of what we see, for nothing has meaning without color (here we extend the meaning of color to include black and white). Try to describe the sky, for example, without referring to color—it is very difficult.

Color defines our world. It is usually seen before imagery. Our eyes are attracted to color to such an extent that the color of an object is perceived before the details imparted by its shapes and lines. At first glance we do not see the different species of trees present in a summer woodland, but rather see the prepon-

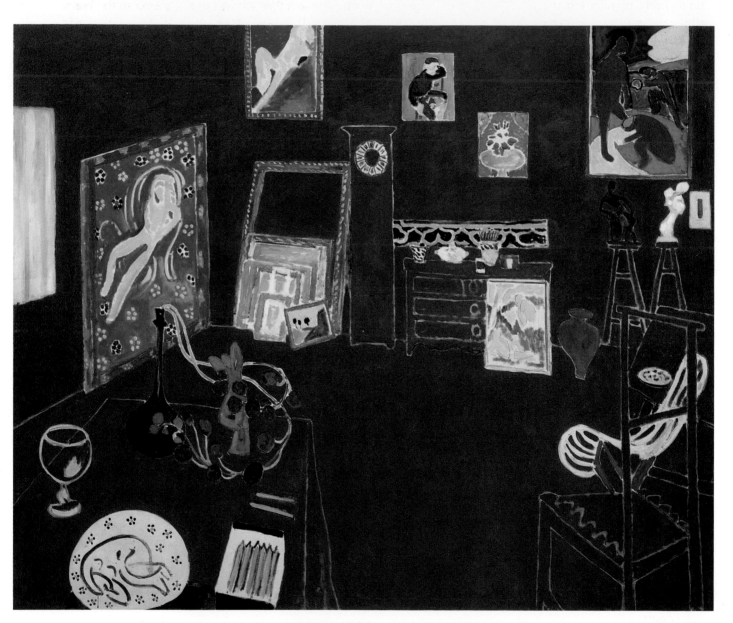

1.1 Henri Matisse, *The Red Studio*, 1911. Oil on canvas. 71¼ x 86¼ in (181 x 219.1 cm). The Museum of Modern Art. New York. Mrs. Simon Guggenheim Fund. Our initial impression is of an abundance of red color. We must take a second look to determine the objects in *The Red Studio*. This is an example of how color is seen before imagery, and in the hands of a master like Matisse it is a case of the exception proving the rule.

derance of green. The artist, architect, and designer, however, are generally concerned with having color and imagery perceived simultaneously. An art work, be it fine or commercial, works best when its color usage allows the viewer to see the content of the piece (both color and imagery) together. When this is accomplished a work's message is conveyed immediately, without a "second look" on the part of the viewer (**fig. 1.1**).

Color can also be described by two very different methods or points of view—objectively, by referring to the laws of chemistry, physics, and physiology; and subjectively, by referring to the concepts found in psychology. Similarly, our perception of objects depends both on physical factors—such as their actual **hues** (the name of a color: red, yellow, blue), their lightness and darkness in relationship to surroundings—and on more psychological and cultural factors.

PHYSIOLOGY

Physiologically color is a sensation of light that is transmitted to the brain through the eye. Light consists of waves of energy, which travel at different **wavelengths**. Tiny differences in wavelengths are processed by the brain into a myriad nuances of color, in much the same way as our ear/brain partnership results in our interpretation of sound. Sound lets us interpret our auditory language; color lets us interpret our visual language. Because each of us is unique, our eye/brain reactions differ. Thus, when we speak of color, we cannot speak in absolutes but must resort to generalizations. These are sensations that *seem* to happen to all of us.

As light passes into the eye (**fig. 1.2**) it comes in contact with the covering near the back of the eye known as the **retina**. The retina is made up of layers of different cells, including those known as **rods** and **cones**. The function of the rods is to allow the brain to see dimly lit forms. They do not distinguish hue, only black and white. The cones, however, help us to perceive hues. The cones in the eye only recognize red (long wavelengths), blue-violet (short wavelengths), and green (middle wavelengths), and relay these color messages to the cones of the **fovea**, an area at the center of the retina, whose cones transmit to the brain. The brain then assimilates the red, blue-violet, and green impulses and mixes them into a single message that informs us of the color being viewed. When we see red, for example, this is because the red-sensitive cones are activated while the green and blue-violet ones are relatively dormant. Yellow is the result of the green-sensitive and red-sensitive cones being activated and mixed while the blue-violet cones remain comparatively inactive (**fig. 1.3**).

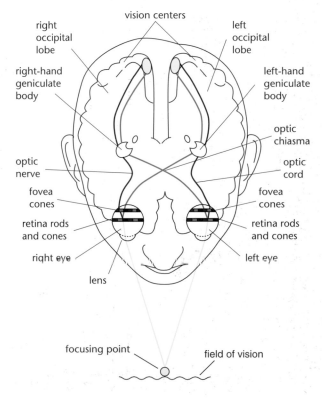

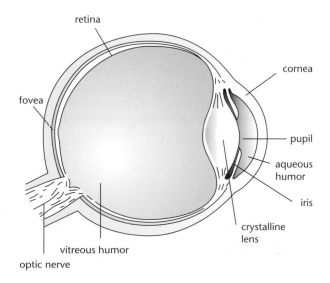

1.2 The human eye. We distinguish the world of color after light passes through the cornea and pupil and strikes the retina, which subsequently passes messages to the fovea from where they are transmitted to the brain.

1.3 The eye/brain processing the color yellow. The yellow sensation is passed through the lens of the eye and is converted in the retina to the light components of red and green. From the retina these components are conveyed to the fovea, which transmits them to the brain. The brain mixes the red and green messages to create the yellow that we see.

HOW LIGHT GIVES OBJECTS COLOR

The great physicist and mathematician Sir Isaac Newton (1642–1727) was a pioneer in studying light under laboratory conditions to provide a logical framework for understanding color (see page 13). His early research into color phenomena resulted in his discovery that sunlight is composed of all the colors in the spectrum (**figs. 1.4, 1.5**). Using a ray of sunlight directed through a prism, Newton observed that the ray of light was bent, or refracted, and the result was an array of projected colors, each with a different range of wavelengths, in the following order: red, orange, yellow, green, blue, indigo, and violet. This array, the constituents of light, is known as the **visible spectrum**.

When light strikes a surface, certain wavelengths are absorbed and others are reflected (bounced back) by its **pigments,** or coloring matter. This process gives the surface its color. For example, we see red when only the red wavelengths are reflected off the surface of an object, such as a red apple, and the remaining wavelengths are absorbed. Different combinations of reflected wavelengths form all the observed colors. When all the wavelengths are reflected off a surface and mixed, the result is white. (White light is that light that we perceive as daylight at noon.)

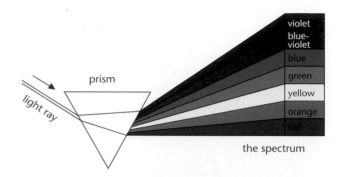

the spectrum

1.5 The visible spectrum. Of the seven lightwaves, violet has the shortest wavelength and red the longest.

FACTORS IN PERCEPTION

There are many factors affecting our perception of a color, such as the surroundings of the object, its surface texture, and the lighting conditions under which it is seen. How much of a color is used, whether it is bright, dull, light, or dark, and where it is placed in relation to another color are also crucial factors in our perception.

Media and Techniques

Our perception of color in works of art is strongly affected by the type of medium used. Painting alone offers a myriad of different types of media, such as oil, acrylics, and water, that affect our perception of color. We must also take into consideration the type of support employed—canvas, board, or paper, and so on—and what grounds are used, such as **gesso** or primer. Even the brands of paint can provide differences, because of the mediums used for their mixture. How does a pencil line or sketch affect the visual perception of color in a watercolor painting? The textile artist works with a vast array of yarns and fibers, each imparting its unique qualities of sheen and **texture**. Ceramic glazes can result in an overlapping of colors that changes our perception of the piece. We can also experience the same types of color variations in printmaking.

Eye and Brain

The human eye in combination with the brain's reaction tells us how to distinguish the type of color being seen, as well as its relative purity and lightness. But memory also exerts an influence. Most of what we see is based on the memory of a color—when and how we have experienced it before. In addition, certain colors are perceived more easily than others. Yellows and greens are seen before other hues, while red and violet are the most difficult to perceive. If we take

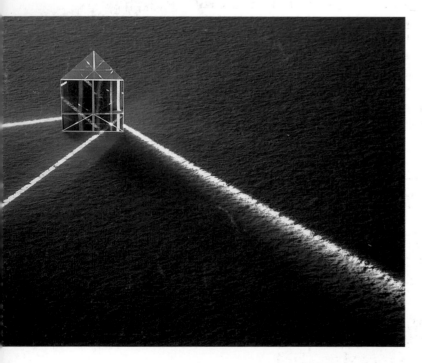

1.4 The spectrum generated by light refracted through a prism. A close examination of the seven major colors of the spectrum also reveals several graduated ones between them. For example, the human eye can detect red-orange between red and orange, and blue-green between blue and green.

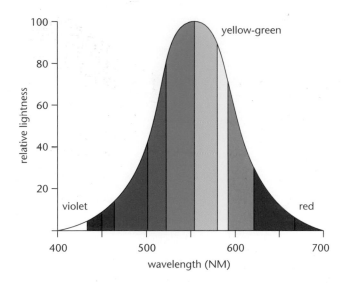

1.6 The perception curve. The yellow and green wavelengths register highest on the relative lightness axis. Someone with normal vision perceiving colored lights of equal energies will register the yellow-green segments of the spectrum first, because they appear brighter than all the other ones.

another look at the hue order of the visual spectrum, we see that a perception curve is formed, with the yellow and green hues at the curve's height and red and violet forming its lower extremities (**fig. 1.6**).

Psychology and Culture

Memory, experiences, intelligence, and cultural background all affect the way a color's impact can vary from individual to individual. This is not to say that the color will be perceived differently, but that that perception will *mean* different things to different people. Let's say we have black—is it the color of death? Maybe in most Western cultures, but not in China and India, where white is regarded as a symbol of death. In America and many Western cultures the bride usually wears white and white is deemed a bridal or wedding color. In China, however, the bride is attired in red. The mailbox on the streets of the United States is blue, but in Sweden the mailboxes are red. The American tourist in Sweden has a more difficult time finding a site to mail those postcards home because of the color change from the familiar blue to red.

LOCAL, OPTICAL, AND ARBITRARY COLOR

The quality of light further determines the quality of any color that we see. A red barn in brilliant noon sunlight will appear red, but a different red than one we would observe at sundown or on a rainy day. Armed with this knowledge, artists, architects, and designers can influence the color sensations of those who view their work. They may use color in three ways to impose these sensations: local or objective color, optical color, and arbitrary color. **Local color** is the most natural. It reproduces the effect of colors as seen in white daylight, exactly as we expect them to be: blue sky, red barn, and green grass. When the artist has a highly realistic style, the composition is rendered in exact colors and values (**fig. 1.7**). **Optical color** reproduces hues as seen in

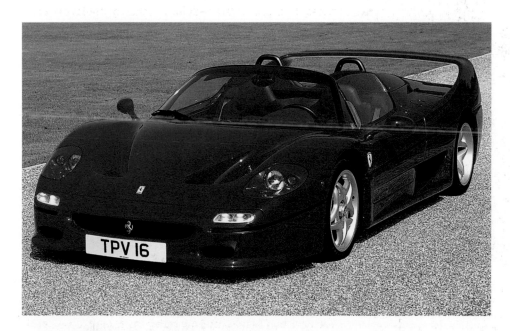

1.7 Ferrari F50, 1996. The local color of this car stands out on a bright, cloudless day.

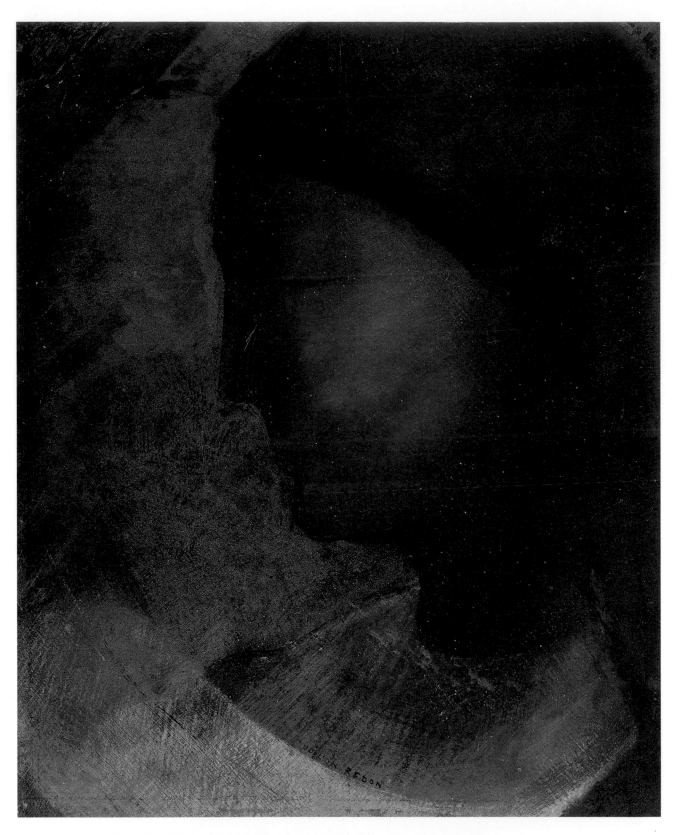

1.8 Odilon Redon, *The Golden Cell (Blue Profile)*, 1892. Oil and colored chalks, with gold, 11⅞ x 9¾ in (30.1 x 24.7 cm). British Museum. Bequest Campbell Dodgson. The Symbolist painter Redon uses a gold background in order to suggest a Byzantine mosaic of the fourteenth or fifteenth century, which typically employed this color. However, he chooses to interpret the woman's dreaming face in arbitrary color, associating her in his fantasy with the Virgin Mary, who is traditionally rendered in blue.

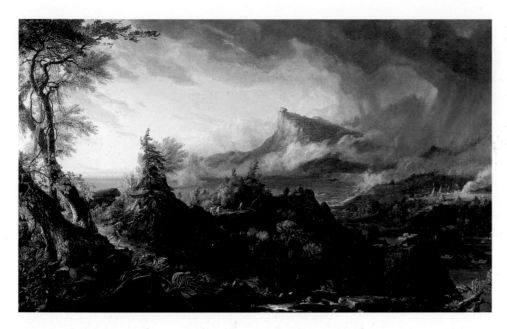

1.9 Thomas Cole, *The Course of Empire: The Savage State*, 1834. Oil on canvas, 39¼ x 63¼ in (99.7 x 160.6 cm). The New York Historical Society, New York. Weather conditions determine subtle changes in the optical color of this landscape. The effects of sunlight originating beyond the left of the painting can be seen tinging the light-green leaves in the left foreground, while gray thunderclouds serve to darken the landscape in the central and right-hand areas.

lighting conditions other than white daylight: in the rain or thunder (**fig. 1.9**), at sunset, or in indoor lighting. Again the composition is rendered in a somewhat naturalistic way. **Arbitrary color** allows the artist to impose his or her feelings and interpretation of color onto the images (**fig. 1.8**). Here, natural color is abandoned for the artist's choice. A gray stone bridge may be executed in warm oranges and beiges if the artist wants the bridge to impart a feeling of vitality and warmth. Arbitrary color is most often seen in twentieth-century art, especially among the Expressionists and Fauves, whereas local and optical color are employed in more realistic styles.

CONCEPTS TO REMEMBER

☐ Color is usually seen before imagery.
☐ The physiology of the eye and the brain's reaction enable us to perceive light as different colors.
☐ The color imparted by an object is produced by the mixture of wavelengths reflected from its surface.

☐ Our perception of the color of an object is dependent upon several factors, such as illumination, media, techniques, quantity, relationship to other colors present, memory, and culture.
☐ Most color usage employs one of three aspects of color—local color, optical color, or arbitrary color—and any of these can be manipulated by users to create desired reactions in the viewer.

Exercises

1 Observe an object under different lighting conditions, and, if you can, take some color photographs. How do the different conditions affect its color?

2 Collect and label pictures (magazine photographs are good) showing local, optical, and arbitrary color.

CHAPTER 2
Color Systems and Color Wheels

Over the centuries colors have been mixed according to three different systems. **Subtractive color** is the process of mixing pigments together, such as we see in painting. As we saw in chapter 1, the pigments in an object enable it to absorb some light waves and reflect others (**fig. 2.1**). When these pigments are blended, more light is absorbed and less is reflected—hence the term "subtractive." By contrast, the colors in light are additive—the more they are mixed with other colors, the lighter they become. **Additive color** is the process of mixing colored light, such as in theatrical lighting or television. The **partitive color** system is based on the reaction that colors have when they are placed next to each other. Bear in mind that all colors are seen in relation to other colors rather than in isolation.

Color wheels are color arrangements or structures that enable us to organize and predict such color reactions and interactions. As you will see, just one wheel or system may not satisfy all our needs. For example, the painter uses subtractive color (to create various colors of paint) and partitive color (to create color reactions according to where the paint colors are placed). The photographer uses additive color (to create the colors or **values**—lightness or darkness—within the photograph) and partitive color (to impart reactions and interactions between the photographic imagery). The textile artist uses subtractive color (to create colors of yarn and textiles by dyeing) and partitive color (to impart reactions and interactions that occur from color placement). It becomes obvious that all art media use partitive color, and that the specific materials employed within each medium can be either additive or subtractive. Each artist must determine which wheel or wheels best satisfy the needs at hand.

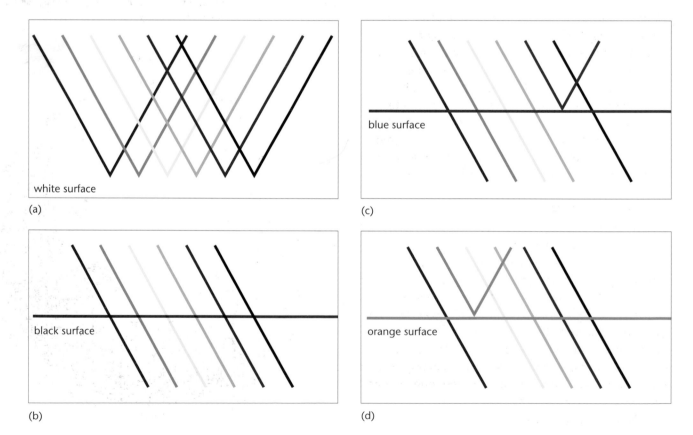

(a) white surface

(b) black surface

(c) blue surface

(d) orange surface

2.1 The surface absorption of light rays. A white surface (a) will reflect all light rays that strike it while a black surface (b) will absorb them. A colored surface (c) and (d) will reflect the same colored light ray striking it but absorb other colors.

THE PIGMENT WHEEL

The mixing or **pigment wheel** is the basis for working with subtractive color; it imparts information about the reactions colors have when they are actually mixed (**fig. 2.2**). Its **primary colors** are red, yellow, and blue, which are used in combination to form the other hues. The term "primary" tells us that this is a color that cannot be obtained by mixing. When two primary colors are mixed together a **secondary color** (or intermediate color) is the result of the mixture. Yellow and blue mixed together result in green. Red and yellow mixed together produce orange, and a mixture of red and blue results in violet (sometimes called purple). Thus the secondaries are green, orange, and violet. When a primary color and an adjacent secondary are mixed, **tertiary colors** are the result:

- red + orange = red-orange
- orange + yellow = yellow-orange
- yellow + green = yellow-green
- green + blue = blue-green
- blue + violet = blue-violet
- violet + red = red-violet.

When using this wheel keep in mind that red, yellow, and blue cannot be obtained by mixing pigments, and that when these three primary pigments are combined a muddy black is the result. Imperfections in the pigments mean that the black is not pure, as it should be in theory. Also, note that the secondary and tertiary hues are not equal mixtures of their components. Mixing equal amounts of yellow and blue pigments together will result in a green that is more yellow-green than green because yellow is stronger than green.

THE PROCESS WHEEL

In contrast to the pigment wheel, the **process wheel** gives us three basic primaries—yellow, magenta, and cyan—that do, upon mixing, result in purer hues (**fig. 2.3**). This primary arrangement is the standard employed in color printing and photography as well as pigment (usually ink) manufacture. A look at the colors used shows a very luminous and bright yellow, an intense magenta that is red though leaning toward violet, and a cyan that is blue but tending toward green. When we take equal parts of these primaries and mix them, the following secondary hues result:

- yellow + cyan = green
- cyan + magenta = violet
- magenta + yellow = orange.

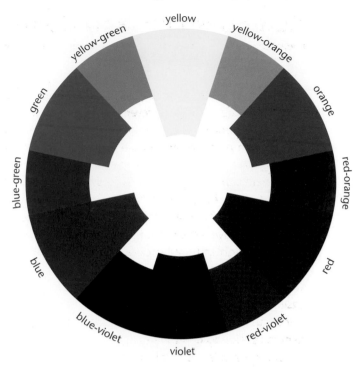

Pigment Wheel

2.2 The pigment wheel. Mixing two primaries from this twelve-step subtractive color wheel produces a secondary. Mixing a primary with a neighboring secondary results in a tertiary.

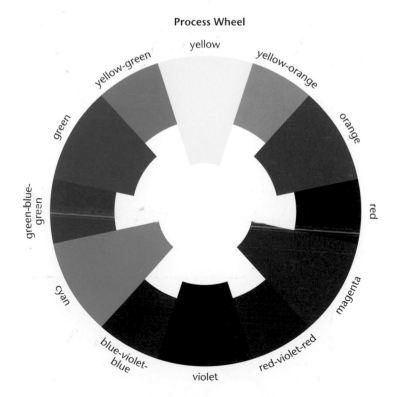

Process Wheel

2.3 The process wheel. The primaries and tertiaries in this twelve-step subtractive color wheel are different from those in the pigment wheel, but the secondaries are the same.

Munsell Wheel

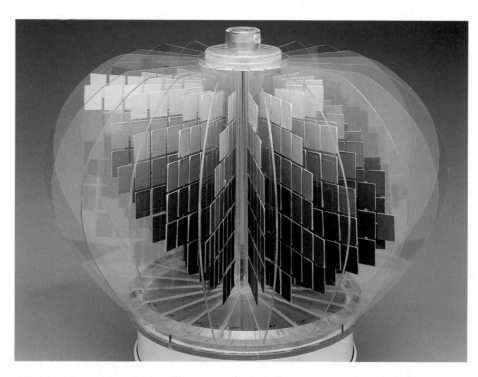

(Munsell wheel labels, clockwise from top:)
yellow
yellow-orange
orange
red-orange
red
red-violet-red
red-violet
violet-red-violet
violet
violet-blue-violet
blue-violet
blue-violet-blue
blue
blue-green-blue
blue-green
green-blue-green
green
green-yellow-green
yellow-green
yellow-green-yellow

2.4 The Munsell wheel. This twenty-step partitive color wheel consists of five primaries, five secondaries, and ten tertiaries.

The resulting tertiaries will be as follows:

• yellow + green = yellow-green

• green + cyan = green-blue-green

• cyan + violet = blue-violet-blue (ultramarine blue)

• violet + magenta = violet-red-violet

• magenta + orange = red

• orange + yellow = yellow-orange.

Again, mixing the three primaries together in equal amounts gives us black.

THE MUNSELL WHEEL

Albert Munsell (1858–1918) developed a partitive color system based on five primary hues or, as he termed them, **principal colors**: yellow, red, green, blue, and purple. These primaries are based on **afterimage** perceptions that derive from hues that we see in nature. Afterimaging is an optical reaction that occurs after we stare intensely at a hue and then shift our eyes to a white surface; this second hue is termed the afterimage. If, for example, we stare at a red dot, the resulting afterimage will be blue-green. Munsell set up each afterimage as the complement to his principal (primary) hues. A **complementary hue** is the hue that occupies the position directly opposite

2.5 The Munsell color tree. There are ten vanes to this tree, corresponding to the five primaries and five secondaries of the Munsell wheel (see fig. 2.4). In this view, the complementary primaries of yellow and blue-violet can be seen across from each other.

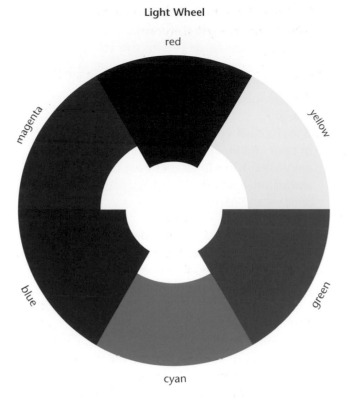

Light Wheel

red

yellow

magenta

green

blue

cyan

2.6 The light wheel. This six-step additive color wheel consists of three primaries and three secondaries.

on a color wheel. From this base he was able to arrange his **Munsell wheel** (**fig. 2.4**).

His arrangement resulted in the complementary combinations of yellow and purple-blue, red and blue-green, green and red-purple, blue and yellow-red, and purple and green-yellow. These afterimages comprise the secondary hues of the Munsell wheel. He further systematized the color wheel into a three-dimensional form that he termed a "tree" (**fig. 2.5**). Intervals of value, measuring the lightness and darkness of a hue, are shown along the trunk or vertical axis, with 0 as black and 10 as white. The intervals between are assigned the numbers 1 to 9. Any color along the inner-most vertical axis is called a **neutral**, a nonchromatic hue of white, gray, or black which does not contain any pure hue. Branches or horizontal intervals measure the **saturation** or relative purity of each hue, with the pure hue being located at the outside edge. The remaining intervals along each horizontal branch consist of colored gray mixtures in varying degrees of purity.

We will explore Munsell's system further in the section on color theorists (see page 17). It is used by dye manufacturers for yarn and fabric coloration, as well as in interior design and in the production of cosmetics, computer hardware, and paint. For example, Liquitex acrylic paints carry Munsell color notations on their tube labels. Partitive color usage often relies on the interactions resulting from afterimaging. Because the Munsell wheel is the wheel based on afterimaging, we will base all our information concerning color on this wheel unless otherwise noted.

THE LIGHT WHEEL

The **light wheel** is based on the additive color system and provides information concerning light rays and transparent color. Here the primary colors that form the other hues are red, green, and blue. The secondaries are as follows:

- red + green = yellow
- green + blue = cyan
- blue + red = magenta.

Since these are combinations of colored light, when all the primaries are combined, white results. The total absence of light results in black. Because light is being added to light, the more color rays are mixed or fused with other color rays, the lighter they become. The light wheel is used for theatrical lighting and projection (**fig. 2.6**), and is now the basis for video and computer graphics as well.

THE VISUAL WHEEL

The **visual wheel** grew out of work done by Leonardo da Vinci (1452–1519) on complementary colors, and greatly influenced Renaissance painting. This wheel was the forerunner of the concept of partitive color theory and was used in a partitive as well as a subtractive manner. The visual wheel was then superseded by the Munsell wheel, which was more scientifically accurate.

The primary colors of the visual wheel are red, yellow, green, and blue (**fig. 2.7**). The secondaries are as follows:

- red + yellow = orange
- yellow + green = yellow-green
- green + blue = blue-green
- blue + red = violet.

The visual wheel is arranged so that the complementary combinations are yellow and blue, orange and blue-green, red and green, and violet and yellow-green. When these primaries are combined the result to the human eye is a gray.

Visual Wheel

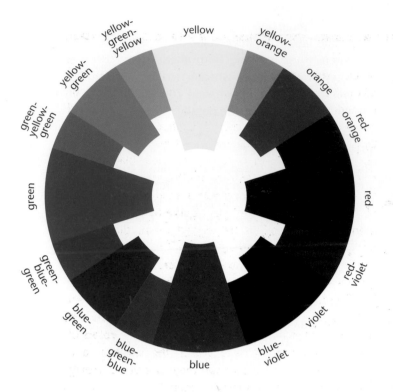

2.7 The visual wheel. This sixteen-step partitive (and subtractive) color wheel consists of four primaries, four secondaries, and eight tertiaries.

CONCEPTS TO REMEMBER

☐ The three basic color systems are subtractive color, additive color, and partitive color.

☐ The five basic color wheels are:
 (1) the pigment wheel (subtractive color),
 (2) the process wheel (subtractive color),
 (3) the Munsell wheel (partitive color),
 (4) the light wheel (additive color), and
 (5) the visual wheel (subtractive and partitive color).

☐ Specific color wheel choice depends on the effects of color and imagery desired in the art medium employed. The painter uses both the subtractive and partitive wheels. The photographer uses the additive and partitive wheels.

Exercises

1 Make a list of various art media (painting, sculpture, printmaking, etc.), crafts (weaving, batik, ceramics, jewelry, etc.), and commercial visual media (interior design, architecture, advertising, photography, etc.). Note what color systems (subtractive, additive, partitive) and color wheels (pigment, process, Munsell, light, visual) would be used by each.

2 Create three compositions of identically-spaced stripes in an art medium of your choice. Within the first, choose a complementary pair of hues from the pigment wheel; within the second, a complementary pair from the Munsell wheel; and within the third, a complementary pair from the visual wheel.

CHAPTER 3
Color Theorists

In trying to understand the important influence of color on our lives, color theorists have from ancient times to the present attempted to explain both scientifically and psychologically how color reacts. In doing so they have devised systematic frameworks and rules for our dealings with color. Although color is a sensation, and as such its reactions cannot be neatly categorized, our awareness of the work of color theorists does help us in understanding color. Color usage is complex and knowledge of how color theory has evolved lets us utilize these various theories, where appropriate, in working with color.

COLOR THEORY IN THE ANCIENT WORLD

The first hint of **color theory** was formulated by the ancient Greek philosopher Empedocles (492–431 B.C.). Empedocles' observations of his surroundings led him to the conclusion that the eye of the observer perceived color; color is not a property of the object being observed. Democritus (?460–?370 B.C.) developed the first atomic theory. He stated that the world was composed of atoms and that color was the result of atomic arrangements. Here were the first bare bones of color theory evolving from a combination of speculation and observation. According to the great Greek teacher and philosopher Plato (428–347 B.C.), perception was a property of the individual perceiver—the problem, therefore, was how to distinguish between reality and appearance. Color is a sensation that allows us to describe what we see.

In *De Coloribus* (the first known color book), the Greek philosopher Aristotle (384–322 B.C.) attempted to explain the composition of colors and how they were related. Aristotle assumed that all colors were derived from the blending of sunlight, fire, light, and lack of light in varying degrees. Aristotle's hue identification included white, black, red, yellow, brown, violet, green, and blue, and he proposed that varying mixtures of black and white with these hues would result in the formation of all the perceived colors.

LEONARDO DA VINCI

The Renaissance artist and scientist Leonardo set out his beliefs on color theory in his *Treatise on Painting*, which was not published until 1651. He wrote that black and white were indeed colors, and assigned white, yellow, green, blue, red, and black as the simple or primary colors. This was the first appearance of the four primaries of the visual wheel, even though Leonardo did not arrange them in a circular configuration. Working by observation from his own optical reaction, Leonardo concluded that certain responses took place when colors were placed next to each other; this was later to become known as **simultaneous contrast**. Essentially he discovered that when placed side by side, complementary colors (or, as he termed them, direct contraries) intensify each other.

Leonardo was also extremely interested in developing what we now know as **atmospheric perspective**. This describes the tendency of forms seen at great distance to become uniform in hue and value. He recorded the sky changes and their effect on colors of objects both near at hand and in the distance, and wrote, "colors will appear what they are not, according to the ground which surrounds them."

Leonardo ranked colors in importance, saying that white was the first and simplest of colors and represented light, second was yellow (earth), third was green (water), fourth was blue (air), fifth was red (fire), and sixth was black (total darkness). He also worked with modeling and shading of objects, using light and **shadow** effects (**chiaroscuro**, "light-dark" in Italian) in his painting, and further developed this concept into the technique known as **sfumato**, in which hues are softly graded and blended to give a hazy, blurred effect.

SIR ISAAC NEWTON

The English physicist Isaac Newton was interested purely in the physics of color, rather than in perception. He discovered that as a ray of white light passes and is bent, or refracted, through a prism it is broken into an array of colors, or spectral hues—red, orange, yellow, green, blue, indigo, and violet (see figs. 1.4, 1.5). He noted that white light was a mixture of all the spectral hues. He took this "array" and turned it into a two-dimensional circular model that became the first color wheel. Notice that the hue divisions of Newton's wheel are not equal but are based on the extension or proportion of each hue in relation to the spectrum (**fig. 3.1**). Newton found when mixing pigments of opposite hues on his wheel (complementaries) that "some faint anonymous colour" resulted. Newton was never able, in his

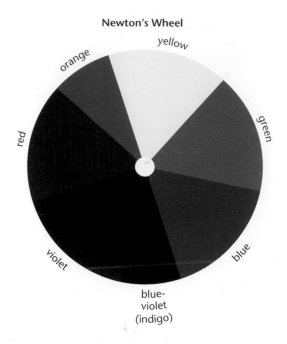

Newton's Wheel

yellow
orange
green
red
blue
violet
blue-
violet
(indigo)

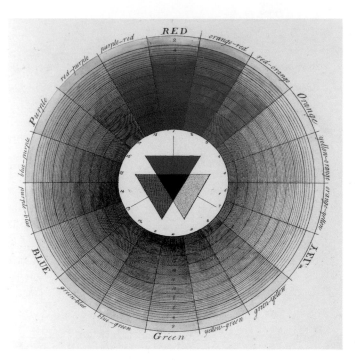

3.1 Newton's wheel. Newton proposed a color wheel based on the adjacent sequence of seven wavelengths within the visible spectrum (see fig. 1.5). The hue divisions are unequal because they are based on the proportion of each wavelength relative to others in the spectrum. The white at the center indicates the light source within which all the wavelengths are contained.

3.2 Harris's color wheel, from *The Natural System of Colors*, c. 1766. Royal Academy of Arts, London. Moses Harris derived his eighteen-step color wheel from the three primaries of red, yellow, and blue, which here overlap to black. As each hue approaches the center, it takes on deeper shades of gray.

experiments, to mix pigments of two or three of his hues to obtain white, because his theory was based on the mixing of light (additive color), while the mixing of hue pigments is based on subtractive color.

MOSES HARRIS

Moses Harris, an English entomologist and engraver (active 1766–1785), wrote *The Natural System of Colors* in 1766. In this book he presented red, yellow, and blue as the primary hues, which he termed "primitives." The mixture of these primitives produced the "compound" hues (secondaries) of orange, green, and purple. The primitive/compound mixtures were each categorized into two progressions—red and orange yielded red-orange which was more red than orange, and orange-red which was more orange than red. The Harris wheel was divided into eighteen equal hue divisions and each division was then graded by value, light (plus white) to dark (plus black) (**fig. 3.2**).

JOHANN WOLFGANG VON GOETHE

In 1810 the German poet Goethe (1749–1832) published his *Theory of Colors*, which he thought would

be more important to posterity than his poetry. He was one of the first modern thinkers to investigate and record the function of the eye and its interpretation of color, rather than the properties of light. He was a vigorous opponent of Newton's physics of light.

The two-dimensional wheel he developed was based on a triad of primaries—red, yellow, and blue—with the secondaries as complements of the primaries. In addition to his color wheel (**fig. 3.3**), which reflected previous diagrams, Goethe formulated a color triangle which he felt further reinforced color relationships (**fig. 3.4**).

Goethe assigned a number to each of the hues according to their relative **luminosity** (the ability of the hue to give a glowing impression):

- yellow = 9
- orange = 8
- red = 6
- green = 6
- blue = 4
- violet = 3.

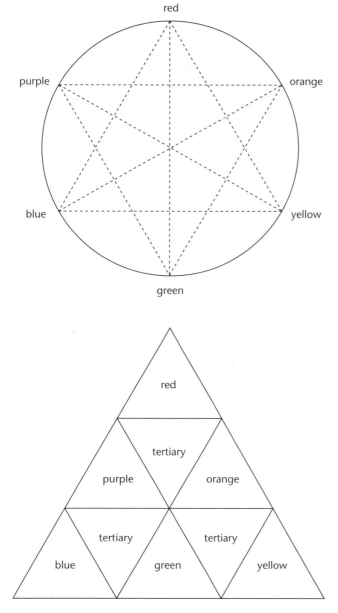

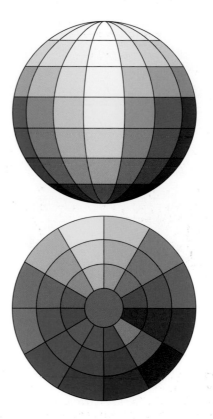

3.5 Runge's color sphere. The outer edges of Runge's sphere show near white at the top and black at the bottom (top diagram), with pure hues in the middle (equator). Note that the pure hues at the equator are different values, while the hues plus white at the top merge into the same value.

3.3 and 3.4 Goethe's color wheel (*above*) and color triangle (*below*). The corners of the triangle contain the primaries: red, yellow, and blue. The secondaries form the middle of the triangle's sides, connecting the primaries. The remaining areas are the tertiaries, which are the result of mixing two secondaries with the adjacent primary. These tertiary mixtures were less intense than what we commonly call tertiaries today.

White was the most luminous at 10 and black the least at 0. In fact, he explored every aspect of color and its reactions, including the role of complementary colors in creating shadows, simultaneous contrast, **successive contrast**, the effects of cast light on an object, and proportional color use, leaving us with one of the foremost research references available to artists in all fields of endeavor.

PHILIP OTTO RUNGE

Philip Runge (1777–1810) was a German painter. In his book *The Color Sphere*, published in 1810, he arranged twelve hues in a spherical format, thus giving us the first three-dimensional color model. Runge's primaries were still red, yellow, and blue, and the remaining nine hues were interspersed to form a diameter or equator around the center of the sphere (**fig. 3.5**). The hues were each mixed in two steps, with white on one side of this equator and two steps of black on the other side. In short, each of the hues evolved to black on one side of the sphere and to white on the other.

J.C. MAXWELL

Maxwell (1831–1879), a Scottish physicist, experimented with the concept of additive color and its resulting color combinations, as a property of the behavior of light. His two-dimensional color diagram took the form of a triangle with green, blue, and red at the points

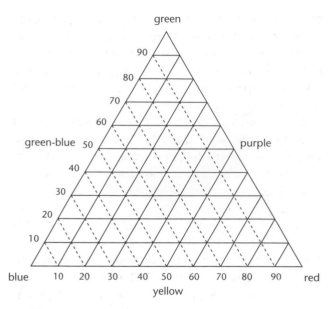

3.6 Maxwell's color triangle. Maxwell's triangle was based on light mixtures that approach pure white at the center.

(primaries), and green-blue, yellow, and purple forming the sides, with white in the center (**fig. 3.6**). He also experimented with spinning colored discs (the Maxwell color discs) and discovered that when spun these color combinations formed other hues—red and green spun together, for example, resulted in a yellow reaction. Maxwell's work led him to the field of color photography, in which he proved to be a pioneer of modern-day photography.

MICHEL EUGÈNE CHEVREUL

The French chemist Chevreul (1786–1889) was hired by the famous French tapestry-weaving studio Gobelins, to be its dye master. In this position he began his intensive investigation into color and its reactions. His findings became part of his major publication *The Principles of Harmony and Contrast of Colors*. He verified that all hues could be obtained from mixtures of the primaries red, yellow, and blue, but his greatest contribution was his recording of the reactions that colors have when placed side by side or in relationship to each other. This research led to the color theory laws of simultaneous contrast (based on complementaries), successive contrast (based on afterimages), and **optical mixing** (see pages 97–102). His research led to his proposing "color harmonies" which are used to this day in the form of **color schemes**. Although Chevreul was writing during the Impressionist period of art, his theories were

more dramatically applied by Neo-Impressionists such as Seurat (see fig. 11.7).

OGDEN ROOD

The American Ogden Rood (1831–1902) received schooling in both art and science, and published his research from this dual point of view in 1879 as *Modern Chromatics*. He proposed that colors differed from one another as a result of three variables—purity (saturation), luminosity (value), and hue. His experiments were concerned with the optical mixing that occurs in **pointillism**, a painting technique in which dots of pure hues are placed together on a white ground so that they are mixed by the eye. While Rood's color wheel (a three-dimensional cone) was based on the primaries red, green, and blue, their arrangement was such that the complements were the result of afterimages, rather than the dull colors obtained by pigment mixing (**fig. 3.7**). Rood felt that once an artist knew what the direct complement or contrast of a hue was, he or she could imbue a glowing brilliance to a work that exceeded the hue's brilliance.

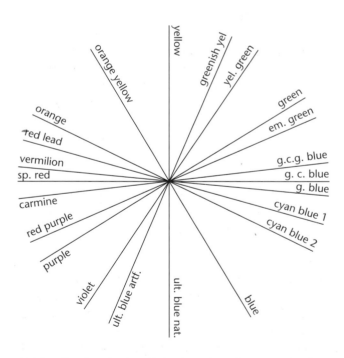

3.7 Rood's color wheel. In his book *Modern Chromatics* (1879) Rood emphasized the importance for artists of a sound knowledge of complements so that applied colors could then reveal their natural brilliance, even colors that are comparatively dull in isolation. In his own words, ". . . paintings, made up almost entirely of tints that by themselves seem modest and far from brilliant, often strike us as being rich and gorgeous in colour, while, on the other hand, the most gaudy colours can easily be arranged so as to produce a depressing effect on the beholder."[1]

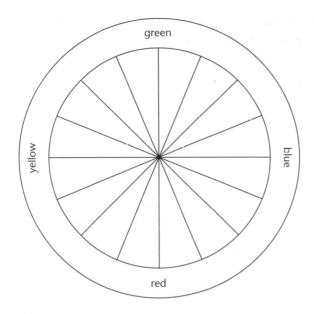

3.8 Hering's primaries. Hering's primaries of red, yellow, green, and blue are the same as those on the visual wheel (see fig. 2.7).

EWALD HERING

Ewald Hering (1834–1918) was a German physiologist and psychologist who was concerned with theories of color perception. He established his primaries as red, yellow, blue, and green (**fig. 3.8**); many color theorists today still refer to these four as the psychological primaries, or the primary colors of vision. The Hering color diagram was based on perception, not on the physical mixing of colors. It was triangular in form, with pure hue at one point, black at another point, and white at the third point. Both Wilhelm Ostwald's work (see page 18) and the Swedish Natural Color System (NCS) are based on Hering's theories.

ALBERT MUNSELL

The life's work of American-born color theorist Albert Munsell (1858–1918) led to his system being adopted by the United States Bureau of Standards as the acceptable language of color. This language was published by Munsell as *Color Notation* in 1905. He followed Hermann Helmholtz (1821–1894) in stating that color could be described according to three variables—hue, value (lightness or darkness), and **chroma** (saturation or brightness). He assigned a numbering system to these variables as they occurred within each hue category. His experimentation led to his expansion of the primary hues (which he termed

principal colors) to number five—red, yellow, blue, green, and purple. Afterimages of these principal colors formed the basis for Munsell's complementaries—red and blue-green, yellow and purple-blue, blue and yellow-red, green and red-purple, and purple and green-yellow.

As described in chapter 2 (pages 10–11), Munsell's color tree represents gradations of value along the vertical axis, and gradations in saturation or chroma as steps along the horizontal "branches." The "equator" of the solid shows the hues (**fig. 3.9** and see fig. 2.5). Munsell gave each of the hues the number 5 and an initial letter (or letters), so that red is 5R, yellow-red is 5YR. He allotted the hues that fall between the five principal and five complementary hues an intermediate numbering system, so that 10R is a hue that falls halfway between 5R and 5YR. The number 5, therefore, indicates the midpoint of each hue family (**fig. 3.10**).

Munsell expressed the value of the hue by adding a number between 0 and 9 as the second part of the notation, so that 5R5 is a middle-value red, and 5R9 is a very pale pink. Finally, Munsell added a notation after a slash to indicate the chroma, or level of saturation or purity, of the hue at that value, measured in equal steps from neutral gray to the greatest saturation seen in each hue at a particular value. So, a pure middle-value

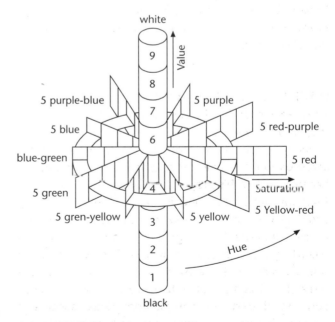

3.9 A three-dimensional diagram of the Munsell tree. Hues are positioned on a vertical axis showing values from light (above) to dark (below). Saturation is measured on a horizontal axis, with dull-gray hues at the center evolving into the brightest hues at the outer extremities. This illustration shows saturation at the middle value of 5.

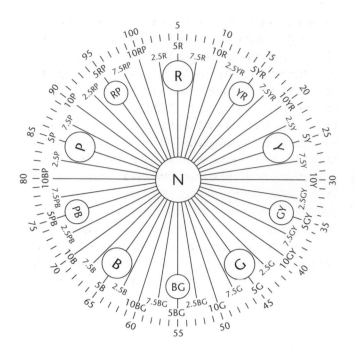

3.10 A cross-section of the Munsell tree. This bird's-eye view shows the five primaries and five secondaries of the Munsell wheel and tree (see figs. 2.4–2.5), with "N" signifying the neutral, non-chromatic value of hues closest to the vertical axis. The numbers 5, 7.5, 10, and 2.5 running clockwise around the two innermost rings of numbers signify different stages in the progression from one primary to the next secondary, and so on. Courtesy of GretagMacbeth, New Windsor, NY.

red is 5R5/14, whereas a less saturated red of equal value may be 5R5/6.

The Munsell notation may be summed up as follows: the first number and letter is the hue, the second number is the value, and the third is the chroma. Each plotting of a hue was flattened out into pages that became the branches of the Munsell color tree revolving around the value–scale trunk. This system allowed the artist to determine the components of a color without experimentation, and therefore to determine the reaction or interaction that a particular color choice would impart. It also provided pigment specifications that were precise, allowing industry to become color standardized.

WILHELM OSTWALD

The Nobel Prize-winning German chemist Wilhelm Ostwald (1853–1932) based his color model on geometric progression. A value scale based on the absorption qualities (the quantity of white light absorbed) added arithmetically would result in a 1, 2, 3, 4 . . . format. However, when absorption is analyzed on a geometric basis, we see a scale of 1, 2, 4, 8, 16, 32 . . . This provided a scale with more optically equal steps in value gradation. Ostwald's resulting gray scale contained eight steps.

His color system consisted of two triangular solids joined at one side, with black at one point, white at the other, and twenty-four pure hues at the "equator" (**fig. 3.11**). He based his hues on the familiar red, yellow, and blue primaries. Ostwald's premise was that all colors are a combination of hue, black, and white. Thus the intermediate portions of his color triangles were based on percentages of black, white, and hue. Within each of these percentage mixtures the total was always 100 percent, which made them "complete." Ostwald termed the addition of white to a hue or color "tinting"; the addition of black, "shading."

C.I.E.

At the 1931 International Commission on Illumination (Commission Internationale de l'Eclairage, or C.I.E.) the need for standardization of color notations was explored. The outcome was a precise color matching system based on lights. Here mechanics rather than observation or pigment measure served as the basis for color identification. A colorimeter was used to measure the three variables of any color: the luminance (intensity of light given off), the hue, and the saturation. Together, these three values determine the "chromaticity" of a color.

The C.I.E. chromaticity diagram, or triangle, has the hues (stated as spectral hues or wavelengths) around

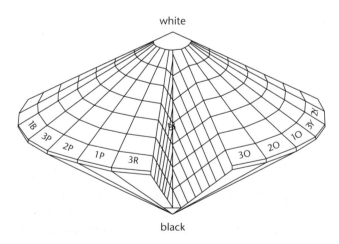

3.11 Ostwald's color solid, from *Color Science*, 1931. Ostwald first presented his color specification model in 1917. It has since been criticized by some artists for being too scientific in the creation of artworks. Adding black and white to a hue to create gray is markedly different from Munsell's method of arriving at gray by mixing a hue with its complement.

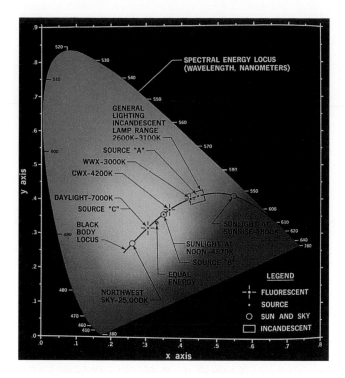

3.12 The C.I.E. color diagram. The scientific foundation of the C.I.E. diagram affords a precise color standard for industry, but the diagram is not a practical tool for the artist.

version of the sphere developed earlier by Runge (see page 15). However, Itten placed yellow at the top of the diagram because it was the brightest of the hues and the closest visually to white light. The diagram contained twelve hues that were each presented in seven gradations from light at the center to dark at the points (**fig. 3.13**). The advantage of this type of diagram was that the students could observe the differences in hues as well as the values of the hues simultaneously.

Itten encouraged students to explore color reactions and required from them many types of gradation scales, because he felt that gradations led to chromatic unity in any work. Students were encouraged to use rectilinear designs in a grid format for their experiments because color reactions could be easily observed. In his later work he proposed six basic contrasts of color:

1 light–dark
2 cold–warm
3 complementary
4 simultaneous contrast
5 quality or saturation
6 quantity or extension.

the edge and the mixing or sum of these hues in the center, called E for equal energy (**fig. 3.12**). For light mixtures E is white; for pigment mixtures E is black or a dark neutral mixture. Although the diagram is termed a triangle, in fact it is a curve based on the luminosity curve.

The advantage of the C.I.E. system is that it provides industry with the means of accurately and consistently matching colors of barely perceptible differences. Such an objective standard eliminates differences in human interpretation, as well as problems caused by the fading of painted or colored swatches.

JOHANNES ITTEN

The Swiss teacher and artist Johannes Itten (1888–1967) is probably best known to the color student for his book *The Art of Color* and its condensed version *The Elements of Color*. Itten taught both color and design at the enormously influential Bauhaus School in Germany, where his approach to education included both mental and physical conditioning. Each morning Bauhaus students did aerobic-type exercises on the roof of the building prior to Itten's lectures and classroom work. Itten developed his color sphere and "star" for his Bauhaus preliminary course in 1919. The star was simply a flattened

Itten's Wheel

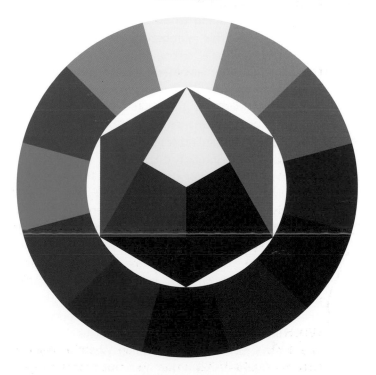

3.13 Itten's color wheel. Itten employs the primaries red, yellow, and blue in the center triangle. This triangle is surrounded by the secondaries green, violet, and orange, which are the respective complements of the primaries. The outer circle is an arrangement of primary, secondary, and tertiary hues.

In 1961 Itten developed another wheel based on the primaries yellow, red, and blue which assumed a triangular position within the circle.

ALFRED HICKETHIER

The German painter Alfred Hickethier (1903–1967) concerned himself with color reproduction in printing, particularly the multicolor gravure process. His studies of pre-existing color theories led to his development and publication of standardized color sheets for printing. The *Hickethier Color System* was published in 1952, followed by *Color Mixing by Numbers* in 1963. Hickethier's premise was that the myriad of colors available to color printing, as well as other media, had to be easily obtained and identified. To this end he assigned his primary colors and black and white each a number: white 000 (the absence of all color), black 999 (the presence of all color), yellow (process yellow) 900, red 090 (his red is most visually identifiable as magenta), and blue 009 (his blue is most visually identifiable as cyan). Yellow occupied the first digit, magenta the second digit, and cyan the third digit of his three-digit system. These numbers represented the proportions or parts of a hue that were to be mixed with another to form other colors. Thus orange was numbered 990 or 9 parts yellow, 9 parts magenta, and 0 parts cyan, leading to an equal mixture of yellow and magenta. This numbering system allowed for observation of pale colors and color mixtures not accounted for in other systems. Hickethier used a color solid in the form of a cube for his system. This solid, which contained one thousand colors, had the primaries yellow, red (magenta), and blue (cyan) on the outer edges with ten intervals or steps between (0 = no color to 9 = full intensity). His system allows for very precise mixing of color that results in the same color each time an identical combination is mixed.

JOSEF ALBERS

As a teacher at the Bauhaus School, Josef Albers (1888–1976) became absorbed with how color reacts and interacts. He not only investigated color interactions on his own by developing exercises but insisted that students pursue independent investigations. While at the Bauhaus, he refined Itten's work (see page 19) as well as that of the abstract painter Wassily Kandinsky. The teaching diagram he used most often was a triangle, very much like Goethe's color triangle, which had red, yellow, and blue at its points, orange, violet, and green at the midpoints, with red-gray,

yellow-gray, and blue-gray in between (**fig. 3.14**).

After Bauhaus, Albers came to the United States, where he eventually became a member of the fine arts faculty at Yale. Here he deepened his explorations into color theory and produced the book *Interaction of Color* (1963). Much of the content of his course was based on the phenomenon of simultaneous contrast. He was not just interested in the optical mixing that results from a pointillistic style, as shown in Seurat's painting technique (see fig. 11.7), but he also became absorbed in the reactions that occur where edges of color meet (see page 101). In his own paintings, and in those of his students, Albers used few colors and strong contrasts in a rectilinear format. These formats were used over and over again to investigate the infinite color combination possibilities and their varying effects. This type of thinking led to his "Clef" series and his famous "Homage to the Square" series. Albers did not confine his investigations of color to painting and printmaking alone, but explored how varied materials interacted. This is most evident in the weavings executed by his wife, Anni.

FABER BIRREN

At his death, Chicago-born and educated Faber Birren (1900–1988) was completing yet another book on color to add to his extensive list of more than twenty-four books and several hundred published articles on

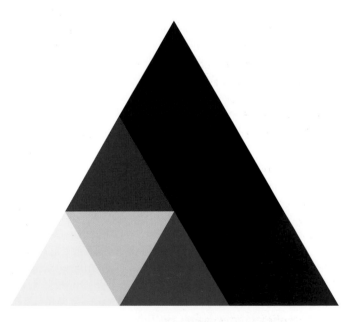

3.14 Albers's color triangle. While at the Bauhaus, Albers used this color diagram (developed with Hirschfield-Mack) in his classes.

the subject. His color education began at the University of Chicago's School of Education under Walter Sargent. Birren went on to become one of the best-known and most widely read color authorities and consultants of the twentieth century.

In 1934 Birren designed his "Rational Color Circle," which arranged hues in equal intervals but tended to include more warm than cool hues in its make-up, so that the neutral gray "center" was asymmetrically placed. His rationale for this was that the eye sees more warm hues than cool ones. Although he retained the premise that red, yellow, and blue were primaries, within the warm area of his wheel he added a leaf green and within the cool area a turquoise. Red and green were complementary, and could function as either warm or cool.

Like Itten, Birren was interested in color harmonies. Basing his work on that of Chevreul, he proposed a "harmony of colors" as follows:

1 elements of harmony
2 harmony of adjacents
3 harmony of opposites
4 harmony of split-complements
5 harmony of triads
6 harmony of dominant tint.

In 1937 he developed a color triangle as part of his continuing investigation of the "harmony of color forms". This triangle dealt with the visual and psychological aspects of any color. He stated that there are pure colors or hues, white, and black. These three elements at the points of the triangle can be combined so that white added to a color gives a tint, black added to a color gives a shade, and black added to white gives a gray. They were placed intermittently on the triangle. The center of the diagram showed tone that is a combination of the three elements of black, white, and color.

Using his "harmony of color forms," which Birren felt charted color effects, unlike the color schemes used until this time, he evolved what he termed the "new perception" of color. Among these color effects we find the following:

1 the effect of luster
2 the effect of iridescence
3 the effect of luminosity
4 the effect of transparency
5 the effects of chromatic light
 (see pages 111–114).

FRANS GERRITSEN

Dutch color theorist and artist Frans Gerritsen first published his color theories in 1975 as *Theory and Practice of Color*, to be followed in 1982 by his *Evolution in Color*. Gerritsen based his work on the laws of perception. He felt that previous color theories had been based on subtractive theory, additive theory, or partitive theory, which did not share a common point of view—additive worked with colored light, subtractive worked with actual pigment mixing, and partitive worked with reactions of color when placed side by side. All the theories did, however, have one significant thing in common—the eye and its reactions to color combinations.

Gerritsen came to the conclusion that the human eye has specific color sensitivities—if the entire visible spectrum were viewed in terms of a narrow band of color at a time, the eye would show that it was most sensitive to blue, green, and red. These colors became his new primaries. All other colors, he felt, could be created by combining these three primaries. For example, the color yellow is situated on the spectrum midway between red and green, therefore the sensation of yellow is created by the "spilled-over" energy sources from the red and green. Gerritsen believed that all current color theories could be explained in terms of his own concept if they were viewed from the perspective of the eye or, more simply, the light that is entering the eye. He established yellow, magenta, cyan, and black as the new primaries for photolithography.

Gerritsen's color wheel identified colors by a numbered position on a multi-dimensional complex shape where the primaries were designated by absolute wavelengths and intensities between 0 and 100. This system, he claimed, could positively identify over six million different colors. In summary, Gerritsen accomplished the following:

1 He established that the eye was the point at which all color theory started.

2 He fixed the colors of red, green, and blue (light sources) as the primaries for all future color theory work.

3 He eliminated the confusion between the different color theories by re-interpreting them in terms of his new concept.

4 He put all future color research on a sound scientific basis.

- [] Distinct steps can be discerned in the development of color theory over the centuries. At first, color was viewed in terms only of light versus dark and as relating to the elements of fire, water, air, and earth.
- [] From Newton onward, the behavior of light, especially white light, became a subject of concern, for example, how it was divided into various wavelengths which imparted hues.
- [] Various attempts were made to impose order on such findings by proposing "wheels" to show the relationship of one color to another. This aided the study of the mixing of color.
- [] As knowledge of optics and brain function grew, color theorists concerned themselves increasingly with the reaction that color has on the eye (observation), our brains (perception), and our memory (consciousness). Color theorists attempted to encompass all of these variables in a single system. However, we see and use color in so many different forms that no single system can answer all the needs of color theory.

Exercises

1 Do a simple composition based on the colors of one of the color theorists in this chapter.

2 Do two identically structured compositions, one based on the colors identified by Aristotle and the other on the primary colors identified by Leonardo da Vinci.

CHAPTER 4
Coloring Agents

Artists, architects, and designers must use materials in the creation of their works and these materials all contain color that is either **achromatic** (neutral, such as black, white, or grays) or **chromatic** (hued, such as red, yellow, or brown). The aim of the practitioner is to reproduce the colors found within the visible spectrum and their variations. Each work or medium employed in a project requires a different form of color usage or coloring agent. Prior to the nineteenth century, artists mixed their own pigments according to desired usage. Now, however, the artist usually deals with premixed colors, although the components of a color can differ from manufacturer to manufacturer and from medium to medium.

ADDITIVE COLOR MIXING

Let us begin with the mixing of light, which is an additive process. The art media using light mixing include theater, film, video, and television. The lights are mixed by placing colored filters (red, blue, or green) in front of a projected light ray. If red, green, and blue are all projected we get white light (**fig. 4.1**).

The video camera records images that are transmitted as light patterns. Again, we see three light primaries at work: red, blue, and green. The transmitted light patterns are converted into signals indicating **chromaticity**, a measure of the combination of hue and saturation, and **luminance**, a measure of value, or lightness and darkness. The picture tube is coated with dots of phosphors in red, green, and blue that are activated by the transmitted signals, resulting in the color television image. Magnification of a television image reveals combinations of tiny red, green, and blue-violet dots. When two light rays are projected their sum or combination is brighter than either ray by itself. For instance, yellow is much brighter than the red and green light beams projected as its components.

Computer graphics color monitors function in much the same way as video with the same light primaries of red, blue, and green (see pages 147–148). While the light primaries are the basis for computer graphics, the computer graphics color menus are fashioned after the Munsell system of color notation, which allows the artist to function in a pigment-like environment. Thus, although the computer-screen image is based on additive color mixing, the computer-printer image is based on subtractive color mixing. The printout of the screen image will be duller than that seen on the screen.

SUBTRACTIVE COLOR MIXING

Pigments and Dyes

Subtractive methods of creating colors are based on pigments or **dyes**. Pigments are powders that are in a **binder** such as acrylic or oil which cover or adhere to a surface. Dyes are pigments that are dissolved and absorbed in a fluid. **Lakes** are organic pigments or dyes that are combined with inorganic **mordants**, or fixatives, to extend the pigment range and create brighter colors. The color of a pigment is determined by how it absorbs light rays. By approximating the appearance of reflected light, pigments attempt to match the color seen in the visual spectrum.

The art media of drawing, painting, printmaking, ceramics, textiles, enameling, and embroidery are all

4.1 The mixing of light. When two of the projected additive primary colors—red, green, and blue—are overlapped, they create the secondary colors of yellow, cyan, and magenta. White light is the result of combining the three primaries.

4.2 Mel Bochner, *Vertigo*, 1982. Charcoal, conté crayon, and pastel on canvas, 9 ft x 6 ft 2 in (2.74 x 1.88 m). Albright-Knox Art Gallery, Buffalo, New York, Charles Clifton Fund, 1982. Working in a variety of dry pigments, Bochner makes his charcoal lines wrestle with conté crayon lines to convey a sense of dizzy, frustrating activity.

4.3 Margie Hughto, *Canyon*, 1991. Colored clays, slips, glazes, and copper, 11 x 7 in (28 x 18 cm). Courtesy of the artist. Hughto uses liquid pigments such as slips and glazes to enhance her ceramics, and here she oxidizes the copper. She also employs the natural colors of clay, strata, and fossils—all of which contribute to the feeling of earthiness and prehistory that a canyon conveys.

4.4 Navajo blanket, nineteenth century. Based on a sand-painting design, this blanket shows two supernatural beings flanking the sacred maize plant, which was their gift to ordinary mortals. The artist designed the piece with a number of orange/blue and red/blue-green complements in mind. The yarn fibers were dyed in a variety of colors before being woven together.

based on pigment usage (**figs. 4.2–4.4**). Pigments can be categorized into dry (drawing, employing pencils, chalk, crayons, and conté crayon), liquid (painting, printmaking, ceramics, enameling, batik, employing paints and inks), and combination (embroidery, weaving, both of which employ yarns that have been dyed).

Fibers can be dyed by either natural or synthetic means. *The Color Index* lists over 8000 dyes available to the fiber artist. Prior to dyeing, many fibers must be washed or scoured and then treated with a mordant. The mordant helps the fiber accept and fix the dye, and can affect the color. The most common mordants are alum, iron, tannic acid, tin, and copper. Dyeing procedures vary: direct dyeing, when a mordant is not required, is most commonly seen in hand or natural dyeing procedures; dispersed dyeing is used for artificial fibers such as nylon that will not take water-soluble dyestuffs; reactive dyeing is used for cellulose fibers that need to bond chemically with the fiber; and vat dyeing

achieves coloration after the fiber has been treated and exposed to sunlight, air, or an acid solution. The most common vat dye is indigo, which becomes activated when exposed to the air. Indeed, vat dyeing derives its name from the original method of dyeing indigo in a vat. The first synthetic dyes were developed in 1856 and are known as **aniline dyes**. These were based on alcohol and coal-tar derivatives. The aniline dyes were succeeded by azo dyes, which are petroleum-based. The azo dyes are more colorfast and brilliant than the aniline.

Pigments come from both natural and artificial sources. Natural pigments are derived from animal and vegetable substances (both organic), as well as from inorganic materials. The inorganic materials may include various oxides, metal compounds, minerals, and clays, which must go through a series of transformations prior to their final use as pigments. They are mined, sifted, washed, crushed, pulverized, sometimes baked (calcination), ground, baked again, and reground

(**fig. 4.5**). The fineness of the resulting pigment particles determines the quality of the color and its covering ability. The coarser the pigment powder, the greater are the chances of cracking, dirt damage, discoloration, and general deterioration. Natural organic pigments are derived from all aspects of nature—plants, woods, mosses, roots, nectars, animals, and so on—which are chopped, ground, boiled, and dried to extract the pigment powders. Natural pigments have a tendency to fade, but as they fade their basic color does not change. Chemical pigments, by contrast, fade to a different color.

Pigments can also be derived from synthetic means, and the chemical world offers us myriad possibilities. Artificial pigments are obtained by dry distillation (burning) of various substances such as charcoal, coal, peat, petroleum, and fossils, which results in tar. The tar is further distilled to form oils, naphthas, pitch, and benzol. The colorless liquid resulting from fossil coal tar forms the base for aniline dyes.

The various pigments have entirely different mixing properties and require diverse types of vehicles or binders to transform them into workable tools. This variety also causes each medium, such as the paint, drawing tool, or yarn, to behave differently, especially when we try to mix them. White paint is fifty times brighter than black so when mixing a light hue such as

yellow with neutrals, it takes very little black to change it but a larger quantity of white. Conversely, a dark hue such as violet requires a large quantity of black to effect a change and very little white. When two pigments are mixed the result is duller or darker or both.

All color use is affected by atmospheric conditions, either natural or artificial. These conditions will result in color deterioration; the artist, therefore, should use the highest-quality materials available to slow down this inevitable process. In order for a pigment to function at its best it should:

1 not react (fade or turn pale) when mixed with light or any liquids;
2 have permanence—in other words it should remain stable in any atmospheric conditions imposed on it by light, heat, or cold;
3 cover the support or ground well and retain its brilliance (**fig. 4.6**).

Binders and Grounds

The materials an artist employs in any work are usually a combination of pigment and another substance. It is this combination that reflects and absorbs in varying degrees the light hitting it, resulting in varying qualities of color. The artist must be concerned with the behavior of any pigment, especially its **tinting strength**. Tinting strength refers to how a pigment's intensity reacts when mixed with white and the binder. The combining or binding agent is known as the **vehicle** and can consist of oils, waxes, gums, water, or acrylics. The pigments themselves, whether natural or synthetic, are usually in fine powder form; they are then mixed or suspended in a medium or binder that serves as the vehicle. The binder must also allow the pigment to adhere to the surface or ground. The binder thus has a twofold effect, and the nature of the binder will determine how a particular medium works or feels. The binder totally surrounds the pigment particles and controls the effects of atmosphere, oxidation, drying time, and transmission of light reflection. Because of this we find that art media are often referred to by the terminology used to describe their binders.

Binders are classified as dry or liquid. A survey of the dry (pigment plus substance) binders can be found in Appendix 1. Liquid binders are formed by suspending pigment in fluid. A survey of liquid binders can be found in Appendix 2.

Surfaces or grounds may be prepared in a variety of ways. Most grounds the artist employs begin with white. This is because white is a neutral and represents

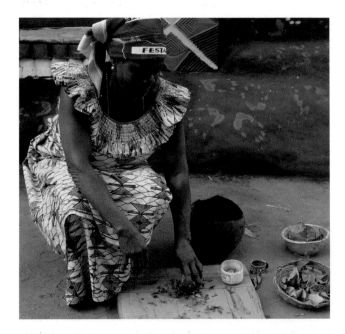

4.5 Pigments. This Nigerian woman is grinding leaves to make a color pigment. The resulting paste is mixed with black pigment to produce a glaze for decoration.

4.6 Leonardo da Vinci, *The Last Supper* (before restoration), c. 1495–98. Fresco, 15 ft 1⅛ in x 28 ft 10½ in (4.6 x 8.6 m). Refectory, Convent of Santa Maria della Grazie, Milan. Fresco technique requires the application of paint to a damp plaster wall in order for pigments to fuse with the plaster as it dries. However, Leonardo's methods were slow and he couldn't keep pace with the speed of the drying process. Pigment and plaster did not fuse well and over time the paint began to flake off. The fresco has recently been restored, with mixed results.

the total absence of color. We recognize color in terms of its relationship to white even though most art progresses to a finished work where little or no white is visible. The painter normally prepares the canvas or surface by priming it with gesso, originally a combination of chalk, powdered plaster, or whiting mixed with glue. Most painters today use an acrylic polymer-based primer to provide a uniform painting surface.

The combination of pigment and surface very often creates a new surface: the quality of the color emitted as reflected light by the pigment therefore changes. In painting, for example, the paint covers the background surface or ground and becomes another surface—the one that is most visible to the viewer. In watercolors, the paint and the ground are both surfaces and form a new combined surface. The weaver utilizes pigmented yarns to form an entirely new surface composed of many components—the warps and wefts. Their yarns, however, have become surfaces impregnated by pigment that is applied in dye form. The embroiderer, like the watercolorist, often uses a ground that is a textile embellished with yarns, resulting in combined surfaces that form new surfaces. The photographer's

paper ground is changed by the chemical dyes (yellow, magenta, or cyan) used for color photography which creates the image and a completely new surface. The photographer and yarn dyer use less dye or weaker dye solutions to achieve a paler color. The watercolorist usually works this way as well. The opaque pigment painter (using oils, gouache, etc.) must add white pigment to lighten the color.

Artists' colors all have certain characteristics that are the result of their pigment origination. A list of these characteristics can be found in Appendix 3.

Color Printing

The artist wants red pigment to absorb all the light rays except red and to reflect the red back to the viewer. We do, however, find that artists have attempted to cause pigments, which are subtractive color, to behave as additive or light color. This was the basis on which the Impressionists and Neo-Impressionists sought to achieve their effects. The pseudo-additive color was formed by the placement of colors next to each other. The easiest method of accomplishing this was the use of small dots, as seen in pointillism.

4.7 The four-color printing process. Here we see the yellow, magenta, cyan, and black printing plates used in four-color printing, as well as the finished shot with all plates combined. The color values print as a series of dots so small as to be undetectable as dots by the human eye. The enlargement shows the dots that are combined and printed to create the illusion of the four-color image.

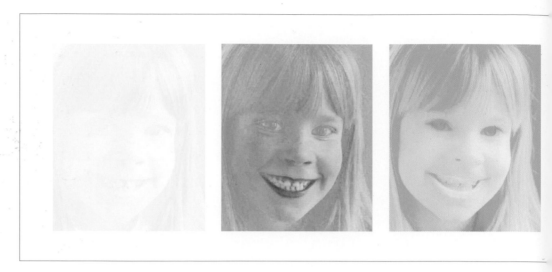

4.8 The Pantone Matching System for specifying color for the printer.

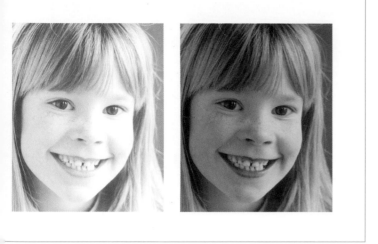

The same concept is found at work in color printing. In four-color process printing, screens of dots are layered on top of each other, each screen containing a different color (**fig. 4.7**). The screens used are black, process yellow, process magenta, and process cyan inks. The eye optically mixes these dots to form all the hues. The density of the screen and the size of the dots determine the lightness or darkness of the color. The smaller the dots, the paler the color will be. Flat color printing also works with transparent overlays of yellow, magenta, and cyan that are superimposed upon each other. Here, however, the designer indicates on the overlays which areas are to be printed in which colors.

Printers also rely on the **PMS system** (Pantone Matching System) for color matching (**fig. 4.8**). Based on nine colors, plus black and transparent white, the system shows the percentages of these colors required to produce a particular color. "Recipes" are given for 747 different colors, allowing the printer to mix the inks to produce the desired color. The graphic designer using printing inks must take care when attempting to reproduce various colors accurately. Dark blues, dark greens, and very warm reds cause problems because printing inks are transparent; these color choices require numerous layers of printing ink to achieve the desired result. Many graphic designers are also faced

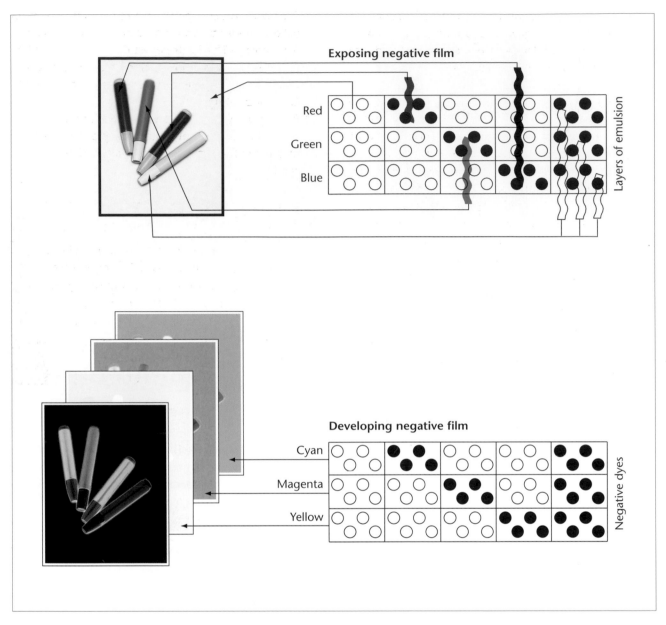

Exposing negative film

Red

Green

Blue

Layers of emulsion

Developing negative film

Cyan

Magenta

Yellow

Negative dyes

4.9 Exposing and developing color film. The diagram above shows different color layers of film exposure. The diagram below reveals the process colors of cyan, magenta, yellow, and black that are used in printing from plates exposed to negative film.

with a tight budget, and so often find themselves working with only one or two colors. The knowledge of how color behaves is most important if the graphic designer is to get a single color to function or appear as many.

Photography

The photographer works in black-and-white or color. Black-and-white photography relies on value changes from dark to light. Color photography, in both print and transparency forms, is made possible by a film that

consists of an **integral tripack** made up of three layers of a gelatin (**fig. 4.9**). Each of these layers takes care of a different color. The top layer comprises silver halide which is sensitive to blue light; a yellow filter beneath the silver halide layer blocks the blue light from passing to the second and third layers. A second layer is sensitive to green and blue light, and the third layer is sensitive to red light. These sensitizing dyes, therefore, are the primaries red, green, and blue. The camera exposes the tripack layers to the light mixtures it records, and the developing process activates the

dyes. The result is a full color print or transparency. Photographers also have the option of attaching a colored filter to the lens which will impose the desired color reaction on to the tripack.

CONCEPTS TO REMEMBER

☐ Coloring agents are the means by which the artist imposes color on an image or object.

☐ Additive color principles apply to the media of film, video, television, and computer graphics, and utilize the light primaries of red, green, and blue.

☐ Subtractive coloring agents depend upon colors being created from pigments (powders plus a binder) and dyes (pigments dissolved in a fluid).

☐ Pigments are of three types—dry, liquid, and combination—and are derived from either natural or artificial sources. The ideal pigments do not react to being mixed, have permanence, provide good coverage, and retain brilliance. Pigments are usually mixed with binders, which are classified as dry or liquid.

☐ Four-color process printing uses layers or screens of yellow, magenta, and cyan which optically mix to form colors. The Pantone Matching System (PMS) is also used for printing and relies on nine colors, black, and transparent white to create the desired color of printing ink.

☐ Photography is of two types—black-and-white and color. Color photography employs a tripack of three light-sensitive layers combined on the film.

Exercises

1 Collect or create color-chip examples of one color from various media (oil paint, pastels, yarn, photography, printing, and so on) and observe the different effects of that color.

2 Collect examples of photographs and the objects photographed, and examine the color changes between them.

Part II Dimensions of Color

We have looked at how we perceive color
scientifically and reviewed the different
systems by which color can be organized.
The varied contexts in which color is used
can lead us to the conclusion that each color
use requires an individual approach—the
painter's mixing of pigments and the reactions
that these paints have when placed next to
each other (subtractive and partitive); the
theater technician's deployment of colored
lights (additive and partitive); and the weaver's
dyeing of yarns and the effect of the yarn
placement (subtractive and partitive). Despite
their varied uses, however, colors do share
some common characteristics: the properties
of colors, which we will call their **dimensions**,
their placement reaction or position (how
they interact with other colors), and their
psychological effects.

 Every color has four dimensions—hue,
value, intensity, and temperature. Color works
as a combination of all these dimensions.
Artists, architects, and designers must develop
each of these dimensions for their own
individual purposes and the requirements of
any particular project.

Opposite: Albert Bierstadt, *Untitled Landscape*, detail, 1868
(see also fig. 6.6).

CHAPTER 5
The Dimension of Hue

The first dimension of color is hue. Hue is simply the kind or name of a color. Red, for instance, is red without any orange or violet in it. A hue without any white, black, gray, or complement (which is the opposite hue on the color wheel) in it is termed a **pure hue**. The hue name is the term used to describe a particular wavelength. The labeling of hues can be one's personal choice, but "Color-Aid" papers (see Appendix 4) provide the easiest reference for determining hues. What is most important is that a hue be recognized. When asked to identify pure hues, students usually choose a red-red-orange for pure hue red and a green-green-yellow for pure hue green. When trying to get colors to react and interact, they find that red-red-orange imparts different reactions from those achieved when pure hue red is used (**fig. 5.1**).

MIXING HUES

Let us look at the colors that result when hues are mixed in various ways. In order to obtain our pure hues we must put into practice our first method of acquiring a new color, which is the mixing of two primaries. Let us review the primaries of the various color wheels that work with color mixing.

Pigment Wheel

- red + yellow = orange
- yellow + blue = green
- blue + red = violet.

5.2 Jacob Lawrence, *The Studio*, 1977. Gouache on paper, 30 x 22 in (76.2 x 55.9 cm). Courtesy Seattle Art Museum. © Jacob Lawrence. The orange rectangular frames are examples of subtly mixing pure hues (red and yellow) to create a secondary one (orange); the visual partnership is such that one cannot tell which of the pure hues is the parent. The warmth of the orange forces it towards us; its lack of shading flattens the foreground. Perspective is thereby reduced (aided by non-converging ceiling lines) and a stagelike effect is created.

yellow	yellow-orange-yellow	yellow-orange	orange-yellow-orange
orange	orange-red-orange	red-orange	red-orange-red
red	red-violet-red	red-violet	violet-red-violet
violet	violet-blue-violet	blue-violet	blue-violet-blue
blue	blue-green-blue	blue-green	green-blue-green
green	green-yellow-green	yellow-green	yellow-green-yellow

5.1 Pure hues. This chart broadly follows the principal color wheels (see figs. 2.2–2.4) in listing twenty-four pure hues from yellow through to yellow-green-yellow.

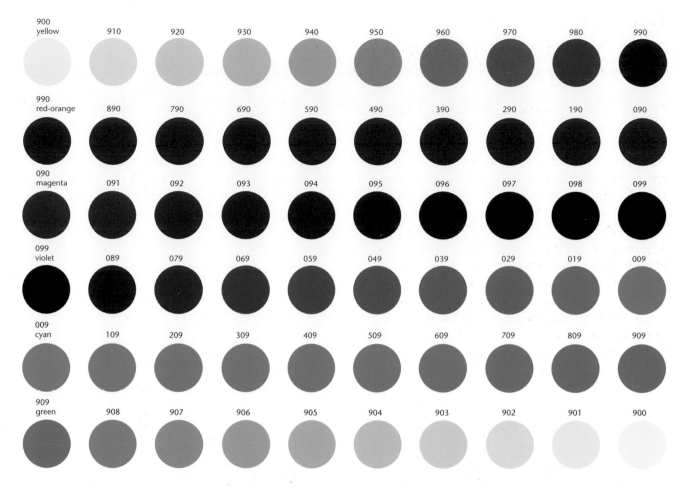

900 yellow	910	920	930	940	950	960	970	980	990
990 red-orange	890	790	690	590	490	390	290	190	090
090 magenta	091	092	093	094	095	096	097	098	099
099 violet	089	079	069	059	049	039	029	019	009
009 cyan	109	209	309	409	509	609	709	809	909
909 green	908	907	906	905	904	903	902	901	900

5.3 Process-wheel hues. These hues are generated using the Hickethier numbering system, which offers precise proportions for creating colors. If, for example, a fiber artist mixes various batches of dyes in identical proportions, each batch mixed will reveal exactly the same result.

Mixing these primaries results in secondary hues, which should be such that you cannot tell how much of a primary is present, or which primary is the **parent**. They should be in an equal *visual* partnership, even though unequal proportions of the primaries will be required to achieve this result (**fig. 5.2**).

Munsell Wheel

- yellow + green = yellow-green
- green + blue = blue-green
- blue + violet = blue-violet
- violet + red = red-violet
- red + yellow = orange.

Here again we are mixing primaries to obtain secondary hues that also should be an equal visual primary partnership.

Light Wheel

- red + green = yellow
- green + blue = cyan
- blue + red = magenta.

Now we are projecting colored lights to obtain new hues.

Process Wheel

When we use the process-wheel hues and mix a primary hue with another primary hue *in equal proportions* a secondary hue results. If we vary these proportions we find a system developing much like that of Alfred Hickethier, whose system is used by printers and color photographers (see page 20) (**fig. 5.3**).

Hues can be mixed in three different ways:

1 Two primaries, in equal or unequal proportions. A visually equal mixture produces a secondary.

5.4 Andrew Wyeth, *The Battleground*, 1981. Tempera on panel, 49½ x 45⅝ in (125.7 x 115.9 cm).
Nelson-Atkins Museum of Art, Kansas City, Missouri. Gift of Enid and Crosby Kemper Foundation.
The broken hues (earth colors) used in the field, buildings, and woods beyond add great depth
and richness to the composition, especially when seen in conjunction with the dominant blue of
this figure's hat.

2 Two adjacent colors in equal or unequal proportions. The visually equal mixture of a primary and an adjacent secondary produces a tertiary. The visually equal mixture of a primary and a tertiary produces a **quaternary**, and the mixture of a secondary in a visually equal proportion with a tertiary produces a **quinary**.

3 Two complementary colors in equal or unequal proportions (see Chapter 7, pages 49–55).

BROKEN HUES

A **broken hue**, or broken color, is a combination of unequal proportions of all the primaries (**fig. 5.4**). The broken hues found in nature, such as russet, gold, or ecru, are known as **earth colors**. In painting the most commonly named earth colors are known as ochers. Because we are working with unequal proportions (if the proportions were equal, the result would be black), we can develop an infinite number of broken hues that can be related to a particular primary (the parent hue), depending on the amount used. If we use nine parts yellow, five parts cyan, and one part magenta, the

5.6 Broken hues. This composition displays a considerable amount of yellow hue, broken with small amounts of red and blue. The reds and blues are also broken using the other primaries, with the exception of the red on the iris petal at the very top. Courtesy Jessica Niemasz.

5.5 A computer-generated color triad showing the development of broken hues. The outer chips forming the triad's edges reveal mixtures in varying proportions of the primary hues, while the inner chips show the results of mixing just the primaries yellow, magenta, and cyan. The inner chips get duller as their hues become more and more broken. Courtesy Indrani Novello.

resulting broken hue, a pea green, would have as its parent yellow. Subtractive mixing is at work, because the light rays imparted from each hue are canceling each other out and the result of this war depends on which is the strongest—the parent hue. Since they contain some of each of the primaries, the resulting broken hues have the wonderful facility of going with every other color. Note that it takes just a touch of the primaries to create a broken hue (**fig. 5.5**). You will also observe that broken hues are usually warmer and more opaque as well as being less intense than other hues. When incorporated in a composition of pure hues, broken hues add a quality of richness (**fig. 5.6**).

HUES IN COMPOSITIONS

Compositions often work best when there is a dominance of one hue at work: few hues over a wide area generally create a more intense lasting impression than many hues over a narrow area. When one hue is dominant we term that hue as working for the **tonality** of the piece.

5.7 Secondaries, tertiaries, and pure hues. In this detail of a rendering for a theatrical set, the hues are mostly secondaries and tertiaries except for the touches of pure hue yellow at the top of the door knocker. Courtesy Jennifer Kievit.

Primary, secondary, and tertiary hues provide us with different visual reactions when used. The primary hues attract the eye; they are the most **stable** and the most easily recognized of the hues, and they offer the greatest **contrast**. We see all other hues in relation to primary hues. The primary hues red, yellow, and blue function well when used in small quantities on small areas in the upper portions of objects or compositions, because eye flow is normally from top to bottom. If used in the middle or bottom of a composition, these primary hues can impart a jarring effect and eclipse everything around them, causing the viewer to take a second or third look in order to comprehend the imagery. When primary hues red, yellow, and blue are used over large areas they overshadow everything else and the color ends up being seen before the imagery.

Secondary hues are less stable than primary hues and are compatible with other colors. Secondary hues function well in large masses and in the lower portions of objects or compositions. Tertiaries are the least stable of the hues and they impart the least contrast. When used in a two-color composition, tertiary hues can become stable by using them in greater proportion to the primary hues or by dulling the primary. Tertiary hues, like secondaries, work well in large masses and on the lower portions of objects or compositions (**fig. 5.7**).

It is extremely advantageous for artists to be able to recognize Munsell primary, secondary, and tertiary hues, and to capture pure hue recognition in their memory.

CONCEPTS TO REMEMBER

☐ The hue of any image determines the color interactions that occur. A color can be a pure hue, a mixture of hues, a neutral such as black, white, or gray, or any combination of these.

☐ Partitive, additive, and subtractive mixing of colors produce different results. In order to predict a color's reaction, we must be able to identify its predominant pure hue, or parent. Broken hues are extremely important to any work.

☐ Hue dominance imparts tonality. The quantity and placement of primary, secondary, and tertiary hues in a work produce important different visual reactions.

Exercises

1 Create one-inch squares of each of the hues in the color medium of your choice. The hues created must match the pure hues of "Color-Aid" paper. Refer to the layout used in figure 5.1.

2 Develop a color-sample chart that has pure hues on its outside edges and broken hues elsewhere. Refer to figure 5.5. You must be able to show which broken hue relates to which parent hue.

3 Do a simple composition employing broken hues and the pure hues red, blue, and yellow. Make sure the composition satisfies the principles of pure hue placement and quantity, as seen in figure 5.7.

CHAPTER 6
The Dimension of Value

The second dimension of color, value, refers to the lightness or darkness of a hue. The values of a specific hue can be changed only by adding black or white; the resulting color is called a **tint**. White is the lightest value, black is the darkest, and middle-value gray is neither white nor black. When no black or white is present in a color it is a pure hue. Red is a pure hue, whereas pink is a light value of red or a "tint of red." When imparting light or dark values in a composition, the artist must consider the various properties of different art media. For example, use of softer pencils will result in darker values, and addition of water can lighten inks or watercolors, which will increase their transparency. The photographer controls value by use of lens openings, shutter speeds, and type of film, in addition to the obvious variables of time, atmospheric conditions, and lighting, as well as during the development phase in the dark room.

THE VALUES OF HUES

The pure hues vary in value. Pure hue yellow, for example, has a lighter value than pure hue violet. Therefore, yellow and violet must be adjusted by the addition of black or white in order to be of equal value. Here are the pure hues ranked from lightest to darkest: yellow, yellow-orange, orange, yellow-green-yellow, red-orange, yellow-green, green-yellow-green, red, green, red-violet, green-blue-green, blue-green, blue-green-blue, blue, violet, blue-violet. This ranking of hues by relative value shows us that when two hues are mixed, the resulting hue will be darker than the lighter hue of the partnership and lighter than the darker one.

It is important for artists to recognize when hues are of the same value. As a rough visual test, two hues placed next to each other are the same value when you squint at them and they blend together as one. Do not confuse value and brightness. We are only looking at the lightness and darkness of the hue, not its intensity. We start by working out a scale that ranges from black to white in equal intervals visually. The middle of this scale will be a gray that is neither white nor black, and this is known as **middle-value gray**. Munsell's value chart uses the notation 9/ to denote white, 1/ to denote black and 5/ to denote middle-value gray. It is helpful to punch a hole in the center of each value on your scale with a paper punch to enable color samples

to be placed beneath for viewing. Now we take our pure hues and add black and/or white to them and match these hue values to our gray scale. Lighting also has a great bearing on matching values. Red, orange, and yellow appear darker in reduced light, while blue and green look lighter. In strong light, lighter pure values will seem more intense; in dim light, dark-valued pure hues will seem more intense. Keep these points in mind when selecting the values for a work (**fig. 6.1**).

When pigments of equal value are mixed together, the resulting color will be a darker value. This is the result of subtraction (more wavelengths are absorbed and less light is reflected). When mixing pigments, we find that adding black makes orange appear brown, while yellow becomes olive. When we add white to a pure hue it will make it lighter in value and cooler. Gray can also be added to alter a hue. In fact, if the correct gray is added to a pure hue it can change its intensity without changing its value. This gray must be exactly equal in value to the hue it is mixed with. The resulting color is termed a **colored gray**.

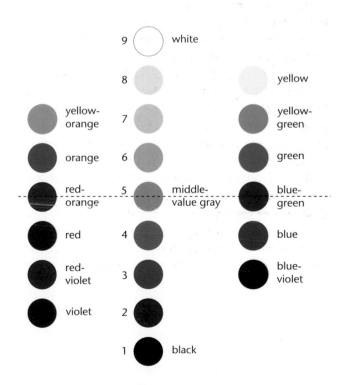

6.1 The values of hues. This diagram shows the relative values of hues at full intensity. The horizontal broken line corresponds to middle-value gray.

Black, white, and gray are almost impossible to find in nature, for the natural grays that can be seen in most landscapes contain pure hues; these are known as **broken tints**. In the last chapter we defined broken hues as hues that contain some of each of the pigment primaries. Broken tints are simply broken hues that have had a varying amount of black and white added to them. In essence they are much paler (or darker) earth colors.

Discords

The effect obtained when the value of a hue is opposite to its natural order is called **discord**. For example, violet is a naturally dark hue; to discord violet we would add white to obtain a resulting lavender. Therefore, lavender (a light tint of violet) is a discord of violet. Naturally light-valued hues such as yellow are discorded by adding black, which reverses their natural order.

Discords play a supporting role in artists' work. They are easily overshadowed by colors that are not discorded, but they do stop the tendency of hues to "spread" visually. Large areas done in light discord (**pastels**) should be avoided, because large areas of light discord tend to weaken a composition. Small amounts of light discord, on the other hand, reduce monotony.

Light discords also generally provide the best **highlights** (the lightest value on a surface or object). The discord chosen should be based on the primary color closest to the object featuring the highlight. (However, if the object in question is painted in a primary color, the highlight should not be a discord of that color, but the next closest primary.) On an orange, for example, the highlight would not be pale orange but a very pale red. Looking again at the orange, we see that the closest primaries are yellow and red. Yellow is discorded by adding black, and red is discorded by adding white or black.

Light discords must be accompanied and supported by lighter tints of hues that are naturally lighter on the pigment wheel. Lavender, for example, would require pale red, pale orange, or pale yellow. Dark discords must be accompanied and supported by darker tints of hues that are naturally darker on the pigment wheel. Dark orange (which is a discord) needs darker red, darker violet, or darker blue (which are not discords). Red and green can be discorded by adding either white or black. This is because pure-hue red and pure-hue green are close to being of middle value. Triad color schemes (see Chapter 9, page 76) can become more

Discords (lighter)	Pure Hues	Discords (darker)	Highlights

6.2 Discords and discord highlights for each of the pure hues. A highlight is the area of an object that receives the greatest amount of direct light. Red has a pale blue highlight, because that will be a discord of the closest pigment primary—yellow or blue—but of the two only blue can be discorded by adding white. Blue has a pale red highlight, because the nearest pigment primaries are green and violet, but of the two only violet can be discorded by adding white.

pleasing when discorded hues rather than pure hues are employed. Luminosity works with discord when the hues are of exactly the same value (**fig. 6.2**). For example, when red and blue-green colors both have white added to them and are of the same value, the visual reaction is one of vibration as well as a glowing sensation of luminosity.

VALUE AND SPATIAL CLARITY

Value clarifies space and the form of an object in four ways: two-dimensional forms are made to appear solid as a result of shading; value creates pattern and texture; value imparts emotion; and value can give definition and emphasis.

Shading

One cannot deal with value without exploring shading. Chiaroscuro is the traditional form of shading that relies

6.3 Lorenzo di Credi, *Drapery for a Standing Man*, late 15th–early 16th century. Brush and gray wash on brown paper, 15¼ x 10⅝ in (38.8 x 26.9 cm). Louvre, Paris. The robe's folds are enhanced with various shadow effects. The deepest shadow areas (core of shadow) are juxtaposed with highlights in the arm, hip, and knee areas that suggest the smooth, shiny, luxurious quality of the man's garment.

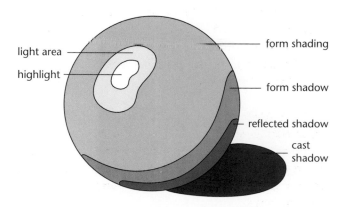

6.4 Highlights, shading, and shadow effects. As the light source strikes less and less of the ball's surface, those areas of the ball become increasingly darker. Eventually it blocks out the light to cast a shadow, which is then reflected back up onto the ball's surface.

on systematic changes in value resulting in highlight, light, shadow, **core of shadow**, **reflected light**, and **cast shadow** (**fig. 6.3**). The highlight is the lightest value on a surface. These intense light spots usually denote smooth or shiny surfaces. A composition or an object does not have to have highlights. Light and shadow are the intermediate values that define the areas between highlight and core of shadow. Core of shadow is the most concentrated area of darkness. Reflected light is the light that is bounced back from nearby surfaces. This area clarifies the shadowed portions of a form and the artist must take into account the hue of the object as well as the hue of the plane by combining the local color of the object with the hues being reflected onto the surface. Cast shadows are shadows thrown by the object onto an adjacent plane and they, too, must take into account the hue of the object and the hue of the plane (**fig. 6.4**).

Let's look at an orange. We know its surface is orange. Now let's say it is resting on a green table. Our light area is going to be a lighter value of orange. Our shadow is a darker value of orange. Next we have the core of the shadow. We know this is going to be darker but it is also duller, for addition of a hue's complementary color will dull that hue. We must therefore add some blue (orange's complement) to our orange and black mixture. Our next area is that of the reflected shadow. We know that the surface area is a dark dull orange but it must now contain some dull green (green with its complement red added) because the green table hue is reflecting up onto the orange. That brings us to the cast shadow. The table hue is green so the shadow will be a dull green with orange in it, but as the shadow goes farther away it gets weaker. At this point we have one area left to consider—the highlight. We know it is going to be a very light value but it is not going to be orange. It is going to be a discord of red. Orange's nearest primaries are red and yellow. To discord yellow we must darken it, so that's no good. But we can discord red by lightening it, so the palest red possible will be our orange's highlight. As we see in fig. 6.2, extremely pale red and extremely pale blue are our highlight choices. When we have the option of using pale red or pale blue, we use pale red for natural objects and pale blue for man-made objects. Pale red is a warm color and natural objects are usually warm in temperature; pale blue is a cool color and man-made objects (steel, plastic, etc.) are usually cool in temperature.

When shadows are cast, the surface colors of the depicted objects are affected. Color reflects onto the

6.5 Raindrop patterns. Raindrops are influenced by the wind, here blowing from right to left and resulting in a left-slanting pattern. The top of a raindrop striking a transparent surface will be dark in value compared with its much lighter part extending downwards, because the lower part is denser and will be raised so that light will hit it first and create the highlight.

planes surrounding it. A room with a red rug and a white ceiling should be rendered with the ceiling having a pale dull red tinge to it. The farther away from a reflective surface we go, the weaker the reflective power. A brown tree trunk may be greener at its base

than at its top due to the reflection of any green grass at the base.

Pattern and Texture

Because differences in value provide contrast, value also creates texture and pattern. Contrast delineates shapes as well as space, providing both obvious and subtle pattern and texture. In nature we see this concept at work when we observe the patterns created by raindrops falling on a surface or observe an animal's fur and record the contrasts created by the light and dark values that are present (**fig. 6.5**). Rough texture is created by a wide contrast between light and dark values across the surface. When there is less contrast the texture will be subtler.

Emotion

Because pure white and pure black produce the greatest clarity, sharp contrasts produce the effect of precision, firmness, objectivity, and alertness. Close values, on the other hand, produce feelings of haziness, softness, vagueness, indeterminacy, quiet, rest, introspection, and brooding (**fig. 6.6**). Dark compositions give feelings of night, darkness, mystery, and fear, while

6.6 Albert Bierstadt, *Untitled Landscape,* 1868. Oil on canvas, 27¾ x 38½ in (70.5 x 97.8 cm). Columbus Museum of Art, Columbus, Ohio. Bequest of Rutherford H. Platt. Bierstadt achieves a hazy effect in the clouds obscuring the mountains in the center by adopting the close values of off-whites, grays, light blues, and light violets. To achieve the contrasting effect of clarity, he renders the thin horizontal ribbon of foaming water in pure whites, and he contrasts them sharply with black and other dark colors in the foreground rocks and trees.

6.7 The effects of value contrast on visual size. Although the small circles are the same size and the backgrounds are the same size, extreme contrasts between circles and backgrounds reveal the illusion of size differentials. The white circle against a solid-black background appears larger than the other circles. The white background with a solid-black circle appears larger than the other backgrounds.

light compositions impart feelings of illumination, clarity, and optimism. Dark values seem quiet and subdued. Compositions with middle values seem relaxed, less demanding, and form combinations that go unnoticed.

Definition and Emphasis

Contrast in value can be used to create emphasis. Light values will seem more active, increase distance and spaciousness, and make objects seem larger.

Value is extremely important to artists' work, for without light or dark we are unable to see anything. Light and dark help to move the eye around a composition, much as line does, and in doing so create a sense of movement. Changes in value also delineate objects or parts of objects in the same way that line defines the edges of an object. The greater the contrast of the values used, the more pronounced the delineation.

Contrast and Toning

The wider the difference there is between values the greater the contrast. Wide differences in contrast—the widest being black and white—can make objects stand out and increase their perceived size (**fig. 6.7**). When black and white alone appear on a surface, optical mixing may take over—the intermediate grays we observe are the result of the proportions of black and white that are present. For instance, a very fine black line on a white surface appears to be lighter in value

than a very wide, bold, black line. The closeness of the lines or dots will also affect the value perceived. This is the principle on which printed photographs work (see pages 28–29). The size of the dots, and their distance apart, determines the relative lightness or darkness perceived. In short, the greater the proportion of white to black that is present, the lighter the value perceived will be (**fig. 6.8**).

Contrast can also affect the balance of a piece. The greater the contrast there is between values the smaller is the amount needed to achieve balance. On a white ground we would need a smaller amount of black than gray to achieve balance. When a composition is worked on a mid-value surface, as opposed to a very dark or very light surface, the procedure is called **toning**. Toning forces the artist to use correct values in order to create space. The novice can easily employ illogical value relationships when using toning.

VALUE IN COMPOSITIONS

Light values tend to blend together when used in a composition. This is also true of compositions composed of middle values and those of dark values. Elements from compositions of related hue and similar value are difficult to distinguish at a distance, and when working with these types of compositions, proportion becomes very important. When **analogous hues** (hues adjacent to each other on a color wheel) of the same or near value are placed next to each other they tend to blend into

6.8 Umberto Boccioni, *Study for "Dynamic Force of a Cyclist* II," 1913. Pen and ink on paper, 8½ x 12³⁄₁₆ in (21.6 x 31.1 cm). Yale University Art Gallery, New Haven, Connecticut. Collection Société Anonyme. The large areas of black and white lend the composition its sense of dynamic contrast. The very thick black lines appear to be darker in value than the very thin black lines. The areas of white space next to black lines give the illusion that those lines are lighter in value than they are.

Disappearing Boundaries **Dissolving Boundaries**

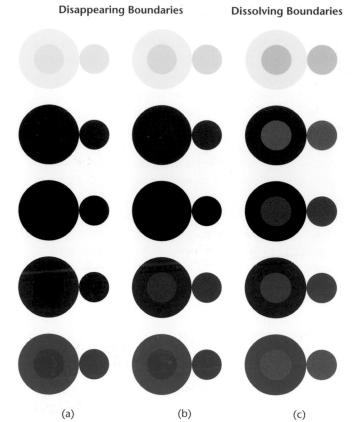

(a) (b) (c)

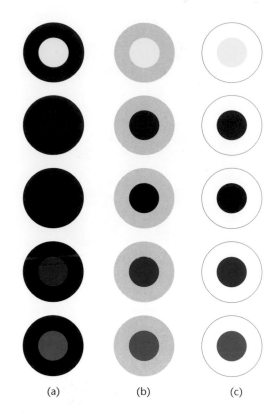

(a) (b) (c)

6.9 Disappearing and dissolving boundaries. The five pure hues in the big circles correspond to the five Munsell primaries (the same hue in each row). The two small circles in column (a) feature identical analogous colors cooler than the colors in the large circles (moving counter-clockwise on the Munsell wheel). The small circles in column (b) feature identical analogous colors warmer than the colors in the large circles (clockwise on the Munsell wheel). In both columns (a) and (b) the closeness of analogous hues causes boundaries to disappear in varying degrees. The small circles in column (c) feature identical broken hues of the hues in the large circles, causing boundaries to dissolve in varying degrees.

6.10 Hue values and backgrounds. When placed in column (a) on black backgrounds, the five Munsell primaries appear to be richer than they are and yet remain well-contained by the black; when placed in column (b) on neutral, gray backgrounds, they appear to advance forward, spread outward, and imbue their backgrounds with their complements; when placed in column (c) on white backgrounds, their luminosity is weakened, and they appear darker than they are.

each other. This blending means that boundaries disappear. When equal-value broken related hues are combined the resulting effect is one of dissolving boundaries. Disappearing boundaries are caused by analogous hues; dissolving boundaries are caused by broken hues (**fig. 6.9**). In order to accomplish these evocative, mysterious effects we must be sure that the hues used are adjacent or nearly adjacent on the color wheel and are exactly the same value. When working with values that are close the edges of objects seem to be fuzzy. This can be combated by using hard edges on objects of hues that are close in value or by outlining.

Every color is seen only in relationship to another color or colors. One must be able to predict how a color

will be influenced or changed by its surroundings. White weakens the luminosity of hues adjacent on the color wheel and makes them appear darker. Red is dark on white, but warm and luminous on black. We also find that middle gray or middle-value hues are those

6.11 Mixed shades with gray. This two-part composition shows the effects of adding gray (left) to the mixed shades (right). Courtesy Lorraine Spontak Moreno.

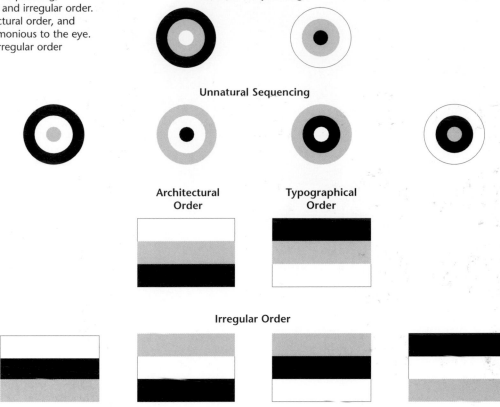

6.12 Natural and unnatural sequencing; architectural, typographical, and irregular order. Natural sequencing, architectural order, and typographical order are harmonious to the eye. Unnatural sequencing and irregular order are jarring to the eye.

Natural Sequencing

Unnatural Sequencing

Architectural Order

Typographical Order

Irregular Order

most strongly influenced by the hues around them. A middle-value gray or neutral will make hues adjacent to it appear stronger; in fact the gray or the neutral will become tinged with the complement of the hue. Therefore a hue surrounded by gray will seem more colorful (**fig. 6.10**). Light-value colors tend to expand and wash over an area while dark-value colors tend to contract and pull within themselves. Remember, too, that white or black can be added to any mixed shade (a combination of complementaries). The value of the shade will thereby be changed, but it will still relate to a particular parent hue (**fig. 6.11**).

As we have previously noted in our discussion of hue, a composition of few hues is generally more pleasing than one of many. A composition of few hues that are executed in many values tends to be even more appealing. In fact, when using a wide range of values in a composition, it is best to limit yourself to as few hues as possible.

As it moves through a composition the eye naturally notices the white or light-value hues first, then the gray or middle-value hues, and finally the black or dark-value hues. This eye movement becomes much more fluid when the white or light values are on the right-hand side of the composition progressing to the black or dark-value hues on the left. We also find that our eye is most satisfied with black or dark values at the bottom and white or light values at the top.

Order

When colors or shades of gray are sequenced within a composition, order is achieved (**fig. 6.12**); and imposing orders can thereby achieve harmony. Value plays an important part in establishing such an order. We find that the eye is most comfortable with naturally progressing value relationships:

1 background black, followed by gray, then white, or
2 background white, followed by gray, then black

When we change the sequencing from natural value order, the effect is visually jarring:

1 gray background, followed by white, then black
2 gray background, followed by black, then white
3 white background, followed by black, then gray
4 black background, followed by white, then gray.

Now let us assign the letter A to white, B to gray, and C to black and investigate what happens when the sequencing order changes. When they are arranged horizontally the first and simplest order is A, B, C, or

6.13 Rembrandt van Rijn, *Self-Portrait on a Sill*, 1640. Oil on canvas, 40⅛ x 31½ in (101.9 x 80 cm). National Gallery, London. In order to capture the richness and texture of dark velvet and fur, Rembrandt employs predominantly dark-value hues and black. Dark values also occupy much of the background and sill, while broken hues emphasize the figure's outline. Minute touches of pure hue can be observed in the trim of the hat, collar, and undergarment.

6.14 Joseph Mallord William Turner, *The Fighting "Téméraire," Tugged to Her Last Berth to be Broken Up*, 1838. Oil on canvas, 35¾ x 48 in (90.8 x 121.9 cm). National Gallery, London. Turner highlights the luminosity of twilight by creating a dramatic triangular contrast of light and dark hues. As if pointing toward the bright but dying sun, he positions two elements rendered in very dark hues—the tugboat and what seems to be a bobbing log. By focusing attention away from the *Fighting Téméraire* and yet towards the notion of death, Turner portrays the ship as a ghostly apparition.

6.15 El Greco, *View of Toledo*, c. 1597. Oil on canvas, 47¾ x 42¾ in. (121.3 x 108.6 cm). Metropolitan Museum of Art, New York. H.O. Havemeyer Collection. Bequest of Mrs H.O. Havemeyer. El Greco achieves pictorial order and supernatural drama by his careful arrangement of blacks, grays, gray-blues, and whites in the background sky, and by the blacks threading their way into the foreground. The abundance of green has a counterbalancing restful influence. The overall sense of color harmony fights with the turbulent feelings generated by the composition to create in the viewer a strangely jarring effect.

white, gray, black. Here we find ourselves going from dark at the bottom up to light in a logical order that is termed **architectural order**. Architectural order is usually associated with landscapes. If we invert the relationship to get C, B, A, or black, gray, white, we have what is known as **typographical order**. Typographical order, as the name implies, allows text to be noticed and read comfortably. Here we see that having bold, darker, or heavier text at the top of the area results in better eye/brain comprehension. The remaining sequences are referred to as irregular order and are relatively unstable. All of these sequences can be converted to light-value, middle-value, and dark-value hues or combinations of hues.

A different kind of order can be brought to compositions that consist primarily of pure hue, dark-value hues, and black. Rembrandt was a master at painting with this type of palette (**fig. 6.13**). Sometimes a work is composed of a range of light-value to dark-value hues. Renaissance artists employed such combinations in their chiaroscuro shading. The pre-Impressionist painters such as Turner used the combi-

nation of light values and black to achieve luminous effects (**fig. 6.14**). An order with a more jarring and emotional effect employed a range of dark-value hues to white. This was the type of color composition that El Greco used (**fig. 6.15**) as well as the Impressionists. A combination that utilizes pure hues, light-value hues, and white gives the glowing impression of light (**fig. 6.16**). Employing any of these value orders brings harmony to a work.

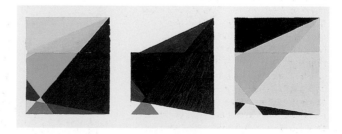

6.16 Value orders. This three-part composition has been rendered in the same colors using different value orders from left to right: light balancing dark values; dark dominating light values; light dominating dark values. Courtesy Michael Bailey.

A composition could also range from white, through pure hue, to black, and the visual impression created would rely on the proportions of the value ranges used.

Any composition rendered only in black, whites, and grays that is pleasing and visually correct can be matched to hues by value matching, and the composition usually is visually resolved. Therefore, it is advantageous to work on a composition in black, whites, and grays, adjusting until it pleases the eye, and only then matching the desired hues to these values. This exercise helps to offset the overriding influence that hues can impart. Values are creating harmony. In the initial absence of color, the eye-brain reaction to color is eliminated so that the execution of imagery can remain the fundamental goal. When colors are matched up afterwards, color and imagery will be seen simultaneously.

CONCEPTS TO REMEMBER

☐ Value refers to the lightness or darkness of a hue. The medium employed affects the value of any color just as much as variations in color placement and illumination. Value also creates space, turns shape into form, and delineates objects.

☐ The pure hues all have different values, and it is important to know where on a value scale any color falls.

☐ Discords are the effects obtained when the value of a hue is opposite to its natural order. Discords can be used to provide emphasis and can bring impact to any work.

☐ Value clarifies space and form through shading, creating pattern and texture, imparting emotion, and giving definition and emphasis.

☐ Different values create contrast, which plays an important role in the clarification of imagery as well as in the balance of a piece.

☐ A composition of few hues but with a wide range of values is often visually appealing. Arranging values in an ordered sequence provides harmony as well as clarifying space within the work.

Exercises

1 Generate an achromatic value scale of thirteen steps—white will be chip #1, black will be chip #13, and middle-value gray will be chip #7—in the artistic medium of your choice. The chips should be mounted so they butt together and no white lines appear between the values.

2 Generate chromatic value scales of thirteen steps each that are equal to your achromatic scale. Make sure the chips butt together and no white shows. Refer to figure 6.1.

3 Do a simple composition using only black and white which employs optical mixing that results in visual grays. Refer to figure 6.8.

4 Do a composition that employs shading.

5 Choose a painting by an artist of your choice and render it in blacks, whites, and grays, matching the values to those of the painting.

CHAPTER 7
The Dimension of Intensity

Intensity, or saturation, defines the degree of purity of a hue, or, more simply put, how bright (as opposed to light) or how dull (as opposed to dark) a hue is. All pure hues are fully saturated, so for example, pure hue red is red with no white, black, or complementary hue in it. When no hue is present the color is achromatic and has an intensity of zero. We would see this as gray.

Black, white, and gray can, however, impart intensity effects. Gray may be described as more saturated than white, leading to the observation that black is fully saturated. Gray is also considered to be more luminous or bright than black, and white is the most luminous. Thus when pure black or pure white are used in a composition they are noticed before the other hues and colors present (**fig. 7.1**).

CHROMA

A term often used in association with intensity is chroma, which is synonymous with saturation. Chroma is a measure of a hue or color's purity or brightness. All pure hues are at their full chroma, but these pure hues differ among themselves as to chroma strength. If we examine the complementary combinations on the pigment wheel, we see that pure hue yellow has a stronger chroma than its complement violet, pure hue red is stronger than its complement green, and pure hue blue is weaker than pure hue orange. If we look at the Munsell primary complementary combinations, we find that pure hue yellow has a stronger chroma than

pure hue blue-violet, pure hue red is stronger than pure hue blue-green, pure hue blue is weaker than pure hue orange, pure hue violet is weaker than pure hue yellow-green, and pure hue green and pure hue red-violet are about equal in chroma strength. From this we can conclude that lighter-value pure hues have a stronger chroma than darker-value pure hues.

COLORED GRAYS

Hues may, however, be diluted by a number of means. We saw in the last chapter how a hue's value may be changed by the addition of black, white, or gray. As we added white to a pure hue it became lighter; the addition of black caused the pure hue to become darker. The addition of gray to a pure hue, however, can result in a dulling of the pure hue when the gray added is the *same value* as the pure hue that is receiving the addition. The result is termed a colored gray.

The concept of colored grays comes to the fore most emphatically when working with the Munsell color system. As we have previously noted, the three-digit notation of the Munsell system corresponds to hue, value, and chroma. The first datum tells us the pure hue, such as 5R, and the next denotes the value, or how much white or black has been added to the hue. With the third datum, which relates to chroma, the Munsell notation allows us to adjust the intensity of each hue by adding varying amounts of an equal-value gray to create colored grays. Let's say our notation

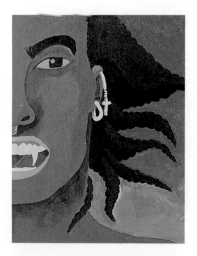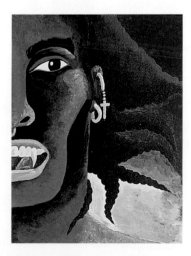

7.1 Adding pure black and white. The contrasting blacks and whites in the right-hand composition give this version more depth. Courtesy Deborah Scott.

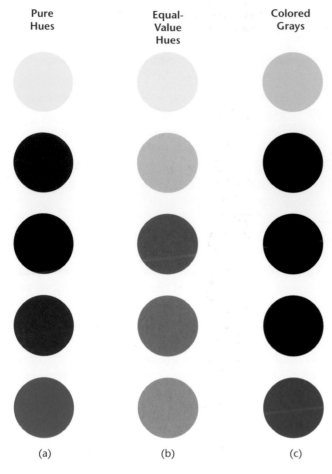

Pure Hues	Equal-Value Hues	Colored Grays
(a)	(b)	(c)

7.2 Munsell primaries, equal-value grays, and colored grays. Column (a) shows the Munsell primaries. Column (b) shows the value of gray equal to the intensity of each primary. Column (c) shows the result of combining the gray value with the primary.

of the parent hues on the scale. The "Color-Aid" papers labeled "shade" are pigment combinations. For example, "yellow shade 1" is a mixture of pure hue yellow and a small amount of pure hue violet; "yellow shade 2" is a mixture of pure hue yellow and a larger amount of pure hue violet.

Complementaries on the Different Wheels

Remember that we are actually mixing pigments to obtain these mixtures, and that the complementary hues on the pigment wheel are different to those on the other wheels—namely, yellow and violet, yellow-green and red-violet, green and red, blue-green and red-orange, blue and orange, blue-violet and yellow-orange. The shades obtained when mixing pigment wheel complementaries are the result of actual pigment mixing in either paint or dye form. On the process wheel, the complementary mixtures are: yellow and blue, red and cyan, and magenta and green. The resulting dull shades can here be achieved by using either pigments or percentage printing screens (**fig. 7.3**).

The Munsell wheel allows the artist to view the reactions of complementary hues when they are placed side by side (partitive color), since the Munsell wheel complementaries are the result of afterimaging (**fig. 7.4**). We see how these complementary combinations enhance each other, in that each color appears more intense or brighter. These combinations do not need to be pure hues only, but can consist of tints of pure hue complementaries.

reads 5R3/4. This would mean that the pure hue red has had black added to bring it down to a dark red or value of 3, then a proportional amount of gray 4 has also been added to change the dark red's intensity (**fig. 7.2**).

COMPLEMENTARY HUES

Hues are termed complementary when they are directly across from each other on the color wheel. A hue can be changed by adding its complementary hue and the resulting dull color is called a **shade**. This complementary addition makes a hue duller or less intense. We find that these shades are similar to broken hues in that they always go well with each other and other colors. Bear in mind that the addition of the complement to a hue also changes its value. On the intensity scale an equal mixture of complementary hues results in a muddy neutral color. Working out from this middle, neutral mixture the shades begin to favor one or other

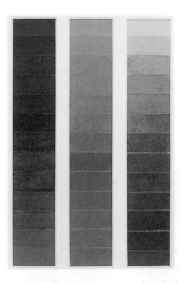

7.3 Intensity scales using colored pencils derived from the pigment wheel. As more and more of a complement is added to each parent hue, the resulting shades become duller. Courtesy Melinda Beavers.

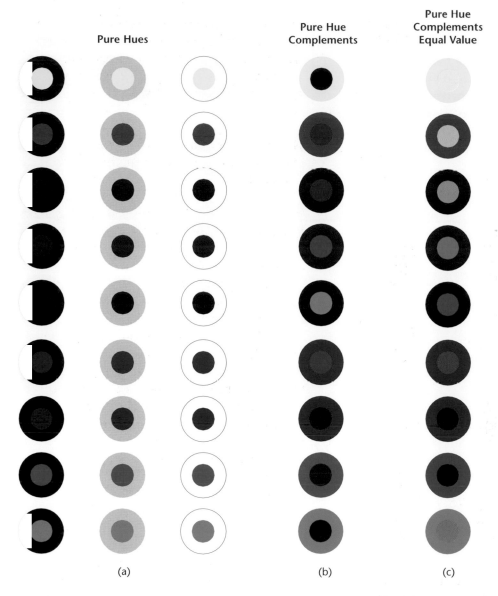

Pure Hues			Pure Hue Complements	Pure Hue Complements Equal Value

(a) (b) (c)

7.4 The Munsell complements side-by-side in pure-hue and equal-value settings. Lighter hues become brighter when surrounded by black, as shown in column (a) (*left*). Complements around pure hues in column (b) serve to intensify those hues. When complements are rendered in equal value, as in column (c), a visual vibration occurs.

False Pairs

A neutral gray is a color obtained by mixing black and white together to achieve middle-value gray. Neutral grays can also be obtained by combining **false pairs**, something that the artist Paul Klee investigated at the Bauhaus. The false pairs are: orange and green, green and purple, and purple and orange. These grays, however, tend to favor one or the other parent hue. Reactions obtained from false pairs are similar to those seen when combining complements, but tend to be less powerful (**fig. 7.5**).

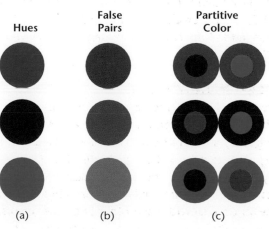

Hues	False Pairs	Partitive Color

(a) (b) (c)

7.5 False pairs. Column (a) shows orange, purple, and green hues. Column (b) shows in descending order the false pairs created by mixing orange with purple, purple with green, and green with orange. Column (c) shows orange, purple, and green in various partitive combinations.

Glazing

Complementary hues can be mixed in another way—by **glazing**, which is the layering of transparent hues. This is how the great Dutch and Italian masters such as Leonardo da Vinci obtained the shades seen in their paintings (**fig. 7.6**). The pure hues were glazed with layers of their pigment wheel complement rather than the shade being mixed on the palette (**fig. 7.7**).

INTENSITY IN COMPOSITIONS

For a pure hue to be at its most brilliant it must be used in a setting whose value is equivalent to its natural

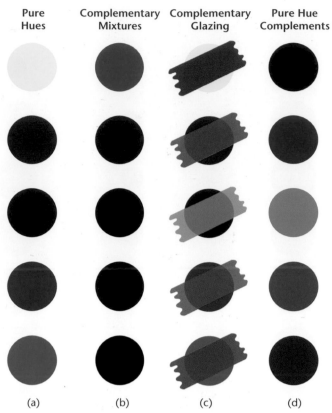

Pure Hues	Complementary Mixtures	Complementary Glazing	Pure Hue Complements
(a)	(b)	(c)	(d)

7.7 Pigment mixing versus glazing primaries and their complements. Column (a) shows the Munsell primaries and column (d) their complements. Column (b) shows the result of mixing primaries with complements, and column (c) of glazing primaries with complements.

7.6 Leonardo da Vinci, *Mona Lisa*, c. 1503–1505. Oil on panel, approx. 30 x 21 in (76.2 x 53.3 cm). Louvre, Paris. Leonardo covered selected painted areas of the *Mona Lisa* with a thin glaze to help create the indeterminate, smoky effect known as *sfumato*.

value. Pure red is most brilliant in a relatively dark composition, while pure yellow is most brilliant in a relatively light composition. When the complementary hues of either the Munsell or visual wheels are used in partitive combination (side by side) they intensify rather than dull each other (**fig. 7.8**). Complementary hues from the pigment and process wheels partitively paired will all intensify each other but to a lesser extent. Side-by-side complementary hues also make each other more luminous. Near complementary combinations produce the same effect but to a lesser degree. When there are great extremes in value, however, color intensity is inhibited.

Complementary colors, when paired, produce startling contrasts. This is because they sometimes exist in wide-value contrast (for example, yellow and blue-violet), or wide-temperature contrast (for example, blue-green and red). No matter how complementaries are used in combination they are unstable. Any hue will appear more intense beside a duller one and vice versa

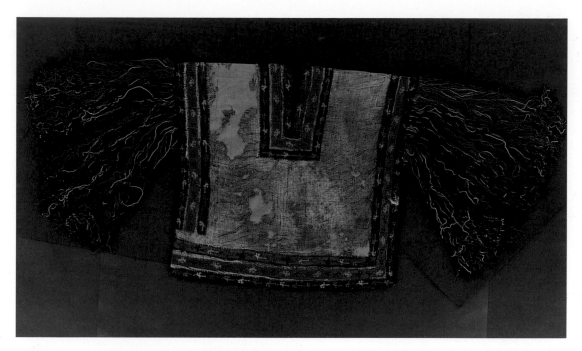

7.8 A shirt with fringed sleeves, Paracas culture, Peru, 300–100 B.C. Cotton and wool, body 21¾ in (55 cm) wide. Etnografisca Museet, Göteborg, Sweden. The partitive arrangement of the complements red and blue green in the neck, shoulder, and waist areas (and mirrored in the sleeves) enhances the intensity of each. Notice also how each hue of red and blue-green contains a pattern of its complement and orange within it.

(see fig. 7.4). High-intensity backgrounds also increase an object's intensity; high intensities attract and give feelings of energy and activity. Low intensities are quiet and subdued and are usually less easily noticed. Moderate intensities are also relaxed and undemanding.

Balance

Complementaries create balance in a composition. Complements in pure hue placed side by side do not alter each other's hue, except to brighten each other. Balance is also achieved by contrasting intense and dull colors. A small amount of a pure hue, for example, may be used to balance a large area of a dull one. Here the contrast of intense versus dull provides the balance. If two complements are used throughout a piece they will usually provide unity. However, if two complements are placed side by side or used only in a limited area they will most likely turn their back on everything around them and enhance each other. Contrasting color schemes exert greater balance than more related ones (**fig. 7.9**).

Hue	Hues and Complements	Hues and Shades

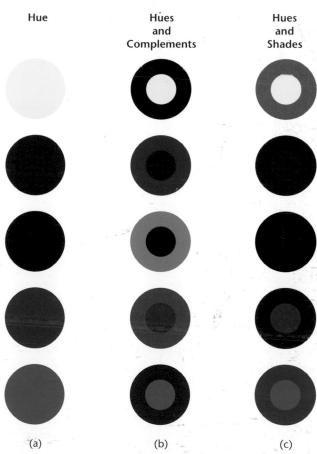

(a) (b) (c)

7.9 A partitive comparison of complementary pure hue combinations and shade and pure hue combinations. Column (a) shows the Munsell primaries. Column (b) shows them with their complements and column (c) with darker, duller shades of themselves. Columns (b) and (c) reveal different ways of achieving balance in compositions.

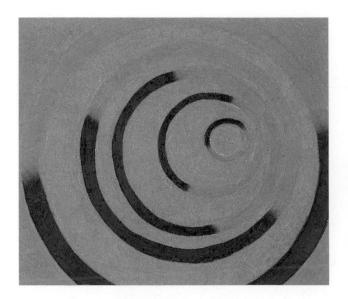

7.10 Equal-value complementary hues and vibrating boundaries. The complementary colors are a light tint of red and a light tint of blue-green, and when equally valued they cause a visual vibration. The light tints of blue and blue-green are analogous hues, and when equally valued they cause boundaries to disappear (see also fig. 6.9). Courtesy Melinda Beavers.

Intensity and Value

Intensity combines with value to alter our perception of hues. The most startling of these effects occurs when equal-value complementary hues are placed side by side. The effect is one of visual vibration and excitement, a reaction that is very useful for creating emphasis. It is imperative that the complements used are equal in value to obtain a visual vibration **(fig. 7.10)**.

Effects of Depth

Intensity can produce effects on objects in space. High intensities make an object seem large, and the more intense a hue is the more it pushes an object forward in the visual field. Light pure hues on a black background will advance according to their value; pure yellow advances the most. Light pure hues on a white ground will recede according to their value; here pure violet advances the most. A pure hue advances more than a duller one of equal value. Low intensities reduce an object's size and increase distance and spaciousness. Objects that are rendered in light-value pure hues (yellow-related) appear larger than objects rendered in dark-value pure hues (blue-related). This is the result of the spreading effect of light-value pure hues (see figs. 6.7 and 7.10).

Proportion

Small areas of a composition usually function better done in brighter hues, while large areas are better done in duller hues. This is an important concept to remember, for we must strive to have color and imagery in a composition seen simultaneously. In most visual situations, color is seen before imagery, so the artist must work to counteract this effect. To this end, one must keep in mind that the brighter or more intense a hue is the more it will predominate over what is being depicted. But when pure hues are used in small amounts, they attract and draw the viewer into the composition. Large areas of a complementary hue tend to intensify its counterpart, whereas small areas or amounts of a complementary hue tend to give a neutral effect; equal amounts of complementary hues give a brownish-gray result. Therefore, we see that the proportion of a hue used affects its intensity. When complementary hues are used in proper proportions the effect is one of fixing the image in time and space.

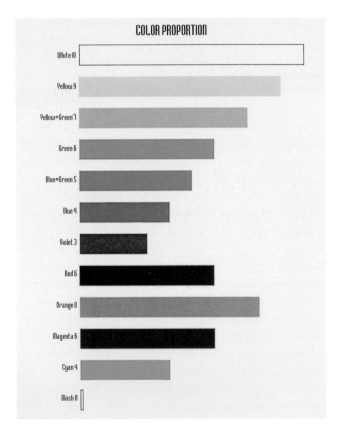

7.11 The relative proportions of computer-generated hues showing the notations devised by Goethe. White and the warm hues have greater strength than black and cool hues. One way to use color in satisfying proportions is to employ white and warm hues over small areas, and black and cool hues over large areas. Courtesy Dreux Sawyer.

The assignment of light (or strength) notations to hues will aid in using them in correct proportion. Let us employ notations devised by Goethe (see page 14) as a basis for our ratios: white 10, yellow 9, yellow-green 7, green 6, blue-green 5, blue 4, violet 3, red 6, orange 8, magenta 6, cyan 4 (**fig. 7.11**). The complementary combination of yellow and blue-violet (according to the Munsell wheel) produces a ratio of 9:3 which means that yellow is much stronger than violet. Red and blue-green produce a ratio of 6:5 which shows that red is marginally stronger than blue-green. Red and green produce a ratio of 6:6 which means they are equally strong. Within a composition a small amount of red and a large amount of green would result in the red becoming very active. When used in their exact proportions (for example, yellow 9, violet 3) hues give quiet, static effects. When the stronger hue in a combination is used in the lesser proportion it becomes vivid. But when the stronger hue in a combination is used in the greater proportion it overwhelms the composition. To achieve perfect balance between two hues one must invert their respective proportions (as yellow is 9, blue is 4, so you would use four parts yellow and nine parts blue to achieve perfect balance). The inversion of hue ratios also leads to a neutral gray when pigment mixing complementary and near-complementary hues. When complementary pairs are positioned abutting each other, their intensity is enhanced. As they become farther apart this intensity, while still present, weakens, but a greater sense of balance is created.

CONCEPTS TO REMEMBER

☐ The brilliance of a hue is dependent on its purity. Pure hues are the brightest possible.
☐ When complementary pigment hues are mixed (subtractive color) they dull the resulting mixture and this is known as a shade. These mixtures are similar to broken hues and afford rest to the eye.
☐ When complementary pure hues are in a partitive setting the greatest impact results. Placing complementary colors side by side enhances a color, while complementary color mixing dulls a color. It must be noted that partitive complementaries are different from subtractive complementaries.
☐ Intensity affects spatial feelings. The more intense a color appears, the closer to the viewer it will appear to be.
☐ Pure hues also have a relative strength, as noted in the proportional scale. It is important to employ correct proportional color usage in any work.

Exercises

1 Create an intensity scale of thirteen steps with complementary pure hues as chips #1 and #13 in the medium of your choice. Chip #7 will be an equal *visual* mixture of both hues so that you cannot tell which hue is the parent. The complementary hues are to be taken from the *pigment* wheel. The chips should butt together so no white shows. Make sure your intensity scale is mounted in the center of your matte board. Refer to figure 7.3.

2 Do two identical compositions, using black and white in one and *no* black or white in the other. Refer to figure 7.1.

3 Do a composition that employs vibrating boundaries. Refer to figure 7.10.

4 Do two identical compositions using the same colors in both. Render them in two ways, changing the quantities of the colors used. The two "identical" compositions should look different.

CHAPTER 8
The Dimension of Temperature

Temperature refers to the warmth or coolness of a color. Research has shown that certain colors stimulate us and increase our temperature slightly, and some colors relax us and decrease our temperature. The **warm hues** are yellow, yellow-orange, orange, red-orange, red, and red-violet. The warm hues are therefore usually related to red, with the warmest hue being red-orange. The **cool hues** are yellow-green, blue-green, blue, and blue-violet—in other words, they are usually related to blue, with the coolest hue being blue-green. Green and violet appear to be neither warm nor cool. Within these various categorizations, the same color can sometimes be warm, sometimes cool. So it is possible to speak of a cool red, yellow, or gray. Warm colors attract the eye more readily, but one must concentrate to recognize cooler hues and colors.

MIXING

The addition of black, white, or the complement to any pure hue can alter its temperature. As we darken a hue by the addition of black, it becomes warmer. White, however, has a cooling effect. The addition of the com-

plement to the pure hue will cause its temperature to reverse. Yellow, a naturally warm hue, will become a cool shade when its pigment complement, violet, is introduced into the mixture. Blue, on the other hand, will turn warmer when its pigment complement, orange, is introduced. From this we may conclude that when a cooler hue is added to another hue the resulting color will be cooler, and, conversely, when a warmer hue is added to a hue the resulting color will be warmer (**fig. 8.1**).

NEUTRALS

Grays and blacks may be warm or cool. When white is mixed with a commercially produced black, the resulting grays will look cool because the black is cool. However, when black is the result of the subtractive pigment mixture of red, yellow, and blue, it is warm and the grays produced by this mixture with white will also be warm. Warm blacks and **warm grays** are best used for natural objects, while cool blacks and grays are best adopted for inorganic or man-made objects. For instance, a black car would be rendered in cool black

8.1 Adding white, black, complement, warm and cool hue to Munsell pure hues. Columns (a)–(d) show the effects on pure hues of adding white, black, and complements. Columns (e) and (f) demonstrate that adding close analogous colors from either side of each pure hue achieves warmer and cooler results respectively.

8.2 Warm and cool blacks and grays. The left-hand composition is rendered in warm blacks and grays and the right-hand one in cool blacks and grays. Courtesy Elly Madavi.

and a black piece of clothing would be rendered in warm black. The warm blacks and grays are called chromatic—these are the "neutrals" used by the Impressionists. Whites may also be warm or cool depending on the binder and pigment manufacturing process used. Flake white is derived from pure white lead, which imparts a slightly gray cast. Titanium white imparts a slightly pink cast and zinc white imparts a faint yellow tinge. Ivory black (bone black) is cool, lamp black (India ink) is cool, and carbon black and Mars black are without discernible temperature (**fig. 8.2**).

"RELATIVE" TEMPERATURES

A hue's temperature changes not only when it is mixed with another hue but also when the hue or color surrounding it changes (**fig. 8.3**). If a warm hue is surrounded by a warmer hue it will appear cooler; when this warm hue is surrounded by a cool hue it will seem warmer. The key to this phenomenon is what occurs in afterimaging. The warm hue yellow's afterimage is cool blue-violet. In most cases a hue

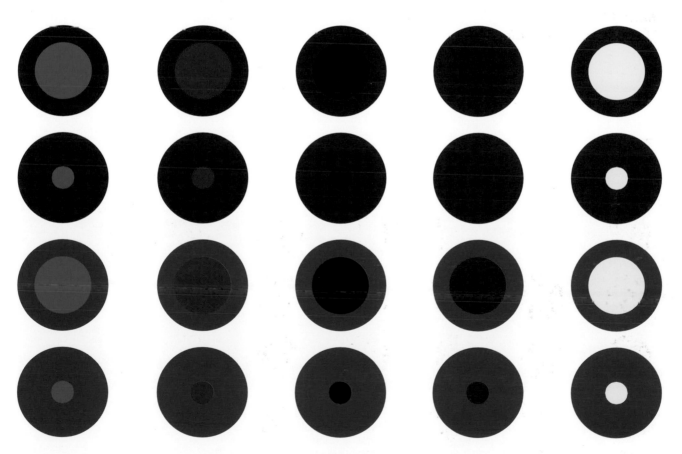

8.3 The effects of warm and cool surroundings on Munsell primaries. The primaries (central circles) are in two different sizes, surrounded in the first two rows by a red-hued (warm) circle and in the last two rows by a blue-green-hued (cool) one. The afterimaging between inner and outer circles induces either a warming or a cooling of their temperatures.

afterimages its opposite in temperature, thus either warming up or cooling down its surroundings. There are exceptions to this rule—if the area of the hue is very small the opposite will happen. So, for example, a very small quantity of yellow on a large field of blue-violet would result in a cooler, more luminous yellow. Thus proportion is another factor affecting the perceived temperature. A two-color composition made up of a warm and a cool hue would be cool if the cool hue were dominant and vice versa. So if the *range* of colors

or hues used in a composition is warm the composition will appear warm; if the range is predominantly cool the composition will appear cool.

From this we may also conclude that every pure hue can be part of either a warm or a cool range depending upon the direction taken on the color wheel that provides the range derivation. Let's look at yellow— when the range used is yellow, yellow-orange, orange, red-orange, the resulting range will be warm. If, however, we work with a range of yellow, yellow-green,

8.4 Paul Cézanne, *Pink Onions*, 1895–1900. Oil on canvas, 26 x 32 in (66 x 82 cm). Louvre, Paris. The background colors are predominantly cool greens and blues, which make the wall recede from the viewer, lending the painting depth. By contrast, the foreground colors are mainly warm reds and oranges, which make the table and fruit advance quite dramatically towards the viewer. The violet on the wall is not as warm as it would be in isolation because of the mass of cool green and blue around it; and the green on the tabletop is not as cool as in isolation because of the amount of warm red and orange around it. The white tablecloth becomes a barrier between the contrasting temperatures of green-blue and red-orange, seeming to heighten both.

green, blue-green, we find that the range imparts a cool temperature and even the very warm yellow will take on a cool quality.

THE EFFECTS OF BACKGROUNDS

The background of any piece is essential to the advancing (warm) and receding (cool) effect of any hue placed on it. Also, keep in mind that the temperature of a color depends upon its relation to other colors with which it is seen (**fig. 8.4**). Warm hues tend to make grays seem cool, and these warm hues remain brilliant on a dark or black background. On a white background warm hues spread and will make the white appear bluish. Warm hues are opaque and dense and when used as a background tend to bring together whatever is seen on them. The eye focuses more quickly on warm hues, which also make objects seem larger. Warm hues also make edges seem less sharp.

Cool hues tend to make gray seem warm and will merge with a dark or black background. On a white background cool hues remain firmly outlined. Cool hues can be made to advance by darkening the warm hues surrounding them. Cool hues appear transparent and weightless. Yellow, which has the lightest pure value, is warm on white, cool on black. Coolness tends to reduce the apparent size of an object and increases the sense of distance. In landscapes we find that distant objects are cooler and more blue-gray (this is the effect of atmospheric perspective). The illusions of space or distance are most easily created by imparting a blue-gray tonality to distant objects (**fig. 8.6**). When this is not done the result is a very flat, one-dimensional feeling.

TONALITY

Compositions often work best when one hue predominates. Similarly, few hues over a wide area tend to create a more intense lasting impression than many hues over the same area. When one hue is dominant we describe it as working for the tonality of the piece. When tonality of color is employed, the result is color unity and, therefore, design unity. Let's say we had a warm design done in red, red-orange, orange, red-violet, violet, blue-violet, and green; the tonality imparted by this composition would be red since red is a component of all the hues used except the green.

Putting the concept of tonality into practice will help you determine what colors to use in a composition. Let us look at a fall landscape. The trees and ground are usually in browns, rusts, oranges,

8.5 The effect of adding one color to all the colors in an artwork. In these nearly identical airbrushed pieces, the addition of blue in the top composition gives it a cooler effect, while the addition of orange in the composition below gives it a warmer effect. Courtesy Glenn Mason.

yellows, golds, reds, and dull yellow-greens; but what type of blue should be used for the sky? Since the predominant tonality imparted is yellow and warm, we might add a touch of yellow to the blue sky; thus the sky will tend towards blue-green rather than blue-violet. When the same colors are set against various hued backgrounds, the background usually governs the tonality of the work. Tonality—and therefore unity—can depend a great deal on repetition. If a small amount of one color is added to all the colors used in a piece, true tonality takes place, and the eye perceives color and imagery simultaneously. Remember that this color addition must also be done to any blacks and whites appearing in the work (**fig. 8.5**).

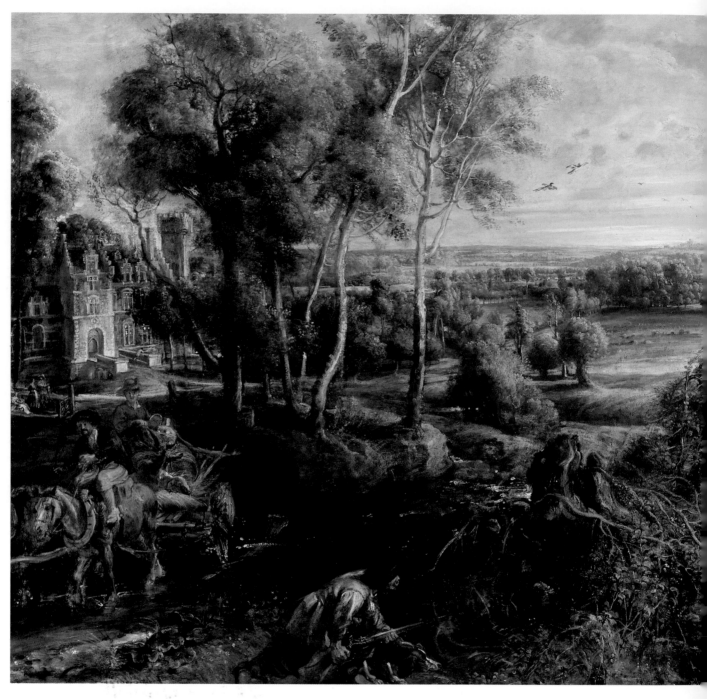

8.6 Peter Paul Rubens, *Autumn Landscape with a View of Het Steen in the Early Morning*, c. 1636. Oil on wood, 51¾ x 90½ in (132 x 229 cm). National Gallery, London. Rubens achieves a sense of great distance by using atmospheric perspective to render the nearer sky in middle-value blue and the distant sky in very light-value blue. Notice the shades of blue in between to represent the receding horizon.

PROPORTION

When using warm and cool colors in a composition, we have already seen that **proportion** plays an important role. If Goethe's color proportions are applied to a composition it will usually be predominantly warm or cool. But when warm and cool colors are balanced so that neither visual temperature predominates, we find that the resulting composition becomes dynamic. This is accomplished by bringing the warm and cool hues to an equal or nearly equal proportion. Let's look at the warm orange, which has a notation value of 8, and the cool blue, which has a notation value of 4. If we invert

**Warm
Dominant**

(a)

**Equally Warm
and Cool**

(b)

**Cool
Dominant**

(c)

these proportions the result will be twice as much blue as orange. Now we see that the blue spreads and expands, providing distance and spaciousness, while the warm orange becomes brighter, more active, and leaps forward, resulting in a **kinetic effect**. The kinetic effect is greatest when the warm–cool contrast is greatest. At any time when a warm–cool balance is present, a sense of depth is imparted. The kinetic effect of warm color advancement can be reversed when the cool hues are intense or pure and the warm hues are shades, or dull (**fig. 8.7**).

8.7 The kinetic effects of warm-dominant, equal warm-cool, and cool-dominant compositions. Notice how in version (a) the dominant orange advances towards us, whilst in version (c) the dominant blue recedes away from us. In version (b) the dynamic tension between equal amounts of orange and blue makes depth and distance more difficult to perceive.

This feeling of temperature affects our interpretation of a composition. Warm hues advance and suggest aggression, sunlight, heat, blood, arousal, stimulation; they are earthy, near, heavy, and dry. Cool hues, on the other hand, recede and suggest sky, water, distance, foliage, shadows; they are quiet, restful, far, airy, and light. As stated, warm hues appear heavier than cool ones and, when placed side by side, these differing visual weights influence their surroundings. Orange appears heavy and is warmer than yellow, for example,

8.8 Anonymous, *Virgin and Child,* 14th century. Mosaic tesserae on wood, 52¾ x 36¾ in (134 x 93.3 cm). Byzantine Museum, Athens. Metallic gold has here been used in the background, haloes, hair, and drapery. Subtle outlines in bright silver contrasting with darker red separate the background from the haloes, while the figures are outlined in black against the background.

so that when it is used in a partitive setting the yellow will not only appear cooler but lighter. The sense of weight imparted by hues or colors leads us to the conclusion that warm, dark hues or colors function best on the lower portions of a composition while cool, light hues or colors are best utilized in the upper portions of a work.

METALS

Metals must be discussed as a part of temperature since their relative brilliance is often interpreted as being warm or cool. The major consideration that must be addressed is the quality of the metal. These materials reflect and are totally influenced by their surroundings while simultaneously retaining their own metallic quality. We will confine our discussion to gold and silver. Gold appears warm in comparison to silver and can function in much the same way as yellow-orange does. The introduction of light onto a metallic gold surface results in varied reactions. When in clear light the top, smooth surface of gold will appear yellow-greenish, while the side of the object will be warmer and, as the background is approached, take on a red cast. Flat gold will not warm up but rather take on a blue-green cast that is cool. Within a composition, the metals will have the highest impact or chroma reaction because of the light reflected from them, which is almost total. So when metals are used on a white background their chroma will be diminished because white is the total reflection of light. On a black background, the gold will be brilliant and very warm because the gold reflects the light while the black absorbs it. Gold will appear warmer on black and cooler on white.

Silver is cool and becomes even cooler when on a white ground. On white its brilliance is also diminished. Black, on the other hand, enhances the brilliance of silver and warms it up, especially when seen in warm, incandescent light. Silver is more strongly influenced by its surroundings than gold; it takes on and reflects everything around it in the same manner as a mirror. Gold and silver interactions can be halted by outlining them with black. This is especially important to consider when they rest against a colored background. Outlining on a black or white ground, however, is unnecessary. On a light ground gold or silver objects will appear larger due to the spreading effect; on a dark ground they will seem smaller and their edges will remain defined and sharp.

Metals can also be used as background. This is a common feature in Byzantine icons (**fig. 8.8**). When

Plain	Gold	Silver	Black Outlines	

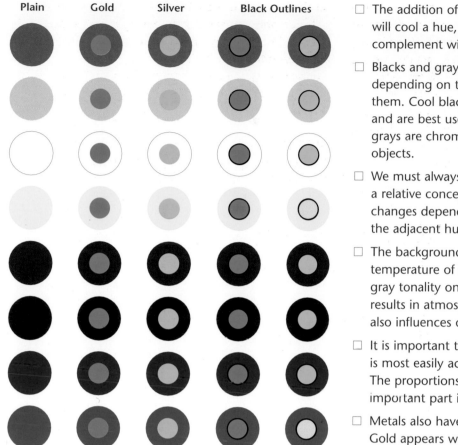

8.9 The interactions of gold and silver with dark-gray, light-gray, white, and with Munsell primaries. A black outline can be placed around gold or silver (the last two columns) to prevent them from spreading.

using a metal as a background it is advisable to outline hued objects with a darker value of the object or black. This serves to restrict the spreading effect that results from the metallic light reflection. Metallic backgrounds must be handled most carefully since they are middle-value but highly light-reflective (**fig. 8.9**).

CONCEPTS TO REMEMBER

☐ Hues can be referred to as warm or cool. Warm hues are those hues related to red and cool hues are those hues related to blue.

☐ The addition of black will warm a hue, white will cool a hue, and the addition of the hue's complement will reverse its temperature.

☐ Blacks and grays can be visually warm or cool depending on the procedure used to create them. Cool blacks and grays are achromatic and are best used on inorganic objects; warm grays are chromatic and best used on organic objects.

☐ We must always keep in mind that temperature is a relative concept. A color or hue's temperature changes depending on the warmth or coolness of the adjacent hues and colors.

☐ The background color temperature influences the temperature of any hue placed on it. Use of blue-gray tonality on distant portions of landscapes results in atmospheric perspective. Temperature also influences our perception of space.

☐ It is important to impart unity to any work and this is most easily accomplished by the use of tonality. The proportions of the colors used play an important part in achieving unity.

☐ Metals also have qualities of warmth and coolness. Gold appears warm in comparison to silver.

Exercises

1 Do a series of color additions to each primary hue forming a scale that shows how the temperature of the color changes. Refer to figure 8.1.

2 Do a composition creating a kinetic effect that is the result of utilizing warm and cool hues and colors.

3 Using the same composition and the same colors, make one warm and the other cool. Refer to figure 8.5.

Part III Color in Compositions

Color must have a purpose within any project, and one's choice of color is the primary method of conveying one's message. Color can reflect mood, emotion, and time frame, and provide the symbolism. These aspects work in conjunction with the principles and elements of design, color interactions, and illumination to impart what the artist, architect, or designer wishes the viewer to see and feel. Whether we are artist or viewer, any project poses a series of questions about the effect of color in the composition. How does color affect the purpose of the piece? Is the color usage universal or suited to only one situation? How does the color fit into the setting in which it is to be displayed? Does the color reflect the personality and background of the artist executing it? Does the color reflect the culture and events in force during its creation? How does the artist wish color to convey the message or statement of the piece? Does the color usage communicate in its totality to the viewer? The chapters in this section will provide the tools for us to answer these questions.

Opposite: Claude Monet, *Le Soleil dans le Brouillard* detail, 1904 (see also fig. 12.13).

CHAPTER 9
Color and the Principles of Design

While color is an important element of design, we must also be aware of how it interacts with the other principles and elements of design, such as rhythm, balance, proportion, scale, emphasis, and harmony. This chapter examines color within these contexts.

RHYTHM

The principle of **rhythm** imposes order and unity on a design, and the rhythmic use of color is crucial in imparting a coherent result to any work.

Repeating hues are extremely important to any piece. Works that lack hue **repetition** will also lack unity. The repeating of a hue can also impart the feeling of movement, as is seen in many Op Art compositions. In such cases repeating hues, contrast in values, and color choice combine to impart vibrating motion (**fig. 9.1**).

Let us look first at what happens when only unrelated pure hues such as yellow, red, violet, blue, and green (the Munsell primaries) are used (**fig. 9.2**). Our eye/brain function must take a "second" or even a "third" look to sort out the impression. Now let's look at the impression imparted by a single hue's repetition. Even more unity results when the hue being repeated is put into an orderly sequence, and now we see that the hues are alternately sequenced. Keep in mind that each pure hue is functioning as a separate element in our repeat. These stripe repeats show how the spatial interval between hues also affects our comprehension of them. The eye is rested when pure hues are sequenced with tints, shades, broken hues, or neutrals. Again we must stress that the use of fewer hues is preferable for visual unity.

9.1 Richard Anuszkiewicz, *Entrance to Green*, 1970. Acrylic on canvas, 108 x 72 in (274.3 x 182.9 cm). Collection of the artist. The green lines are identical throughout the painting but appear to change depending on their partitive setting. The repeating color provides unity and the hue progressions provide motion to the piece.

Pure hues

Pure hues and purple repeat

Pure hues and blue tint repeat

Pure hues and red shade repeat

Pure hues and black repeat

9.2 Repeating pure hues with tints, shades, and blacks. Notice the difference in perception once one color is repeated in a regular pattern. The eye is more comfortable viewing the repeat sequences than the pure hue sequence.

(a) Pure hues

(b) Values

(c) Shades (intensity)

(d) Temperature

9.3 Hue, value, shade, and temperature progression. Row (a) shows pure hues progressing from light to dark. In row (b) one hue moves slowly from a light to a dark value as black is added in small amounts. Row (c) shows the quicker progression from intensity to dullness and back again, as greater shades of black are added at each step. In row (d) hues are sequenced from warm to cool temperatures.

Hues that are put into a sequence or progression allow the eye to move comfortably within a composition. The sense of progression imparts motion. We can achieve this color progression with hues as we have already done with analogous hues. Progression from light to dark is another method, as is traveling from intense to dull. Also do not discount having a temperature progression. This can create a push/pull spatial effect when used correctly (**figs. 9.3** and **9.4**).

The use of a monochromatic (single hue) or analogous (adjacent hue) color scheme is rhythmic in itself, in that the limited palettes necessitate the repeating of hues in various forms (**fig. 9.5**). Tonality can depend a great deal on repetition.

The background of a work should be integrated with the images of any work. One of the simplest methods of accomplishing this integration is to repeat hues in the background that are also used in the foreground. Repeating the hues in this way forms a visual link

between the background and the images by allowing the eye to move back and forth. Putting the concepts of repeating color to work imparts overall unity to a project. If we are using a white ground, the use of black, white, or gray will lead to a visually resolved work because they are all neutral as well as contrasting. When using color and/or hues, employing a colored ground (even if it is a pale tint) or a broken-hued background (such as ecru) will better serve to impart visual unity. The colored ground should repeat or echo one or more of the hues being used in the piece (**fig. 9.6**).

9.6 Background and foreground integration. The blues and violets of the central image are repeated in varying degrees behind and around it, thereby lending visual unity to the composition. Courtesy Arna Arvidson.

Monochromatic

Analogous

9.5 Monochromatic and analogous rhythms. The monochromatic pattern shows different shades of the same hue. The analogous pattern progresses through four steps of Munsell secondaries and primaries and increasingly warmer temperatures (see also fig. 2.4).

BALANCE

Balance concerns itself with the overall visual effect of the components of a composition. Color is crucial in imparting the compositional effect we wish to convey. Color can determine if a composition is to be flat or pictorial. When color is used in a manner that provides the illusion of space or depth, the result is a **pictorial composition**. The use of value, intensity, and temperature all contribute greatly to the success of a pictorial composition, as all these dimensions coordinate to establish an image's location in space. **Flat compositions**, by contrast, rely mostly on hue changes, and they usually do not impart the deep space seen in pictorial compositions (**fig. 9.7**). If the work uses a ground that does not repeat a hue found in the images, more often than not the composition will become flat even if varying values, intensities, and temperatures are used.

Balance can be achieved by placing compositional components either symmetrically or asymmetrically. **Symmetrical balance** is achieved when the compo-

9.7 Flat and pictorial compositions. The left-hand work has a flat appearance due to the predominantly pure hues and the lack of much background gray in the standing figure. By contrast, the right-hand work has more depth and a more pictorial appearance because of the different hue values and more background gray in the figure. Courtesy April Hill.

9.8 Ronald Kitaj, *Walter Lippmann*, 1966. Oil on canvas, 72 x 84 in (183 x 213 cm). Albright-Knox Art Gallery, Buffalo, New York. Gift of Seymour H. Knox, 1967. A quick glance shows two foreground figures to the left of the central axis and this eases the eye off-balance to the left. However, because this side is painted in warm, analogous hues that blend—greens, yellows, oranges, reds—our eyes are pulled back by the sharper value contrasts on the right. In this way, opposing forces create a felt sense of asymmetrical balance.

9.9 Symmetrical and asymmetrical color placement. The left-hand composition looks more harmonious due to its symmetry while the right-hand one looks more jarring but perhaps more interesting in its asymmetry. Courtesy Tricia Malecki.

sition employs "mirror imaging" of the components. Symmetrical balance is greatly reinforced when the colors used also work as a mirror image. Activity now is "frozen"; the moment is static visually.

Asymmetrical balance is achieved when compositional components are not mirrored along a central axis, but the visual placement still produces a pleasing overall effect (**fig. 9.8**). A work whose lines, shapes, and spaces are asymmetrical becomes active, but its activity can be slowed down by symmetrically balancing the colors used. Conversely an otherwise symmetrically balanced work can be activated by asymmetrically balancing the colors utilized in the work (**fig. 9.9**).

As we have previously noted, contrast can also affect the balance of a piece. The greater the contrast between values the smaller the amount needed to achieve balance. On white we would need a smaller amount of black than gray. Compositions are generally color balanced most effectively by using unequal, or asymmetrical, amounts.

Balance is also affected by the proportion of hues. Contrasting color schemes exert greater balance than related ones; this leads us to say that compositions consisting of inverse proportions of warm and cool colors (small amounts of warm colors in comparison to large amounts of cool colors) or complementary colors would be balanced symmetrically. Pure hues must be offset by values or shades of the hues used in order to allow the eye rest. This is why it is so important to be aware of the color content of each and every color being used.

When a pure hue is repeated across a surface, it will eclipse all the other colors and forms present. This can be disastrous if more than two pure hues are used: the result is confusion. The artist must be very aware of this effect when using overall patterning (**fig. 9.10**).

PROPORTION

The design principle of proportion concerns itself with the relationships formed between one part of a design and another part, one part and the whole piece, and all the parts and each other and the whole. We know that hue proportion affects a hue's intensity and temperature function. In our discussions of intensity and temperature we introduced Goethe's concept of color notation. The Goethe color notations were: white 10, yellow 9, yellow-green 7 or 8, green 6, blue-green 5, blue 4, violet 3, red 6, orange 8, magenta 6, cyan 4, black 0 (see fig. 7.10). Remember that these notations are assigned to pure hues. The complementary combination of yellow and blue-violet produces a ratio of 9:3, which means that yellow is much stronger than blue. Red and green produce a ratio of 6:6, which means they are equally strong. Using a little yellow with a lot of blue-violet means that the yellow becomes very active. From this we can conclude that white, which has the highest rating, is most effective when used in

Pure hue yellow
Pure hue red
Pure hue blue

Pure hue blue
Yellow shade
Red shade

9.10 Pure hue patterning. Despite their symmetrical balance, exclusively pure yellow, red, and blue hues in the top composition lead the eye in a frenetic and confusing dance. The identical symmetry with pure hue blue and shades of yellow and red in the composition below achieves greater contrast and allows the eye to come to rest through its sense of harmony.

9.11 Inverting color strength. In this painting a small amount of a stronger hue (orange) appears in a large area of a weaker hue (blue), adding force and balance to the whole. Courtesy Jo Motyka.

very small amounts. When used in their exact proportions hues give quiet, static effects. When the strongest hue in a combination is used in the least proportion it becomes vivid (**fig. 9.11**).

At the beginning of the twentieth century educator and color theorist John Goodwin developed the **triadic color system** which states that there should be an equal balance between sunlight and shadows in a composition, which entails the use of three parts of yellow to five parts of red to eight parts of blue. While mainly used for landscape compositions, Goodwin's triadic color system can be adapted for use in any type of composition. This leads us to conclude that warm colors should be equally balanced by cool colors. When working with more than two hues, we must find the common denominator for the proportional notations and use the numerator from each fraction for the hue notation (**fig. 9.12**). Let's say we are using red, yellow, and blue. Red has a notation of 6, yellow a notation of 9, and blue a notation of 4. The common denominator for these three would be 36. Red 6 goes into 36 six times, hence 6/36; yellow 9 goes into 36 four times, hence 4/36; blue 4 goes into 36 nine times, hence 9/36. When this is done, we find that the hue that has the lowest Goethe notation will now have the highest number (**fig. 9.13**).

The proportion of a hue affects its intensity. When complementary hues are used in proper proportions the effect is of a statically fixed image, so that any composition is greatly affected by the proportions of the hues used.

Compositions of related hues and hues of similar value are difficult to sort out visually at a distance. When working with these types of composition, proportion becomes very important. Always view your work from other than its working distance, for similar hues can be

9.12 The triadic color system. In order to balance warm against cool colors, parts of yellow (warm) and red (warm) are used against parts of blue (cool). The common denominator for yellow, red, and blue is 36; for orange, green, and violet it is 24 (see also fig. 9.13).

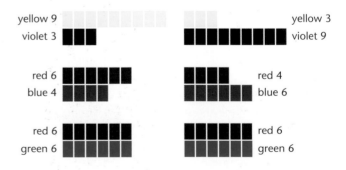

9.13 Pure hue combinations as Goethe notations and their inversions. The notations on the left are Goethe's; those on the right are inverted. For example, an artist would need to use three times as much violet as yellow to achieve harmony in a yellow and violet composition.

sorted out at a short eye range but when viewed at a distance the differences between them will disappear.

The area occupied by a color can also affect its perception. Larger areas of a color appear brighter than smaller areas. Here viewing distance becomes important. As observers, the further away from a color area that we are the duller that area becomes, and its delineating edges of color become correspondingly less sharp.

A study of proportion shows us that when an area is divided into unequal parts the entire area or surface becomes vitalized. So it is with color. Let's say that we are working with red in a composition; three areas of red would be better for color vibrancy and harmony than two. Two equal areas would provide a visual rest and serve to calm down the effect of a color. Therefore, when we wish a particular hue to impart vibrancy, we must use it in unequal parts across the composition. This concept becomes extremely important when we want a color to dominate a composition.

SCALE

The principle of **scale** encompasses the concept of size relationships. For color purposes we must investigate scale in two different ways: (1) the actual area of color used, and (2) the boldness of the color used. The size of any surface influences the intensity of any color. The larger the area is, the less bright and slightly darker it will appear (**fig. 9.14**). This reaction to object size is linked to the fact that the entire surface of any area is not exactly the same distance from the viewer's eye. The closer an object is, the lighter it will appear. One should therefore attempt to use smaller areas of those pure colors that one wishes to remain pure and fully saturated. We also find that the more intense a color is (pure hue being the most intense), the bolder the color will appear (see fig. 8.1). These concepts coupled with the use of color proportion notations allow a hue to impart its maximum boldness. Once a hue has been altered, its boldness is also altered and weakened. The addition of white or black (changing a hue's value)

9.14 Size of area comparisons. Notice the intensity and value differences between the small and large inner circles. Intensity is heightened when these circles are paired as complements.

9.15 The effects of pure hue and shade combinations executed in D. M. C. embroidery floss. The background colors are steps in an intensity chart with yellow and violet as the parent hues. The small, pure-hue yellow squares get brighter as they move into the more violet background areas. All small, pure-hue squares are more visible when placed on a shaded (dull) background.

imparts a less drastic alteration in boldness than changing a hue's intensity (adding the complement) or breaking a hue (by adding two other primary hues so that all three primaries are present in unequal proportions) (see fig. 8.1).

EMPHASIS

The principle of **emphasis** is concerned with the creation of areas of importance for the viewer to focus upon. Color plays an important role in attracting attention, for it is seen before form. The artist can and should predetermine the **focal points** of the work in order to convey the message intended.

Pure hues are more dominant than tints, shades, or broken colors, which can serve as subdominates or subordinates. We find that the more intense or pure a hue is the greater its impact. Any hue will appear more intense beside a dull one and, conversely, any hue will appear dull beside a more intense one. Intensity connotes action and should, therefore, be used for emphasis (**fig. 9.15**). Value (the lightness or darkness of a color) also creates impact. Here again, the wider the contrast the greater the impact.

An in-depth study of the principle of emphasis shows us that the visual center of any enclosed area or piece of work is above and to the side of the actual center of an area (**fig. 9.16**). The "golden rectangle" grid construction also shows how focal points can be effectively placed (**figs. 9.17** and **9.18**).

Once our dominant areas have been chosen we can implement these choices using a number of devices. The first we will explore is the use of color contrast. The wider the contrast there is between adjacent colors the greater the impact. These contrasts can be achieved by use of the greatest contrast pair, which is black and white. Use of contrast in value as a tool for emphasis results in **lost-and-found contour** (when only part of an object is outlined or shown). Lost-and-found contour is most easily achieved by using dissolving or disappearing boundaries. A pure hue paired with its complement also results in emphasis. Equal-value complementary hues placed side by side produce a vibration that can be used for emphasis (see fig. 7.9).

(a)

(b)

(c)

9.16 The visual center. These diagrams show focal points placed at the visual centers. If the circles were positioned exactly at the center of each diagram, the effect would be static and less emphatic.

(a) (b) (c)

(d) (e) (f)

9.17 The "golden rectangle" grid showing focal-point placement. The "golden rectangle" is constructed (a), then a diagonal is drawn across it (b). The main focal point lies in (c) where the diagonal intersects with the second vertical line. If we continue to add diagonals (d–f), the resulting intersections of lines can serve as a guide for placing images.

Contrast can also be achieved when a pure hue is paired with a neutral or shade that is an equal visual mixture with its complement (see fig. 9.10).

9.18 Focal-point placement following the "golden rectangle" grid. Focal points in warm, pure hue orange have been placed on the diagonal against a cool sea of analogous blues. The position of the orange circle above and to the right of center makes that orange circle the main focal point. Courtesy Pamela Muller.

The size and shape of images can also create focal points. Large areas of pure hue can become very powerful. The greatest emphasis occurs when the proportional notations used for color are inverted, as we have previously seen. Color used in a hard-edged mode also provides more emphasis than soft, subtle color transitions or gradations.

Texture has long been used to create emphasis. The rougher a texture is the greater the impact on the eye. Rougher textures make colors look darker. Therefore, the more the surface of a color is fractured the darker in value it will appear.

Emphasis can also be created when arbitrary color is chosen for an entire work or a part of a work. Arbitrary color usage refers to color that seems illogical, subjective, or distorted (see fig. 1.8). When objects have an unexpected or abnormal color, our eye gravitates to them, thus creating a focal point.

Unusual detailing is another method of gaining impact. When a work contains mainly flat, solid colored areas, focal points can be created by the addition of many-hued, highly detailed areas. Such detailing should be used sparingly. An entire piece covered in an array of colors and patterns would lose impact, because of the presence of too many focal points to concentrate upon.

Color usage that sets up a contrast with its surroundings allows the color to become emphatic in

9.19 George Sugarman, *Inscape*, 1964. Polychromed laminated wood, 24 x 144 x 108 in (61 x 365.8. x 274.3 cm). Whitney Museum of American Art, NY. Purchase, with funds from the Painting and Sculpture Committee. Against the neutral stone floor, sculptures stand out emphatically in pure bright-red, orange, and green hues, and in opposing black and white hues. The craggy detailing of the orange sculpture, its fierce suppression by the red object, and its tortuous, serpentine progress across the floor—all stand in dramatic contrast to the plain harmonies of the sinuous and vertically liberated white sculpture.

itself. Sculptors such as Alexander Calder and George Sugarman use pure hues in their works, which are usually positioned in a neutral setting such as a park or city plaza (**fig. 9.19**). Both depend on bright hues rarely found in nature to create a high contrast with the setting.

HARMONY

The principle of **harmony** refers to the visual agreement of all parts of a work. The successful application of harmony results in unity, which is achieved by using the principles of design.

Repetition is the easiest way to achieve harmony, and color is the most common and important means of repeating. Works that lack hue repetition will also generally lack unity. The layering of colors over a constant color is another way to achieve harmony because the underlying color influences the entire composition.

A study of the design principle of harmony also shows us that similarity works much like repetition, but adds the element of variety. Adjusting values, for example, can create variety—red and pink are not the same visually, but are similar in that pink is red with white added. We can thus achieve similarity by using shades that relate to the parent hue.

Harmony can also be imparted through the use of tonality. Even within a composition that employs a very diverse palette of colors, the addition of the same color to each palette color can give a tonality that results in a harmonious composition. Only a very small amount of additional color is necessary to achieve the tonality required (see fig. 8.5).

Two or more hues are harmonious if their mixture yields gray; combinations that do not yield gray have high visual impact. Hues can be made harmonious by surrounding them with a neutral.

9.20 Monochromatic color comparisons. The left-hand work has been rendered in Goethe's notations and the right-hand one in inversions of them. The latter is a more recognizable image. Courtesy Elly Madavi.

The term "color schemes," or "color harmonies," is often used in the world of interior design. Color schemes are nothing more than time-tested recipes, as it were, for colors that work well together, be they related or contrasting. Related color schemes impart harmony and unity to the eye. One related scheme is called the **monochromatic color scheme** and consists of one hue varied in value (from light to dark) or intensity (from intense to dull; in this case, the dull hues must relate to the parent). Such color combinations impart feelings of unity, harmony, peace, and quiet with an emphasis on spaciousness and continuity. For a successful result, we must be careful to use color proportionately. When working with a monochromatic harmony that is based on value, a rating of 10 on white and 1 on black will allow us to impose a proportion

notation on each of the values to be used (**fig. 9.20**). Again the use of Goodwin's triadic color system (see page 70) will allow us to determine the proportions of each tint of the hue to use. If we are using a monochromatic scheme based on intensity, the pure hue will be ranked 10 and the dullest 1.

The second of our related schemes is the **analogous color scheme**, which is based on three or more hues located next to each other on the color wheel. Analogous schemes usually have one hue in common, such as yellow-orange, yellow, and yellow-green, with yellow as the common hue. Analogous schemes become most emphatic when the common hue is a primary hue. They offer visual unity and a sense of calm, and they are most harmonious when the middle hue is the primary. An analogous scheme consisting of red, red-orange, and orange would not be as harmonious as one of red-orange, red, and red-violet. Applying Goethe's color notations for proportion of color, coupled with Goodwin's system of triadic use, allows analogous schemes to function harmoniously (**fig. 9.21**).

Contrasting color schemes exert greater balance than related ones. The **complementary color scheme** is built on two hues directly opposite each other on the color wheel. This combination offers the most intense hue contrast, and we find that each wheel offers a different pairing (see pages 9–12). Using color in the correct proportions is important when utilizing any of the complementary color schemes (**fig. 9.22**).

9.21 Analogous color comparisons. The presence of three closely analogous hues (a secondary blue-violet, a primary blue, and a secondary light blue) lends harmony to these compositions, which employ Goethe's and Goodwin's principles. The primary blue adds emphasis to each work. Courtesy Michele Nolan.

9.22 Complementary pairings. Complements such as orange and blue exert considerable contrast and balance. The right-hand photograph provides the more correct proportion between the hues, because within it the warmer orange occupies a smaller area than the cooler blue. Both compositions employ Goethe's and Goodwin's principles. Courtesy James McGinnis.

9.25 Triadic color comparisons. There is a dramatic difference in emphasis here between Goethe notations on the left and their far more successful inversions on the right. The works show colors equidistant from each other on the pigment and visual color wheels—namely, yellow, blue, and red (see figs. 2.2 and 2.7). Courtesy Carol von Achen.

9.23 Double-complementary color schemes. These compositions show Goethe notations on the left and their inversions on the right. They illustrate different combinations of the double complementary colors violet with yellow-green and orange with blue. Courtesy Xin Xu.

The **double complementary color scheme** is based on two sets of complements and affords less contrast than complementary, split complementary, or triad schemes (**fig. 9.23**). When the hues are spaced equidistant on the color wheel the scheme is called a **quadrad color scheme**. **Split complementary color schemes** are formed from any hue and the two hues at each side of its complement. Here the contrast is less intense than in the complementary schemes but more intense than in the double complementary. Such schemes provide interest and variety (**fig. 9.24**).

The **triad color scheme** offers the next most obvious contrast to the complementary. The hues for each triad scheme are equidistant from each other on the color wheel. Triad color schemes result in a dominance of warm or cool. The combinations are as follows:

- **Pigment**—yellow, blue, red
- yellow-green, blue-violet, red-orange
- green, violet, orange
- blue-green, red-violet, yellow-orange
- **Process**—red, yellow-green, blue-violet-blue
- yellow, magenta, cyan
- **Light**—red, green, blue
- yellow, cyan, magenta (**fig. 9.25**).

We are able to rank color schemes as to their impact, in that some provide more contrast than others. In order of most contrast we find the following color schemes: complementary, triad, split complementary, double complementary, analogous, and monochromatic.

When working with the various color schemes we have covered, do not limit yourself to pure hues, but rather use tints and shade of the hues to further ensure greater contrast and depth, more visual interest, and a harmonious result.

9.24 Split-complementary color schemes. These compositions, showing Goethe notations on the right and their inversions on the left, feature combinations of the split-complementary colors orange with blue-green-blue and blue-violet-blue. Courtesy Arna Arvidson.

- ☐ Color should not be chosen for a composition simply because it is "pretty." Color must serve the artist's purpose.
- ☐ Repeating colors imposes unity and often a sense of movement. This is employing the principle of rhythm in a composition.
- ☐ Be aware of the type of balance that the imagery within a composition provides and employ the color balance accordingly.
- ☐ Color has an impact on the way the parts of a design relate to each other (proportion). Goethe's color notations have to be inverted to work.
- ☐ Pure hue mustn't overwhelm a composition. A pure yellow background would allow one to see little else. However, dull the yellow with some violet, say, and the composition's full color range becomes apparent.
- ☐ The scale of a design is affected both by the area and boldness of the color used. Distance affects how a color is perceived.
- ☐ Emphasis can be accomplished by using color in a number of ways: (1) color contrast (bright/dull, light/dark, warm/cool), (2) area size (large areas of a color versus small), (3) gradation (soft versus hard), (4) texture (rough versus smooth), (5) use of arbitrary color, (6) unusual detailing, and (7) contrast with surroundings.
- ☐ Methods of achieving color harmony are varied: (1) repetition, (2) similarity, (3) use of tonality, and (4) surrounding a color with a neutral color. Several different kinds of color schemes are possible: complementary schemes have the strongest contrast; monochromatic the least.

Exercises

1 Do a series of simple compositions based on progression of hue, progression of value, progression of intensity, and progression of temperature. Refer to figure 9.3.

2 Using two identical compositions based on a single hue, render one in a monochromatic format and the other utilizing analogous colors. Refer to figure 9.5.

3 Using the same composition, render it as a pictorial composition and a flat composition. Refer to figure 9.7.

4 Using the same composition, render it in a symmetrically balanced color mode and an asymmetrically balanced color mode. See fig. 9.9.

5 Do an overall pattern in color that is unified and pleasing to the eye.

6 Do an example of triadic color system balance. Refer to figure 9.12.

7 Using identical compositions and colors, render one in an equal mode of color use and the other in an unequal mode of color use. Refer to figure 9.13.

8 Do an example of employing contrast to create emphasis. Label the type of contrast used.

9 Do an example of employing proportional inversion to create emphasis.

10 Do an example of employing fracturing a surface or unusual detailing to create emphasis.

11 Do a composition in a monochromatic color scheme. Refer to figure 9.20.

12 Do a composition in an analogous color scheme. Refer to figure 9.21.

13 Do a composition in a complementary color scheme. Refer to figure 9.22.

14 Do a composition in a double complementary color scheme. Refer to figure 9.23.

15 Do a composition in a split complementary color scheme. Refer to figure 9.24.

16 Do a composition in a triadic color scheme. Refer to figure 9.25.

CHAPTER 10
Color and the Elements of Design

In the previous chapter we introduced how color relates to the principles of design. We will now explore how color works with the elements of design, which are space, line, form/shape, texture, and light. The elements of design utilize the principles to create the desired visual effect.

One must observe and analyze all the factors that contribute to the rendering of an image. Predicting and determining in advance what you want to happen entails making notes concerning the use of color before you start any work.

SPACE

Throughout this book I have stressed the importance, when creating compositions, of having color and form seen simultaneously. To this end, a working knowledge of color's spatial effects is imperative. We use the term "surface color" to denote the hue of an object, such as

(a) (b)

(c) (d)

10.1 The effects of dark, light, and middle-value backgrounds on objects with similar values. The circle that we see first in the black background (a) is the white one, while the one we see first in the white background (b) is the black one. In the two gray backgrounds (c and d) we perceive first the circles that are at the furthest extremes from gray, namely, black (c) and white (d).

the red barn, the green grass. However, when objects are viewed in **space** certain visual transformations then take place.

Value helps to determine the relative position of an object in space, whether it is close up, in the middle distance, or far away. An object's position is also influenced by the value of the background on which it rests. If the background of a composition is very light (white, or almost white) the objects seen first will be very dark (black, or almost black) (**fig. 10.1**). The same effect occurs when one is in a dark forest looking out toward the light. In order to create space, we must not only adjust the values within a composition but the contrast in values as well. In naturalistic works that have great depth of field we must attend to atmospheric, or aerial, perspective (see fig. 8.6). When choosing the colors for a project, keep in mind that those objects farther away will not only require lighter values of hues but duller ones as well. Colored grays can work very well in this instance, but for creating deep space we must use colors that have a blue-gray tonality imposed upon the desired hue. Colored grays are most easily recognized when compared to the "chromas" in the Munsell system. Look out your window and analyze the contrast and hues provided by those objects near at hand as opposed to those in the distance.

If the background of a composition is a very dark value (black or almost black) the objects seen first will be very light (see fig. 10.1). This effect can often be seen in the still-life paintings of the seventeenth century (**fig. 10.2**).

The middle-value background (neither light nor dark) is the most difficult situation to handle. Generally a middle-value background should be used in a composition only when overlapping of planes is distinct, because it does not impart a spatial feeling and the overlapping planes will reinforce where the images are in space. Much experimentation is required to ensure that the objects' positions in space are clear when working on a middle-value background. One solution might be to say that the middle-value background should be treated as a dark background and to proceed with the objects placed in a sequence getting progressively lighter. Conversely, the middle-value background could be said to be light with objects sequenced to dark (see fig. 10.1).

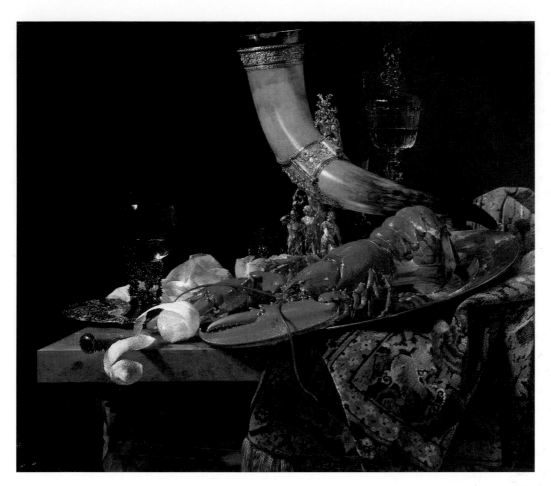

10.2 Willem Kalf, *Still-Life with the Drinking-Horn of the Saint Sebastian Archer's Guild, Lobster, and Glasses*, c. 1653. Oil on canvas, 34 x 40¼ in (86.4 x 102.2 cm). National Gallery, London. Against the very dark background, the colors that clamor most immediately for our attention are the whites and yellows of the lemon, lemon peel, and drinking horn; the white highlights on the background cloth; the white reflections off the drinking glasses, table edge, plate, and lobster; and the bright red lobster itself.

Keep in mind that the background of any piece is essential to the advancing and receding effect of any hue placed on it. In landscapes we find that distant objects are cooler. Thus the illusion of space or distance is most easily imparted by imposing a blue-gray tonality on distant objects (**fig. 10.3**). Coolness tends to reduce

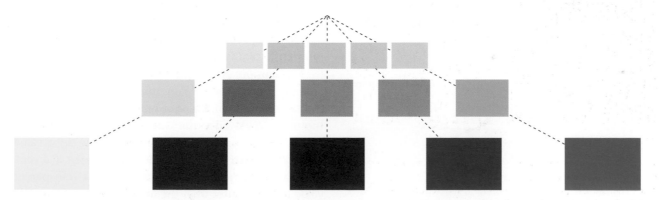

10.3 The illusion of distance. In their landscapes, artists use cooler colors with grays to gain atmospheric perspective and suggest distance. In this example, the foreground colors are warmer than the background ones.

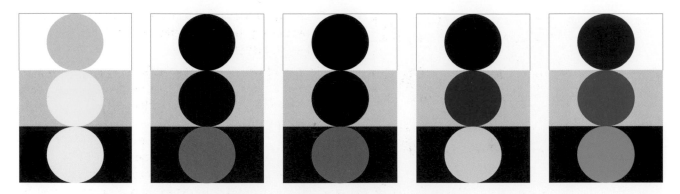

10.4 The influence of background values. Light backgrounds tend to darken objects, while dark backgrounds tend to lighten them. The artist must lighten or darken object areas to capture the effects of light, less light, and no light. Pure hues are here in the gray backgrounds; shades of the hues (plus black) are in the white backgrounds; and tints of the hues (plus white) are in the black backgrounds.

the apparent size of an object, increasing dimensions and distance. Without the illusion of deep space the effect is flat and one-dimensional.

Objects resting against opposing areas of value must change their values within themselves. Let's say we have a tree trunk that comes up from the ground against a dark brick wall but whose higher portions are seen against a light sky. Where the tree trunk is seen against the wall it will be lighter in value than where it is seen against the light sky (where it will be dark), but it is still the same tree trunk with the same surface color—it is the value that is changing (**fig. 10.4**).

We know that distance between any object and the observer involves change in color perception. As distance increases gray tonality results because the color weakens. Trees in summer are a warm green close-up, but at a distance they appear cooler, tending towards green-blue.

The element of space controls the distance, void, or interval between objects in our work and provides interaction between line, shape, color, and texture. Interval can cover the change between warm and cool

and/or dull and bright; these can create space as well as distance and void. The types of **illusionary space** that can be created are shallow (near), medium (moderate), and far-reaching (deep or infinite). **Shallow space** is usually created by simple shading of forms and/or simple overlapping. The images appear to be close to the viewer. **Medium space** is the depth that is conveyed by ordinary vision. Objects or images are within a reasonable distance—neither very close nor very far. **Far-reaching space** is the kind seen in panoramic photographs or landscapes, when we appear to look out to the horizon. This type of space usually extends far beyond the picture plane (**fig. 10.5**). The value of an image helps to place it in space.

The Illusion of Transparency

Transparency occurs when objects overlap but are still seen in their entirety. Here confusion can begin to take over unless transparency is carefully handled, but it has the benefit of allowing the eye to go in and out of space simultaneously. This is called **equivocal space**; it conveys the feeling that the space is changing as we view it. Equivocal space is the basis for most Cubism. Color is a most important factor in establishing equivocal space.

The illusion of transparency is dependent on the changes in hue and value that occur when objects overlap each other. If a light hue or value is placed on top of a dark one, the value of the overlap (the transparent value) will be darker than the light value but lighter than the dark value. Conversely, if a dark value is placed on top of a light value, the transparent value will be lighter than the dark and darker than the light. The hue change of the transparent area is as important as the value change. The tonality of the

Shallow Space	Medium Space	Far-reaching Space

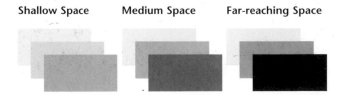

10.5 Shallow, medium, and far-reaching space. As we move from left to right across these images, increasingly greater value contrasts within each group of rectangles give the impression of greater depth, or space.

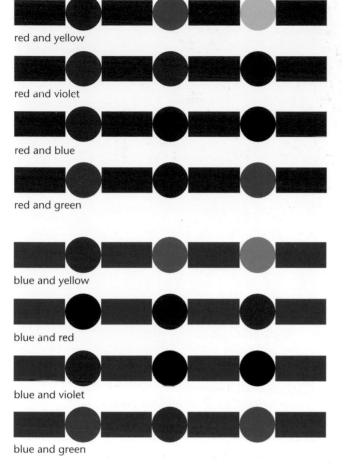

red and yellow

red and violet

red and blue

red and green

blue and yellow

blue and red

blue and violet

blue and green

10.6 The illusion of transparency. The two outermost red and yellow circles (first row) show the colors needed when applying red over yellow and yellow over red respectively to achieve an illusion of transparency and space. The single central circle (first row) shows the visual middle mixture (orange) of red and yellow so one cannot tell which is on top (no illusion of space between them). This principle lies behind all the rows (see also fig. 10.7).

overlap area is that of the area doing the overlapping. Let us say we had a yellow area overlapping a red one. The transparent area would not be orange but rather an orange-yellow-orange, yet a value of orange-yellow-orange darker than that of the yellow. It is important to show the various planes when using transparency so the viewer knows what goes where (**fig. 10.6**).

The illusion of space can also be employed when working with transparency. An illusion of space is accomplished when the value of the overlapped area is close to the value of the overlapping hue. The closer these values become the greater the spatial illusion. Transparency is also most convincing when the light source is coming as if from behind the imagery. The artist can accomplish transparency effects in one or more of three ways:

- changing the color to impart the desired effect
- producing the desired effect by optical mixing
- layering or glazing.

When working with the two latter methods, one should know the values of the components of the mixture. They should be close or exactly the same in value (**fig. 10.7**).

Space is also created by the tonality of the overlap area. If the overlap area is closely related to the overlapping hue (the hue on top), a greater sense of space is created than if the overlap area were closer to an equal mixture of the two hues. Let us again look at the yellow area over the red one. If very little space exists between the two, the overlap would be orange-yellow-orange. To increase the spatial interval the overlap would become yellow-orange and even greater space between the two would result if the overlap were yellow-orange-yellow. In other words, the closer the overlapping area is in hue to the overlap hue (the parent), the greater the space created. Even more convincing space can be created when we apply the value concept of space to our transparency studies. Our yellow overlapping red study now goes a step further. If the red area were mixed with white so it is lighter than the pure yellow, it would appear farther away than the yellow if a white ground were used. We see that we must first determine where the hues are in space and then apply our mixtures to the overlapping areas, adjusting the values accordingly.

If an object is transparent, light can pass through the material and things within or behind the material

10.7 The illusion of space in transparency. The transparent yellow of the smiling face is overlapped by the close value of the yellow-orange, creating the illusion of space. The transparent effect is enhanced by the light source originating as if from behind the composition. Courtesy Mark Hartnett.

10.8 Joseph Wright, *An Experiment on a Bird in an Air Pump*, 1768. Oil on canvas, 72 x 96 in (180 x 240 cm). National Gallery, London. In order to convey the illusion of a rounded, transparent glass air pump (top), Wright painted the edges of the glass with great delicacy, and he rendered the enclosed bird extremely foreshortened and in the sharpest detail. He painted the colors of the man's hand, lace-edged cuff, and sleeve so that we perceive them to change subtly between our observations through the glass and just outside the glass. The dark background, the minutest glass reflections, and some refraction of the man's arm complete the effect. The illusion of the foreground glass jar containing the human skull is enhanced by the back-lit liquid it contains.

can be seen clearly. Glass is a perfect example—it is clear and smooth. One must keep in mind the qualities of the transparent materials. The things seen through the transparent material are very sharp and in some cases even brighter and larger. When working with a transparent object the edges of the form are completely seen in all dimensions—front and back. In short the entire structure must be recorded. When attempting to impart the effect of a totally clear material such as glass, we find that the use of a dark-value background allows us to employ an extremely broad range of values seen through the glass as well as the reflective qualities seen on the glass as the result of light reflections (**fig. 10.8**). We must also keep in mind that this object (such as the

glass) needs shading to put it into space and define its volume. When this has been determined, the object or objects within or behind must have their color adjusted accordingly. Remember that the glass must have its color imposed upon the surface colors seen through it, and that the values and tonality of these mixtures must be convincing. It is important to make notes on what will happen to each color area before trying to execute these effects. These notes will enable you to work out logically the color solutions desired.

Translucency

A **translucent** object allows light to pass through, but the material is not entirely transparent—light is partially

10.9 Translucency. In this example, the diaphanous veil blocks some of the light striking the bride's face and pearl tiara, lending them a darker, softer, and hazier appearance. The outlines to her cheek, neck, and shoulder are particularly fuzzy. A less translucent material such as a lace curtain would block out more light and render objects even fuzzier.

blocked and the things within or behind the material become fuzzy or diffused. A sheer window curtain is a perfect example—it is soft, flexible, and has a gauzy texture. Objects viewed through such a curtain look softer than they really are, with diminished details. Translucency depends greatly upon the effect created by the density and texture of the translucent layer. When working with a translucent object, one cannot completely see the edges of the form due to the relative opaqueness of the translucent material (**fig. 10.9**). As a general rule we find that translucency involves utilizing close values of color. It is handled in the same manner as transparency, but the values are adjusted to impart a softer, less clear visual image. In addition, when we attempt to achieve transparency through more than two layers, those areas begin to become translucent as well as transparent.

Volume Color

The volume of solid objects is fairly easily rendered, because their local color is affected in a simple way by their surroundings. The artist is faced with special

problems, however, when dealing with the volume of transparent images, which require additional analysis. Water, for example, is clear; our rendering of water must tell us how much water is there. The sea reflects the blue of the sky as well as the ocean floor. The more water present the darker or deeper the color used. Near the shore the sky's reflective action diminishes as the sand on the bottom nears the water's surface. Tinges of blue blend with the beige-gray of the sand. However, because of the light reflected on the water the value is also changed. The deeper the water becomes the more the blue takes over (**fig. 10.10**). Similarly, as light reflects on a window pane, the values of the objects beyond it are also changed.

Film Color

Let us now ascertain what happens to surface color when atmospheric conditions are imposed upon it. The open door with light streaming through affects the surface color of objects in that the light forms a layer upon their surfaces. This is **film color**. The light cast nearest the open door will be more intense and lighter in value. However, as we move away from this light shaft the intensity and the value weaken. We must, then, impart this information to the viewer. The areas nearest the light source will remain a light value of the surface color; however, as the light is projected it gets duller and darker, but the shades used still reflect the parent of the surface color. A film color will favor the surface color but this surface color area will be duller (contain the complement of the local color) and have a

10.10 Volume color. As seen in this photograph by the seashore, ocean water reveals a very dark blue-violet color due to the massiveness of its volume and its reflections of the ocean contents, the ocean floor, and the sky. The color of the water near the shoreline is a much lighter blue, reflecting the shallow, beige-gray sands below. Courtesy estate of M. Anne Chapman.

10.11 Local and film color. The light forming a layer upon the local color of the rabbit in the doorway becomes its film color. In order to convey that the light cast nearest the door should be more intense and lighter in hue than that cast toward us and away from the door, the artist has rendered the former as a light value of its local color and the latter as a darker value. Courtesy Michele Nolan.

tonality of the film color—the red light of a sunset, for example—that depends upon the strength of the film (**fig. 10.11**). When designing it is important first to determine the surface color or hues of the imagery. Then adjust these surface colors to impart the desired visual effects. In this way you will retain the tonality of the image.

Intensity and Space

Intensity can produce effects on objects in space. Strong intensities make an object large, and the more intense a hue is the more it causes an object to move forward. We find that small areas of a composition usually function better done in brighter hues while large areas are better done in duller hues (see fig. 7.9). Light pure hues on a black background will advance according to their value, and pure yellow advances the most. Light pure hues on a white ground will recede according to their value, and here pure violet will advance the most. Thus, a pure hue advances relative to a duller one of equal value (see fig. 6.9). Low intensities reduce an object's size and increase distance and spaciousness. When values and saturation of hues or colors in a composition are equal or close to equal, dimension is lost and the surface will appear flat.

Presentation

The presentation of any art work affects the spatial effects that are imparted in the work. Remember that the final presentation of the piece is an integral part of the entire design. It is a good idea to think about the framing, matting, and mounting at the outset of any project, and the color to be utilized must become one with the art work. If this is done the spatial effects one wishes to convey will be reinforced and not destroyed by any framing, matting, or border.

While each work is unique, there are some guidelines that can help to enhance any piece of art. Borders surrounding a work serve several purposes:

- protection
- emphasis in comparison to its surroundings
- interaction with the design to control its impact.

Matting, which is the most common type of border, serves as a barrier especially if the piece is to be handled. The mat can also set the piece apart from its surroundings and get rid of the distractions that might be present such as those seen on a wall. A mat can also clarify what is occurring within a non-representational work by cementing the figure/ground relationship. In a black-and-white non-representational flat composition, the choice of either a black or white mat will determine what is the figure and what is the ground. For representational compositions a white mat is the safest bet since colored mats can interfere with the color relationships occurring within the piece.

Both frames and mats in color should not intrude upon the work. Colored frames should exactly repeat a color that is found in the piece and preferably should be a light value. In this way the frame becomes part of the figure/ground relationship. When in doubt a white mat will always serve as the best choice, or a mat that exactly matches the background of the piece.

Colors that fill a space, as we see in interior design, affect the feeling of space that is imparted. A small room can seem larger if decorated in cool colors. A large room becomes visually small if it is presented in predominantly warm colors. A high ceiling is "lowered" when painted in a warm color.

LINE

Colored and neutral **lines** can have a strong influence on our work. We know that line imparts motion and contour to images, and when areas are delineated in colors that conform and enhance the area, the results are visually credible. This technique was used dramatically by Van Gogh (**fig. 10.12**).

10.12 Vincent van Gogh, *Portrait of Père Tanguy*, 1887. Oil on canvas, 25½ x 20 in (64.8 x 50.8 cm). Private collection. Van Gogh painted a strong red contour almost all around Père Tanguy, which also creeps over onto his face. Together with the pink, white, and green lines rapidly executed on his shirt and face, the total effect is of a fierce monumentality and a fiery disposition. The lines serve to energize the man, making a passively seated figure appear to move before our eyes. The quickly sketched black contour around the Japanese woman in the print at top right also imparts motion, but the subject suggests a quieter disposition than that of Père Tanguy.

| Complement | Black | White | Dark Value | Light Value | No Outline |

10.13 Types of outlining. Complementary outlining attracts attention to the outline, strengthening the complement. Black outlining deepens a hue and forces it to advance, making it more luminous and individual. White outlining diffuses a hue over a seemingly larger area, making it weaker yet still individual. Surrounding a hue with a darker shade of the same hue can force it to recede yet enhance its luminosity. Doing the same with a lighter tint can advance a hue and also prevent a vibration with a neighboring complement.

Outlining

Observation shows that hues remain individual when separated by black or white lines. This becomes especially important when dealing with like or related hue areas. In order for the closely related hues to remain individual, black or white outlining must be used. Without this outlining the variations in hue will cause a feeling of depth because of visual fusing (**fig. 10.13**). Outlining creates closed areas and serves as a barrier between color boundaries, which halts interactions and simultaneous contrast effects (**fig. 10.14**).

Outlining an area of a color with black tends to deepen it, making it richer and more jewel-like. This is one of the principles of stained glass (**fig. 10.15**). Dark or black outlining can add a glowing, luminous quality to an object. White outlining, on the other hand, spreads and washes the hue over an area. The spreading effect of white outlining will lighten and weaken the color energy of the area.

Outlining can affect value by adding excitement to areas of like values by delineating them from one another. Outlining, if used sparingly, can also be used to define focal points—points of emphasis. When complementary hues touch, it can be desirable to outline the object with a light value of its hue. This will halt a vibration effect. For instance, a red flower on a blue-green background might be outlined in pink. Complementary hues attract attention to outlines and an area becomes stronger when surrounded by its complement. When a light value is used on a dark background no outline is needed, but when a dark value is used on a light background it is necessary to outline the object with an even darker value of the hue (see fig. 10.13).

Now we see that we have five methods of outlining: outlining with the complement (use the Munsell wheel complement); outlining in black; outlining in white; outlining in a light value; outlining in a dark value. When combined in a composition, these outlinings help to create space: objects outlined with the complement will be seen first, followed by those outlined in black, then white, a darker value, and a lighter value.

Legibility

Contrary to popular belief, the most easily read combination of colors is not black on white. Walter Sargent (a Chicago art educator) and M. Luckiesch (a Swiss psychologist and color consultant) did research on color legibility during the middle and late twentieth

10.14 Outlining and no outlining. The outlining on the left defines shapes and creates space around them. The lack of outlines (right) serves to open up areas of color to more visual fusing and to give the composition more depth. Courtesy Arna Arvidson.

10.15 Carpenter's Guild Signature window (detail), Chartres Cathedral, France, early 13th century. The use of gray-black lead to separate panes of stained glass was more than just a practical tool to hold such compositions together. Lead was also a powerful visual aid. Its neutral color served to reinforce the luminous, jewel-like quality of the glass within it and to stop the colors spreading.

10.16 Henry Moore, *Sheep #43*, 1972. Black ballpoint and felt pen, 8 x 9¾ in (20.3 x 24.8 cm). Courtesy of Mary Moore. The use of thin to increasingly thicker lines down the sheep's body suggests its rotundity. The heavier use of lines around the shoulders and down the front helps accentuate the turning of the head and suggests the greater amount of wool in those areas of the body.

century and compiled a set of rankings for color legibility (see Appendix 5). The most legible combination of colors proved to be black on yellow, followed by yellow on black; black on white is only fifth on the list. Green on orange is number 30 on the list. Color legibility rankings allow the graphic designer, printmaker, fiber artist, and embroiderer to impart clarity to their work.

Other Types of Line Formation

Often thin-to-thick lines can appear to be lighter (thin) to darker (thick). We can also actually change the value of a line in its trajectory and achieve even more convincing illusionary space or volume (**fig. 10.16**).

When the scale of lines becomes overly bold, the line loses its identity and functions as a shape. This effect is greatly enhanced in compositions where boldness of color and thickness of line are coupled (see figs. 9.11 and 10.16).

Adjoining color areas can also create line. So we see that lines can be the result of the meetings of areas of color and value, the meeting of surfaces, and the intersecting of surfaces. When diagonals meet another line, the angular area formed can result in a spontaneous interaction. This is especially true when the angles are

repeated. We will see gray areas where there is only black and white, due to the optical mixing that is taking place.

FORM AND SHAPE

Color is generally seen before form. The artist can, however, alter this sensation so that color and form are observed simultaneously. When this is done, color is used to its fullest capacity. In the following section "shape" refers to a bounded, flat area; **form** in this context is treated as three-dimensional.

The simplest method of implying form is through shading, or through the application of graduated values. Chiaroscuro is one possible method of shading that allows color and form to become one. Artists developed this most realistic shading system during the Renaissance. The premise behind chiaroscuro is that light affects an object's volume and its position in space and time. In this system the transition from light to dark areas is gradual and therefore smooth. These smooth gradations impart sensations of light and atmosphere or space. When dealing with an object to be rendered in chiaroscuro, we must first determine the parts of the object in relation to its shading:

- The highlight—this is the area where the light source is striking the object. It appears on that part of the object directly facing the light source, and the light is at its most intense. Keep in mind that the highlight should be the lightest value discord of the nearest primary hue.

- The light area—this area surrounds the highlight and appears rather light in value. It appears to be the result of light radiating from the highlight, which weakens as it spreads. The parent hue of the light area is the surface color of the object. Therefore, the light is the surface color plus white.

- The cast shadow—this area relies upon the light source to impart its direction and strength. It must contain some of the color of the object as well as of the surface on which the object rests. Thus the cast shadow is composed of the surface color of the object plus its complement, as well as the surface color of the casting surface or ground plus its complement, with the ground surface color dominating.

- Reflected shadow—this is the light that is being reflected back from the ground surface area. Here we also see colors blending, in that the color of the

ground mixes with the color of the object. We must therefore create a color that is a mix of the object's surface color plus its complement with the ground surface color plus its complement. The object's surface color should dominate.

- The form shadow—this is the darkest part of the object that is farthest from the light source and usually is positioned next to the reflected shadow. Form shadow is composed of the object's surface color plus black.

- Form shading—this describes the gradual transition from the light area to the form shadow area, which gradually changes its value from light to dark, producing a smooth transition between the areas. This is composed of the object's surface color, plus white and/or black (see fig. 6.4).

Psychological research has shown that there is a definite relationship between color and shapes. In visual terms, certain colors seem to have a natural correspondence with particular shapes:

- red—squares, cubes, 90-degree angles, structural planes
- orange—trapezoids, rectangles, sharp or hard images, fine details
- yellow—triangles, inverted triangles, pyramids, acute or aggressive angles, pointed sharp forms
- green—rounded triangles, hexagons
- blue-green—liquid
- blue—circles, spheres, rounded angles
- purple—ellipses, ovals, flowing forms.

TEXTURE

The texture of a surface also influences color. We find that the rougher a surface is, the darker it will appear to be. Moreover, the actual texture of a surface affects the color applied to it. If a surface is rough or porous, it will absorb a greater proportion of the lightwaves hitting it, so the color will be perceived as darker. A shiny surface, on the other hand, will reflect more of the light and the color will appear lighter. Obviously, the reflective qualities of a shiny surface also mean that the colors of the surrounding surfaces will be mirrored.

Value and intensity of hue can combine to imply a rough texture on a flat surface. Contrasts of light and dark across an area allow that surface to be perceived as having highs and lows. Dark values often denote shadows within forms. These shadow areas must not just be dark (hue plus black) but duller (hue plus black plus complement) as well. The dull colors (shades) used

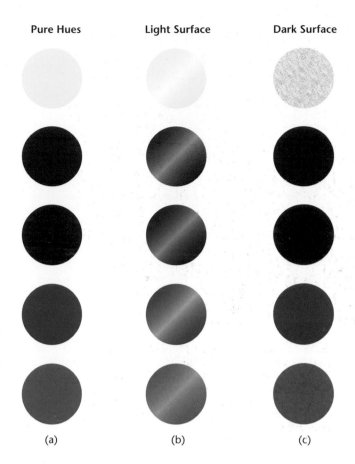

Pure Hues **Light Surface** **Dark Surface**

(a) (b) (c)

10.17 Implied smooth and rough texture. Column (a) consists of the Munsell pure hues. Column (b) shows their application to a smooth surface and column (c) an application to a rough surface.

must relate to the parent color, which is also the surface color. An implied rough textured surface should impart the feeling that the surface is all the same color but that the texture is in some way irregular. The greater the contrast between the values used, the rougher the surface will appear (**fig. 10.17**). We also find the more the surface is fractured the rougher the texture will appear.

Temperature also can impart a textural feeling. A smooth, shiny surface is usually rendered in a cool temperature, while warm color usually imparts a smooth napped texture such as velvet (see fig. 8.1). From this we may conclude that a textured surface is usually warmer than a smooth surface.

Also keep in mind how texture changes in space. Areas close to the viewer must be rendered in more detail and/or rougher than those seen at a distance. As distance becomes greater, texture becomes less discernible. Therefore, the closer the texture is to the viewer, the more intense is its color.

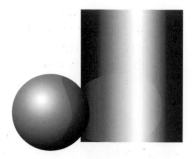

10.18 The effects of reflected color. The highlight on the orange is a discord of red and the reflected shadow at its base is a dark, dull orange with a dark, dull red. The highlight area near the top and center of the rectangle would be a discord of blue and the reflection highlights to the left and right of center would be discords of red and blue.

Reflective Surfaces

Most reflective surfaces are smooth and shiny. In order to denote this type of texture, the artist can apply a light source to the area. As we saw in our study of chiaroscuro, the highlight is a very light value of the discord of the closest primary to the parent surface. If we had a red surface, the highlight would assume a blue tonality that is very light (pale, almost white, blue). We must now denote the shading that the form requires. Once the surface light and darks have been determined, we must analyze what is being reflected by that surface.

Here we must impose upon the surface its surroundings. If our red surface were to reflect an orange, this orange would be seen on the surface (in refracted form, if necessary), but shown with an overall tonality of the red surface imposed upon it. Keep in mind that the red surface's values (including the highlight) change across it and the form of the orange must mix with these to impart the illusion that the orange is being mirrored by the red surface (**figs. 10.18–10.19**). Make notes while studying the visual problem so that all color combinations are thoroughly analyzed.

The combination of intense light reflection and color reflection is the major visual clue that we are observing a metal surface. When working with metal forms we must take into account the value modeling (chiaroscuro) that will define the form as well as the value modeling of the forms reflected on to the metallic surface. These reflected colors must have a tonality of the metal surface but still find their parent color from what is being reflected. The one major color usage change we find here is that the highlight area of the metal surface is not the lightest discord, as previously seen in our handling of chiaroscuro. On metal the highlight area should be white, or the palest value of the hue describing the metal. Keep in mind that the reflective qualities of metal are greater than those of other surfaces, so the highlight and shadow areas will be in

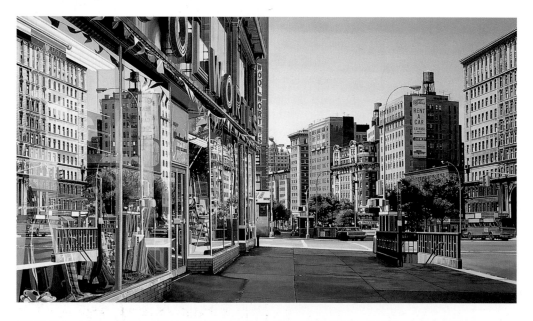

10.19 Richard Estes, *Woolworth's*, 1974. Oil on canvas, 38 x 55 in (96.5 x 139.7 cm). San Antonio Museum of Art, San Antonio, Texas. Lillie and Roy Cullen Endowment Fund. Estes highlights the reflective surface of most of the neon "Woolworth's" letters in various shades of white, gray, light-blue, and orange. He emphasizes just the second and third "o" of the name with a pure red-orange hue to suggest that electricity is only functioning in these letters. With great skill, Estes paints the display windows in such a way that one can see through them into the store and the reflection of the other side of the street.

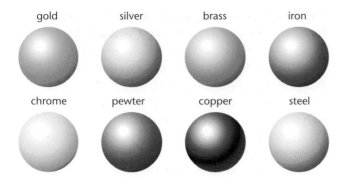

| gold | silver | brass | iron |
| chrome | pewter | copper | steel |

10.20 Achieving metal color usage. It is advantageous to be able to render metallic surfaces without the use of very expensive metallic inks. Highlights should be all-white and shading gradations in sharp contrast.

great contrast. While working with chiaroscuro we found that the gradations of value were very gentle; with metal surfaces the intervals between values are exaggerated. Different metals have different hues and different reflective qualities (**fig. 10.20**).

Water is usually a clear, transparent liquid and as such the areas beneath water droplets must be treated as transparent color. Usually water droplets are rendered in a gray-blue tonality and, because they are rounded, the artist must show this as volume color. Therefore, this gray-blue tonality must incorporate shading with pure white highlights. Because these droplets are concave the surface imagery beneath them will be magnified and have a gray-blue tonality.

LIGHT

One cannot deal with light without exploring shading. The depiction of light on a flat surface is most easily achieved by the use of shading, which also adds realism to shapes and translates them into forms. First, however, we must determine the light and dark areas on the object. Keep in mind the light source hitting the object as well as the shape of the object. Within a composition there is usually a single light source. When no apparent light source is present objects seem flat, whereas the shadows cast from a light source impart depth and dimension to an image. The lightest area will be where the light source hits the object and is the most intense. Study photographs and your environment to see how light hits an area or object, observing how the values and hues can change. Changing the direction of a light source can greatly alter our perception of the composition. Light sources can emanate from the front, the sides, the top, the bottom, the back, or from within.

Metal	Hues	Reflective Qualities
gold	yellow	cool, clear, highly reflective, white highlight, shadows sepia (burnt umber)
silver	neutral, delicate blue-gray (cobalt blue-gray)	cool, highly reflective
brass	smoky, warm yellow (earth yellows—raw sienna, yellow ocher, indian yellow, sepia)	white highlight
iron	heavy, grainy, dense gray	medium reflection, cool gray highlights, blue-grays dark-black
chrome	cool blue-gray (indigo and green)	sharp contrast, highly reflective, influenced by surrounding colors, highlight white surrounded by blues, blues and greens in shadows
pewter	beaten appearance, warm blue-gray	low reflection, no white highlight, no black, blue highlight
copper	orange-red	highly reflective, can have a green patina, brown shadows, light orange highlight
steel	cool gray (ultramarine blue-gray)	medium reflective, no black or white, pale gray highlights

Each type of lighting will reveal the object from a totally different aspect.

When no definite light source is noted, the shading is termed **logical shading**. Because no light is present, there are no cast shadows and the shading only defines forms. The areas closest to us are lightest and vice versa.

In addition to the shading of individual objects within a composition, thought must be given to the overall light quality of the piece. A crisp delineation of all forms is known as **linear composition**. If we were to trace such a composition, the result would be a clear, outlined composition much like a "coloring book" drawing. However, when only parts of shapes and forms are visible with the remaining visual information melting into the background the effect is known as lost-and-found contour. Here the viewer is asked to fill in the remaining visual information from the minimal images supplied. The simplest way to achieve lost-and-found contour is to have parts of objects bathed in light while the rest of the object is of quite dark values on a dark background.

The ground on which an object is placed also affects how it is to be shaded. On a dark background those areas seen first will appear to be very light. The areas farthest away from us will meld into the dark ground. As we look, the light areas will advance while the dark areas recede. On a light background, however, the areas seen first will be dark. The light/dark contrast pushes the dark areas toward the viewer. One must keep in mind how the individual components of a composition are shaded in this situation. The darkness of a forward object causes it to stand out. When a middle-value (neither light nor dark) background is used, the objects become static and calm. We are not exactly sure where they are in space. Most of the form of individual objects is lost and the result can be one of mystery.

How light is used within a composition can convey emotions. Very little light can impart feelings of fear, mystery, intimacy, and night—to mention but a few. A very light composition can impart joy or warmth. Light, therefore, can impart emotion, time, and space to any composition.

Types of Lighting

The type of light that plays on a color greatly influences it. It is crucial to try to replicate white daylight when attempting to reproduce colors. In the United States, as well as the entire northern hemisphere, the ideal condition in which to work is in natural light from the north, because it undergoes the fewest changes as the sun moves and the day progresses. But this ideal is not always practical. Cloudy days and working at night, for instance, necessitate other solutions.

Artificial light can be divided into three types: incandescent or warm (candles, light bulbs, flash lights, torches, gas lamps), electric arc (sodium vapor lights), and fluorescent. **Incandescent lights** give us white wavelengths that warm the surface, so that warm surface color hues appear brighter, cold ones duller. Incandescent light bathes the area in a yellowish glow. **Electric arc lights** use various gases that impart a variety of film colors to the surface. Sodiums, for instance, give a yellow-orange glow. Xenon produces white light and is best for viewing hues. **Fluorescent lights** usually contain a lot of blue film color that greatly alters hue. However, if we can pair it with a pink fluorescent light we can achieve a fairly consistent white light. The best option here is a Dalux fluorescent, which provides the least distortion among this lighting type. The optimal white light is provided by quartz halogen lights. Warm white light is best for viewing inorganic or plastic materials but is less good for organic objects, since it tends to weaken warm colors, making them appear much bluer.

Types of lighting create very different effects; we must remember that, for example, Renaissance works of art would have been painted and viewed by natural light, oil lamp, or candlelight. How would the colors of Michelangelo's Sistine Chapel have appeared in candle or oil-lamp light? When we look at all the great paintings that fill our museums, we must remind ourselves of their original settings. How would the change of scene and lighting affect our perception of them?

We must also be conscious of the type of lighting and surroundings that will be home to our finished works. The optimum would be to have an art work function as the artist intended it to, no matter what the setting.

We also find that while the rods of the eye's retina help us to see in dim light, the greater the contrast present in the object the more distinguishable it becomes. So, for example, black on a dark background is harder to distinguish than black on a light background, even when the light is dim.

Finally, let us look at the quality of light that is illuminating an object. Certainly bright noon sunlight imparts a different illumination than if the object is lit by candlelight. The brighter and stronger the light source, the greater the contrast of values resulting from that illumination. We also find the closer the light source is to the object, the greater the contrast in value.

CONCEPTS TO REMEMBER

- [] Color works with the elements of design—space, line, form/shape, texture, and light—to create the desired visual effect.

- [] We must be very aware of the changes in color that help us to depict an illusion of space. Values of color can determine the relative position of an object in space; and value placement and sequencing of imagery impart this concept. The overlapping of transparent objects in a composition, and the degree of space formed between these objects, relies on careful modulation of hue and value. Translucency weakens the color of the non-transparent material that lies beneath the translucent image. Cast light creates a film of color change across a surface. This film will weaken as the light moves farther away from its source. Presentation of a work is most important: attending to the proper color usage of mat and frame color for two-dimensional works and surroundings for three-dimensional works.

- [] Outlining serves to delineate objects from each other, halt color interactions, and allow a color to remain stable. Use of the five types of color outlining can also help to create space. Different color combinations are legible to different degrees. Where surfaces of colors meet lines are created.

- [] When working with any type of texture one must first determine the surface color of the image as well as the surface colors that are being reflected on to any surface. From these basic color choices, the nuances of value, intensity, and temperature are imposed upon the imagery to determine the desired visual texture effect.

- [] Shading is dependent upon light and one must think about the light source so that shading is convincing. Light also creates space and to this end the values used within a piece must satisfy the desired spatial illusion. The light in which a piece is presented affects how the color is perceived.

Exercises

1. Do a composition incorporating a background. Render the same composition three ways: (1) background light, (2) background dark, (3) background middle value. Refer to figure 10.1.

2. Do a composition that shows transparence and equivocal space. You may use any color medium. Refer to figures 10.6 and 10.7.

3. Do a composition that shows translucence. Refer to figure 10.9.

4. Do a composition showing film color usage. Refer to figure 10.11.

5. Do a composition showing volume color and film color usage. Refer to figure 10.10.

6. Do two identical compositions, one that has no outlining and one that utilizes at least three different types of outlining. Refer to figures 10.13 and 10.14.

7. Do a line composition that incorporates value by changing the line quality. Refer to figure 10.16.

8. Do a composition in color using chiaroscuro. Refer to figure 6.4.

9. Do a composition that contains areas of the same hue, some that impart smooth texture and some that impart rough texture. Refer to figure 10.17.

10. Do a composition showing the reflection of color onto a surface. Refer to figure 10.19.

11. Render a surface as being a metal surface. Refer to figure 10.20.

12. Render an object with varying light sources: from the front, from the side, from the top, from the bottom, from the back, and from within.

CHAPTER 11
Color Interactions

We know that every color is seen only in relationship to another color or colors. Therefore, one must be able to predict how a color will be influenced or changed by its surroundings.

Twentieth-century art broke down conventional barriers in art. Both Futurism and Cubism abandoned the concept of backgrounds and positive/negative space relationships in favor of having the beholder move in and out of space randomly as the work is viewed. To accomplish this one must experiment with the effect of light and dark values on each other and the whole work to impart the desired visual reaction.

AFTERIMAGES

Hues all have afterimages. These afterimages affect adjacent colors, especially white. A white surrounded by hues cannot easily remain white. Let's say we have a red circle on a white background—the white will take on a blue-greenish cast because green to blue-green are the hues that red afterimages; they are red's complements (**fig. 11.1**).

Successive Contrast

Successive contrast is the afterimage reaction that colors impart when the eye views them one after the other. What happens is that as the eye moves rapidly

(a) (b) (c)

(d) (e) (f) (g)

11.1 Afterimaging. The negative afterimage of each big circle seen against a white background will be a pale version of its complement, which can be seen in the smaller, surrounding circles: (a) yellow and pale blue-violet; (b) red and pale blue-green; (c) violet and pale yellow-green; (d) blue and pale orange; (e) green and pale red-violet. The negative afterimage of gray against a white background (f) will be a paler gray, and of gray against a black background (g) a darker gray—again, as seen in the smaller, surrounding circles.

across a work it sees not only what it is viewing but the afterimage of the color previously seen.

We have two types of afterimages—positive and negative. When the afterimage is the same as the color viewed it is termed a **positive afterimage**. A positive afterimage usually occurs on immediate observation and is the result of different colored lights. When the afterimage is seen as the complement of the observed color area it is termed a **negative afterimage**. A negative afterimage occurs immediately after a color is observed and requires more than an instant glance. It also occurs when viewing strongly colored surfaces and in this situation the reaction is more immediate.

The eye "looks for" the complement of any color it sees, and this phenomenon serves as the basis for successive contrast and simultaneous contrast. The complements that we see are those shown on the Munsell wheel. We know that each pure hue "demands" its opposite and that if this hue is absent the eye will produce it, so that any adjacent hue will be tinged by its complement. In short, the adjacent hue will take on a tonality of the afterimaged hue. If two hues of extremely contrasting light and dark value are placed next to each other, as they move away from each other the light hue grows darker and the dark hue grows lighter. This interaction occurs only when hues are used; black-and-white images do not diminish each other because they are neutral colors.

Since a hue afterimages its complement, a yellow object seen on a white background will make this background bluish. A yellow object on a green background will cause the green to be bluish-green and the yellow to be very cool. Also note that white will afterimage black, and black will afterimage white: afterimaging is the result of color seeking its opposite. However, if we outline an area in black or white the afterimage effect is reduced or completely stopped. This becomes especially important when dealing with like or related hue areas. In order for the closely related hues to remain individual, black or white outlining must be used. Without this outlining the variations in hue will cause a feeling of depth because of visual fusing. When white or black outlining is used, it absorbs the afterimaging that occurs and allows the adjacent color to be unaffected. Keep in mind that only pure hues and their light or dark tints will impart an afterimage.

Broken colors and broken hues will not afterimage because they contain some of all the hues of the color spectrum.

Middle grays or neutral colors are the most strongly influenced values. A middle-value gray or neutral will make hues adjacent to it appear stronger; in addition, the gray or the neutral will become tinged with the complement of the hue. Therefore, a hue surrounded by gray will seem more colorful. When one attempts to change gray, the area covered plays an important part. When the gray is a large area surrounding a small area of pure hue, the gray will not change because there is not sufficient pure hue to impart a strong enough afterimaging effect. The smaller the area of gray, however, the more easily it will be influenced or changed (**fig. 11.2**).

Two or more hues are harmonious if their mixture yields gray or a neutral. An example of this can be seen at the middle mixture of an intensity chart (see fig. 7.3). Combinations that do not yield gray or a neutral have greater impact and visibility. Thus complementary combinations are harmonious because their result is neutral or gray. This fact makes sense because when complementary hues are employed, the color spectrum, from the eye/brain's point of view, is completed—nothing is missing, and this is what the eye seeks. Hues can be made harmonious by surrounding them with a neutral. When working with afterimages keep in mind that the reaction spreads to only a limited area. Therefore, quantity of color area plays an important role. The quantity of the color that is afterimaging must be larger than the influenced area.

SIMULTANEOUS CONTRAST

The eye requires the complement of any color it sees, and this imposition and enhancement of color onto an adjacent area of color is known as simultaneous contrast. If we have green next to gray, the gray becomes reddish gray. Simultaneous contrast can also affect shading. Successive contrast is concerned with afterimaging of hues; simultaneous contrast is concerned with the interactions that occur between hues, broken hues, and neutrals.

The eye compares colors with their surroundings and in the process colors are affected by these surroundings. Simultaneous contrast is the result of afterimaging and we may predict these afterimaged hues by equating them to the complementary pairs on the Munsell color wheel. When we do this we note that the same color will appear differently when it is surrounded by different colors. As with successive

11.2 The influences on gray. This composition shows how small areas of gray can be subtly influenced by larger areas of a surrounding hue. The grays on the shirts moving from left to right have taken on yellow-green, blue, and red tinges respectively. Courtesy Elaine Brodie.

contrast, outlining halts the simultaneous contrast effect by creating closed areas and serving as a barrier between color boundaries. Interactions can also be stopped by adding the afterimaging hue to the color that is being influenced. Even a slight addition will usually work.

Achromatic Simultaneous Contrast

There are two types of simultaneous contrast—achromatic and chromatic. **Achromatic simultaneous contrast** concerns itself with black, white, and grays. We find that when grays are placed on black or white backgrounds their value undergoes a change. Middle-value gray is darker on a light background and lighter on a dark background (see fig. 6.7).

Light values, as well as hues, will appear lighter on a dark ground. When gray is placed on a white surface it appears darker, and in fact a value surrounded by a lighter value will always appear darker and vice versa. Black makes adjacent hues appear lighter. When we put white on a black ground we find that the white area appears to be larger than a black area on a white background because white spreads and black, by contrast, contracts.

White weakens the luminosity of adjacent hues, making them appear darker. Red is relatively dark on white, warm and luminous on black. Blue on white appears darker and the white becomes brighter, while blue on black makes the blue appear more brilliant.

Chromatic Simultaneous Contrast

Chromatic simultaneous contrast concerns itself with hue changes that occur due to the influence of the surrounding hues. Here similar concepts apply to those we have noted in our discussion of achromatic simultaneous contrast.

If one is knowledgeable about simultaneous contrast, it is possible to make colors behave in predictable ways. If, for example, we wish one color to behave as or appear to be two colors we should present it against two different backgrounds and make it a middle mixture of the two backgrounds. The separate areas of this "comparative color" should not be placed close together and should be rather small for the effect to work: if they were close together they could be more easily compared and seen to be the same (**fig. 11.3**). Now we see that the artist no longer has a limited palette of colors. A hue or color can be altered by placing it within another color ground. What color ground you use will depend on how you wish your hue or hues to change. This interaction is based on the fact that a surrounding color will subtract itself from any hue that appears on it. If we put orange on a yellow background and a red background, it will appear to be redder on the yellow ground and yellower on the red ground. This is because, in the first instance, the yellow is subtracting the yellow from the orange, resulting in a reddish orange; and in the second, the red is subtracting the red from the orange, resulting in a yellowish orange. Be aware that the color mixtures must be a middle-value mixture as well as a hue mixture.

It is also possible to make two different colors appear to be the same color by placing them on two different, carefully chosen colored grounds. This interaction is also based on subtraction (**fig. 11.4**). Using the same yellow and red backgrounds, for example, it is possible to have a yellow-orange on the yellow ground and a red-orange on the red ground appear as the same color when their mixtures are correct. Here the colors are mixtures of the grounds but favor one or other parent. The mixtures used depend not only on the hue mixtures but their values as well.

The important point to remember here is that if you wish a hue or color to remain the same throughout a work, the grounds—the adjacent hues or colors or the surrounding hues or colors—must remain the same. When this is impossible, outlining should be used instead.

When working with intense versus less intense hues, the most intense color dominates and washes over the less intense color. If we put an intense or pure red

11.3 (*left*) One color like two colors. In order for the small circles within each pair of large circles to appear different from each other in color, their color must be an *equal mixture* of the colors of their large circles (as shown in the single small circles below).

11.4 (*right*) Two colors like one color. In order for the small circles within each pair of large circles to appear the same in color, their color must be an *unequal mixture* of the colors of their large circles (as here shown in the pairs of single small circles below).

on a dull green, the red will become more intense. Conversely, if we put a dull hue on an intense background it will appear less intense—it becomes duller (see fig. 7.9). It must be noted that when a shade is put on a pure hue, the pure hue will subtract itself from the shade, changing its appearance.

Bezold Effect

A nineteenth-century rug designer, Wilhelm von Bezold (1837–1907), found that he could alter the entire appearance of his rug designs by simply changing a single color. This concept became known as the **Bezold effect**. Ralph M. Evans termed this color interaction the "spreading effect." When black or white or a pure hue (at full intensity) are used in an even distribution throughout a composition, the changing of one results in a completely different perception of the composition overall. When white is employed the entire composition seems to take on a light tonality, since the white seems to "wash" over the area. Black produces a darkening

11.5 The Bezold effect. The yellow and orange colors are the same in all three compositions. The completely different effects created in the left-hand and middle examples by the simple addition of one extra color (in this case black and white respectively) is known as the Bezold effect. Courtesy Danielle Pompeo.

tonality. Therefore, the use of a naturally light pure hue will impart a light effect and vice versa. We find also that light-value areas seem larger than when they are rendered in a dark value (**fig. 11.5**).

When unequal quantities of hues are employed, the greatest and most dramatic Bezold reaction occurs when the dominant color used in the composition is changed. Dramatic change also occurs when a contrast between hues and values of hues is present. The Bezold effect is most useful to interior designers when working with fabric, wallpaper, and rug designs. A review of the concept of orders in the chapter on value (pages 45–48) will greatly help in implementing this effect.

OPTICAL MIXING

Optical mixing is the result of two or more colors mixing visually to "become" another color. Optical mixing may most usefully be employed to expand a sometimes limited palette. It also allows one to impose luminous or glowing effects on a work.

Equal values of hues will visually merge and form visual mixtures. The lighter the value and the more contrasting the hue combination, the more difficult it will be to obtain an equal value merging. Similar or analogous hues can also merge, especially if they are close in value. These visual mixtures are usually brighter than the brightest of the hues that are being visually mixed. These mixtures usually appear to be lighter in value as well.

When complementary hues are used the simultaneous contrast effect is not in play; the hues will not change but simply intensify each other, and a more intense color line of each of the hues will appear to form at their juncture (see fig. 7.4). When these complements are the same value they will impart a vibrating effect, and a black line will appear to form where they meet.

As opposed to the actual mixing of pigments, the separate colors in optical mixing are set side by side, and the eye blends or fuses them. This is termed **divisionism**. Divisionism, which can be executed with parallel lines or crossed lines of different hue as well as with dots, often has a ground beneath the colors other than white. Divisionism done in dots of color always has

a ground other than white (**fig. 11.6, 11.7**). When dots of color are used on a white ground, the divisionism is known as pointillism. In either case, the backgrounds alter our perception of the colors on them. Divisionism is the result of simultaneous contrast and optical mixing; pointillism is the result of optical mixing. The artist must be aware of the fact that "dots" can be individual shapes and do not have to be small circles (**fig. 11.8**). To achieve good results we must keep a number of factors in mind:

- the Munsell color wheel—here we are concerned with what happens when colors are placed side by side
- the value of the hues employed
- the intensity of the hues employed
- the quantity of the hues employed
- the viewing distance and lighting conditions.

When dots of hues are used, they tend to fuse together visually and take on a gray cast. Pointillism, a term derived from a Post-Impressionist art style in nineteenth-century France, is most often seen in the works of Claude Monet, Georges Seurat, Paul Signac, and most recently Chuck Close and Arthur Hoener

11.6 Optical mixing as divisionism. The artist has painted red, orange, blue, and white dots onto a flattened broken-red, black, and broken-yellow ground. The outline in white dots helps to silhouette the figure. Courtesy Deborah Scott.

11.7 Georges Seurat, *Sunday Afternoon on the Island of La Grande Jatte*, 1884–86. Oil on canvas, 81 x 121 in (207 x 308 cm.). Art Institute of Chicago. Helen Birch Bartlett Memorial Collection. Seurat created his pointillist painting by scientifically choosing colors and building up layers of dots. In the process he intensified contiguous hues and allowed the eye to fuse the separate dots into broad areas of color. The result is a rich and shimmering painting.

11.8 A pointillist composition. The artist uses the three pure hues of yellow, red, and blue as repeated dots against a white background. Different combinations of the pure hues reveal colors such as red-violet, orange, blue-violet, and green. Courtesy Elly Madavi.

(figs. 11.9–11.10). Pointillist pictures have white backgrounds. When dots of analogous colors (those adjacent to each other on the color wheel) are juxtaposed, luminosity and new hues result. When dots of complementary colors are used the resulting colors are luminous gray mixtures. The color dots that the Impressionists used were usually pure hues (see figs. 11.6, 11.7, 11.8, 11.9, and 11.10).

When working in these styles keep in mind that the proportions of the hues used impart a variety of optical fusing effects. The proportional use of color is, therefore, important. If two hues are of equal intensity, reduce the quantity of the warmer of the hues. Red and green are equal in their proportional notation, therefore the red, as the warmer, would be used in a small quantity. If two hues are of unequal intensity, reduce the quantity of the brighter. Yellow has a notation of 9 while violet has a notation of 3; therefore

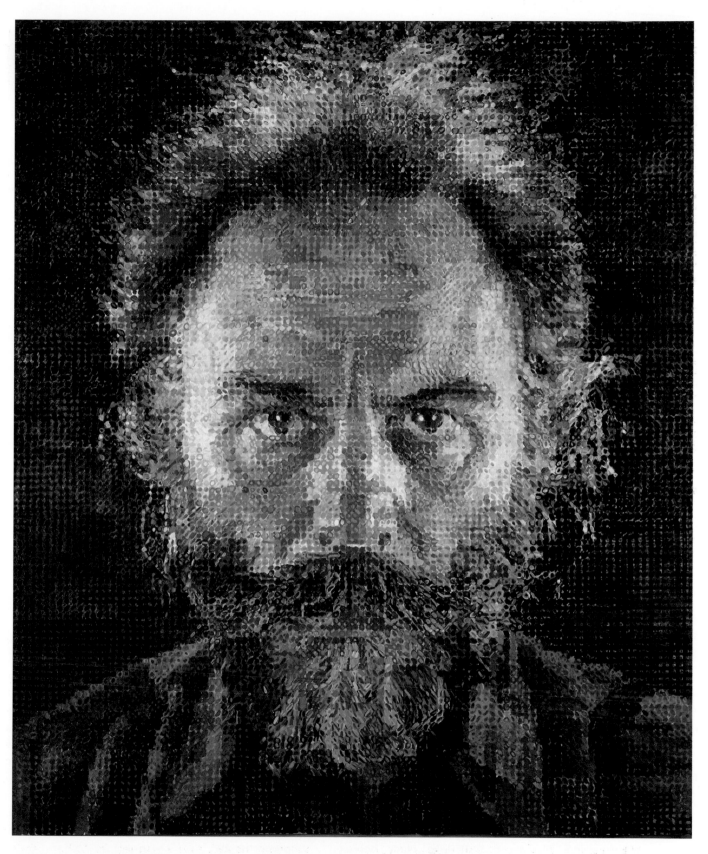

11.9 Chuck Close, *Lucas I*, 1986–87. Oil on canvas, 100 x 84 in (254 x 213.4 cm). Metropolitan Museum of Art, New York. Purchase. Gift of Lila Acheson Wallace and Gift of Arnold and Milly Glimcher, 1987. The direction of the elliptical "dots" imparts texture to the composition. As the distance between the viewer and the painting increases, so the optical mixing will become more apparent.

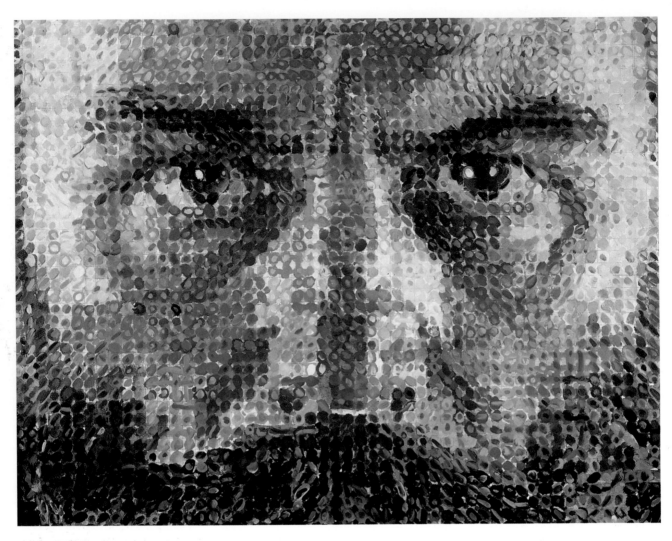

11.10 Detail of 11.9. Close divides his imagery into a grid system, which he then fills with colors. Over those colors he paints elliptical shapes consisting usually of two other colors.

the yellow, as the brighter, would be used in a smaller quantity. The complementary pair of hues that are both the same brightness and are neither warm nor cool are green and red-violet. These can be used in equal quantities in optical mixing.

Let's look at what happens when we place two complementary hues from the Munsell wheel next to each other. We know that hues afterimage their complement. As a result, we can often observe a third color appearing along the abutted edges of the two hues after staring at them for more than thirty seconds. Remember, these should be pure hues, not broken; the afterimaging illusions cannot take place between broken hues since they contain all the components of the spectrum (see fig. 7.4). We also know that if two complementary hues are of the same or similar value a

vibrating illusion will occur. Along with this reaction we should see a third line of color appearing at the juncture of the two hues. Let's say we use yellow-green and a light-value violet; the resulting color will be a blue that tends toward cyan. Orange and light blue will impart a light-value violet. The remaining Munsell complementary pairs will form a black line which will have a shimmering, luminous effect. Optical mixing occurs because the brain wants to get rid of the disturbing effect of the **visual vibration** and creates an outline to half the vibration effect. This reaction works best when the quantities of color used are disproportionate.

Another approach to optical reaction was taken by Josef Albers in his "Homage to the Square" series (**fig. 11.11**). Albers often worked with analogous hues.

The analogous grouping of orange, red-orange, and red gives us a parent hue of red for this grouping. If we were to use blue and green we would end up with a blue-green as the "middle mixture," so our analogous grouping here would be blue, blue-green, and green, with blue as the parent hue. Albers used this middle mixture concept to enable colors to **interpenetrate** each other. Let's suppose we had a square of red-orange within a square of red that is within a square of red-violet. The red square will form a band around the red-orange, but where the red (which is the middle mixture) meets the red-orange an illusion of red-violet will appear along the edge, and where the red meets the red-violet an illusion of red-orange will appear along the edge. Here the laws of color subtraction are put into play. The color seems to be subtracting its own color from adjacent colors. We find that value comes into play here too. The middle mixture of a light value and a dark value will be a middle value. If we have a dark-value square (black) on a middle-value square (middle-value gray), which in turn is on a light-value square (white), we find that where the middle-value gray outlines meet the white a dark outline will be visible, and where the middle-value gray meets the black a light outline will appear. Albers felt the quantity or area size of a color had a bearing—it must be considerable for interpenetration to happen.

Up to now we have dealt with *areas* of color next to each other. Now we will look at what happens when *lines* of color (divisionism) abut and/or intersect and *dots* of color (pointillism) are placed on or near each other. We obtain reactions only when these compositions are viewed from a distance. When unlike colors are placed near or on each other the resulting retinal fusing gives us a new color (see figs. 11.6, 11.7, and 11.8). The degree of believability of these newly formed colors is dependent on how close in value the two hues are. The closer the value is, the more credible the change. The ground hue that is beneath the hues should be light—white or close to white. Let's look at yellow and blue. Used at full intensity we find the yellow to be very light while the blue is dark. On a white background the blue takes over and the mix is not very obvious. However, if we discord the blue (reverse its natural order and make it lighter) we find that the optical mixing produces a yellowish green. Yellow and orange, on the other hand, mix very readily because they are naturally close to each other in value at full intensity. Quantity of color has a great bearing on this reaction—the quantity should be close to equal and in very small amounts that are repeated. The

11.11 Josef Albers, *Study for Homage to the Square,* 1968. Oil on masonite, 32 x 32 in (81.3 x 81.3 cm). The Sidney Janis Gallery, New York. In his *Homage to the Square* series, Albers explored the effects of interpenetrating colors. He carefully developed combinations of analogous hues. As he progressed with the series, he employed more contrasting colors.

illusionary colors obtained from optical mixing have a luminous quality. This luminosity was the desired effect that the Impressionists found they could not achieve with pigment mixture.

As we pair hues with every other hue around the wheel we find some strange things happening with certain combinations. Arthur Hoener took this premise and applied it to his work. Like the color theorist Harald Kueppers, he proposed orange, green, and violet as primaries instead of the familiar red, yellow, and blue. He found that orange and green optically mix to produce yellow, green and violet produce blue, and violet and orange produce red. Hoener termed this optical mixing system **synergistic color**. However, the optical mixing with synergistic color relies on the proportion of the colors used. The new color or hue will be the result of the two hues visually fusing and this hue will tend to the hue that is in the greater quantity. The interaction occurs most easily when the two hues used are similar or equal in value, and when the two are light in value strong visual fusing occurs. This interaction also depends greatly on the ground color. If we put dark

hues on white they will appear to be almost black and literally lose their color identity. If we put a medium-value hue on white, the hue stays stable and simultaneous contrast is the result. When a light-value hue is on a white ground the eye reaction is diminished and the color becomes energized. However, when light values and medium values are placed on a gray background the synergistic color interaction is at its best (see figs. 11.6, 11.8 and 11.9).

Phantom colors result from spreading color that tint neutrals with their hue. This interaction works best on a white background. The white ground will become a pale value of the hue, thus creating a phantom color. The phenomenon is most dramatic when lines of hues have a rough or serrated edge and there is little space between them. For this effect the colors must be repeated across the area (see fig. 11.8).

Optical mixing of colors can change the appearance of a background. The more a background surface is fractured by another color, the more it is altered. Therefore, if we use dots of one hue in one area and dots of another hue in another area, the backgrounds of the two areas will appear different, even though they are the same.

CONCEPTS TO REMEMBER

☐ Every pure hue afterimages its complementary hue and thus tinges any adjacent color with this afterimage. These interactions are based on Munsell complements. Afterimaging, or successive contrast, can be halted by the use of outlining, which allows the pure hues to remain individual.

☐ Simultaneous contrast occurs when colors interact with each other, changing colors that are side by side. Outlining halts such interactions in a partitive setting, as does the addition of Munsell complementary pure hues.

☐ The two types of simultaneous contrast are achromatic and chromatic. As simultaneous contrast is based on subtraction, knowing the components of a color allows us to predict what will be subtracted from that color and the degree of change that will occur both in color appearance and value.

☐ The Bezold effect can allow for the same hues in a composition to impart a different visual result when one hue is changed in ensuing identical compositions.

☐ The interaction that occurs from optical mixing of colors relies on the values of the colors employed, their relationship to each other on the color wheel, their intensity, and the quantity employed. The effects of visual fusing can be predicted by employing the concepts of simultaneous contrast, especially when attempting to achieve divisionist effects.

Exercises

1 Do a composition consisting of gray and a hue or hues so that the gray appears to be a color other than neutral gray. Refer to figures 11.1 and 11.2.

2 Do a composition in which one color appears to be two. Refer to figure 11.3.

3 Do a composition in which two colors appear to be the same. Refer to figure 11.4.

4 Using the same design, render it in three colors identically, except that the third color in one is black, in one it is white, and in one it is a third hue or color. Example: (1) red, green, black; (2) red, green, white; (3) red, green, blue. Refer to figure 11.5.

5 Do a non-objective composition of lines, dots or marks that employs optical mixing. Use a maximum of three hues.

CHAPTER 12
Color and the Effects of Illumination

Color is the result of light, and different types of illumination—sunlight, twilight, candlelight, strip lights—create different color effects. This chapter examines how different effects of illumination—the creation of shadows, changes in time and the weather, the appearance of luminosity, iridescence, and luster—can be conveyed in art works.

As we have seen in our discussions of value, light-value compositions impart feelings of illumination. Indoor and outdoor lighting has a great bearing on values and hues. Different lighting conditions affect hues in many different ways. Red, orange, and yellow appear darker in reduced light, while blue and green look lighter. Black takes on a gray appearance in bright white light or daylight. In strong light, lighter pure values seem more intense; in dim light, dark-value pure hues seem more intense. Keep this in mind when selecting the values for a work. Also keep in mind that fluorescent light not only distorts intensity but the actual hue as well. View your work in both intense and reduced light to make sure it still imparts the reactions desired.

SHADOWS

To begin our discussion of shadows, we must first take a look at what shadows do to aid our perception of an object. Their most apparent function is to transform a shape, which is flat, into a solid object. While outlining can visually impart volume, it does not offer further information concerning light sources or the density of the object. To obtain this information we must add the detailing that shading and shadows provide. We have already seen how chiaroscuro accomplishes this (see page 41). Shadows also allow the artist to define space and spatial relationships as well as to create a mood. When working with shadows we must be aware of the fact that they are created by the absence of light. The depletion of light can be in various degrees, from deep to pale shadows (**fig. 12.1**). We also need to understand how the light angles affect the shadow angles, and how shadows are cast onto neighboring images and objects.

For the rendering of shadows to be believable, the color changes that occur must match reality. For example, the shadow takes on the complementary

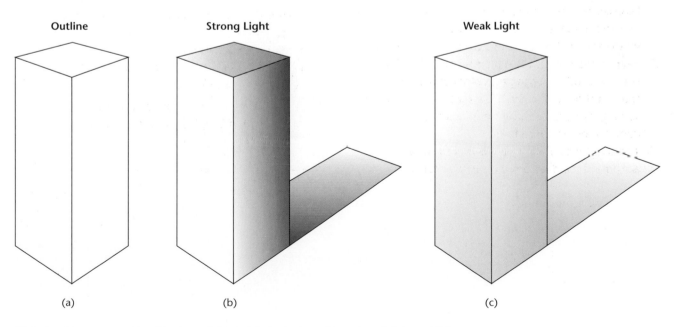

Outline	Strong Light	Weak Light
(a)	(b)	(c)

12.1 An object as an outline (a); strong light and deep shadows (b); and weak light and light shadows (c). We perceive volume in (a), while in (b) and (c) we detect volume, light source, texture, density, space, and mood in different degrees.

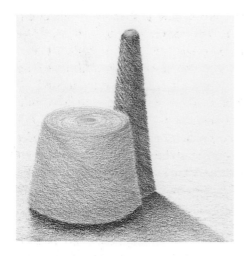

12.2 Light and shadow. The shadow hue (blue-violet) has been chosen as the complement to its ostensible light-source hue, yellow. Courtesy Marianne Hauck.

color, from the Munsell color wheel, of the illuminating light. Hence yellow sunlight will result in shadows with a blue-violet tonality (**figs. 12.2** and **12.3**). This tonality must then be combined with the surface color that they are filmed over as well as the reflective colors of the objects. So the shadow cast by a red object must contain the complement of the red—which should tend toward the red parent—as well as the color of the surface the shadow is resting on and the complement of the illuminating hue. A red object resting on a blue table would cast a shadow that would contain red plus blue-green plus blue plus orange. The more light that hits an object, the more the color of the surface will appear or favor the pure hue or the pure hue plus white. When the light is strong the shadow will be most like the complement of the object casting the shadow. One may work in one of two ways to indicate the

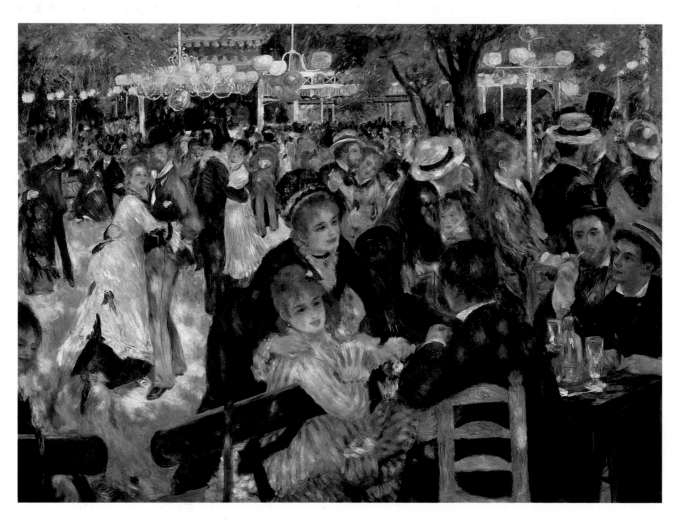

12.3 Pierre-Auguste Renoir, *Le Moulin de la Galette*, 1876. Oil on canvas, 51½ x 69 in (131 x 175 cm). Louvre, Paris. Throughout this painting, Renoir has juxtaposed the yellow of sunlight with its complement, blue-violet, for shadows. These combinations are especially noticeable on and around the dancing couple in the left foreground and on the hats of the men on the right.

shadow's color—changing the hue by physical mixing of pigments, or optical mixing.

There are various types of shadows: cast shadows, perspective shadows, texture shadows, and fabric/fold shadows. Cast shadows are the result of an object blocking the path of the light source. The type of shadow cast depends on whether the object casting the shadow is solid or transparent. A transparent object does not block as much light; the resulting cast shadow is, therefore, a subtle echo or repeat of the overall form of the object casting the shadow. In this case gentle gradations in value are used, and the cast shadow is given a hint of the color of the surface that the shadow is cast upon. One must keep in mind that the purpose of a cast shadow is to impart to the viewer not only the contour or shape of the object but also its volume.

Solid objects cast stronger shadows because by their nature they are obliterating light. Furthermore, there is generally a difference between shadows cast by man-made objects and those by natural ones. The shadow cast by a man-made object is usually hard-edged and sharply defined.

Other factors to be considered include not only the angle of the cast shadow but the strength of color used. For example, a shiny surface is indicated by wide contrasts between the object and the cast shadow.

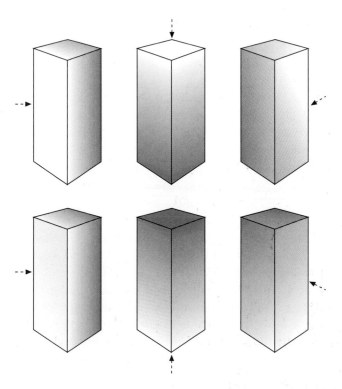

12.4 The way that shadows are dispersed around an object tells us about the source and type of light.

Lighting also affects how a shadow is perceived. Strong light that comes from overhead, such as a noon sun beating directly down, results in a shadow that is dark or heavy as well as truncated. In such cases the detailing on the object is more sharply defined. If, however, the light source is weak and coming from a low angle, such as at dawn or sunset, the shadow is not only extended but graduates from dark at the object to light at the termination of the shadow. When the light source is strong but coming from the side, the contrasts on the shadow as well as the object are weak and the shadow is composed of unevenly dispersed color (**fig. 12.4**).

An object lit from below is lightest at its bottom (closest to the light source) and gets increasingly dark toward the top. These shadows are evenly dispersed, and while detail is lost, areas in relief become powerful. This arrangement can provide a very sinister or evil effect, especially when the object in question is a human face.

Objects that are white, gray, or black cast gray shadows when they are on a white background; if, however, you wish to show that these objects are being illuminated with warm light, the shadows should take on a cool or blue tonality.

As we have noted in our study of design, perspective drawing serves to establish space within a work. In addition to having images and/or objects drawn in correct perspective, we must make sure that the same applies to the shadows they are casting. To this end, perspective shadows must be plotted by drawing guidelines from the light source across the horizon and through the object to establish how they are cast. The steps for accomplishing this are as follows:

1 Mark the position of the light source (which may be in or out of the picture plane) and note its direction.

2 Draw a vertical line from the light source to the horizon line.

3 Draw lines that connect the light source and the top of the object and extend these angled lines beyond the object.

4 Draw lines that connect the junction of the vertical line on the horizon and the bottom of the object and extend these angled lines beyond the object.

5 Plot out the correct angling of the shadow where the angled lines meet (**fig. 12.5**).

We must remember that the value of the shadow becomes lighter as it moves away from the object. Thus

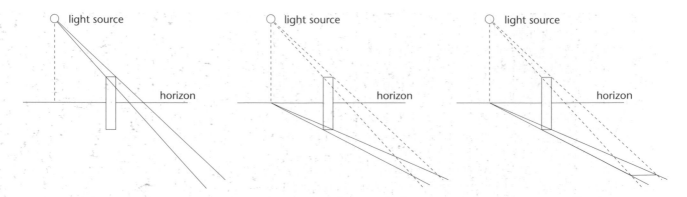

12.5 Shadow plotting steps. In order for shadows to look convincing, the steps in this diagram should be carefully followed.

the darkest values of a shadow will be found close to the object and these values weaken as the shadow moves away from the object.

Not all shadows are cast across a smooth uninterrupted plane. Often shadows form a distorted silhouette of the object. These distortions can be noted most easily by using a large number of plotting lines when forming perspective shadows. The resulting intersecting lines will provide the amount of silhouette distortion needed. If we further distort any shadow by elongating or exaggerating it we find that spatial distance is greatly increased. A change in a shadow's angle usually results in elongation of the shadow. This becomes most apparent when a shadow is cast across a flat surface like the ground and meets a right-angled surface such as a wall. In such cases we must revert to our design studies of drawing various objects on to changing grids:

1 Plot the shadow as though it were cast across a flat surface.

2 Impose a simple grid onto the shadow.

3 Draw a second grid that shows the angle of change that the shadow will go through.

4 Plot the first shadow grid image onto the second grid, thus forming the angled shadow.

Using this type of grid-plotting we see that we are able to plot shadows traveling across any type of surface, be it angular, curved, or a combination of the two, by employing rectilinear, curvilinear, or combination grids. Keep in mind that when a shadow is cast onto another object it follows the contour of that object.

In addition to depicting the shadows that an entire object or image casts, we must also be aware of the shadows that occur on the surface of that object. These texture shadows provide the additional descriptive information needed to impart the surface qualities of the object being viewed—its texture and any dips and folds seen in its form. For example, we must consider the contours of a human nose as well as the way it protrudes from the face. One good rule of thumb is that the greater the depth of a surface, the darker the values of the shadows will be.

When there is a wide difference or high contrast in the highlight on a fold, the eye tends to interpret the object as smooth and shiny. Rough fabrics would graduate more gently from the highlight to the light area surrounding the highlight. The lowest part of the fold has the darkest values and becomes lighter and lighter towards the top of the fold. The darker the value, the deeper we perceive the fold to be (**fig. 12.6**).

TIME AND WEATHER

How the time and the weather are conveyed in art works is to a great extent a function of the lighting. Time encompasses a number of situations, such as time of day (sunrise, morning, noon, sunset, night) or season (spring, summer, fall, winter). Weather also covers different categories, such as conditions (sun, rain, sleet, mist, snow) and location (Southwest, Arctic, tropics, city, country). Our memories and experiences also come into play when imposing time and weather conditions on to a work. We tend to use color in a manner that we think is familiar to us. Stuart Davis employs brilliant, intense color to express his feelings about the physical and emotional atmosphere of New York City (**fig. 12.7**). He sees New York as exciting, with hard, sharp edges and shapes. If Davis had used the color relationships that Gauguin selected for his Tahitian paintings (**fig. 12.8**), the results would appear totally foreign. We do not think of New York in terms

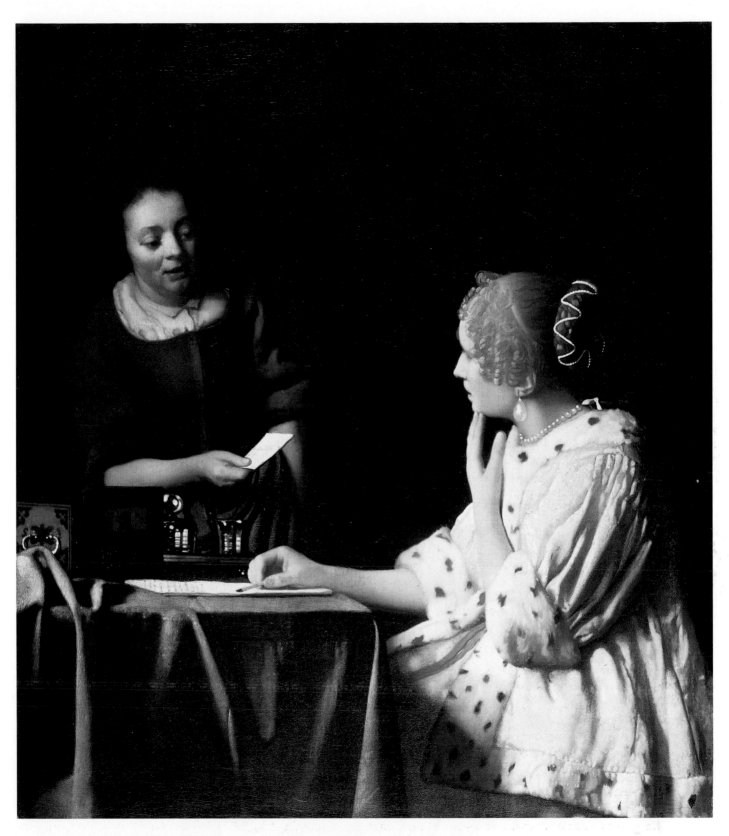

12.6 Jan Vermeer, *Mistress and Maid*, c. 1667–68. Oil on canvas, 35½ x 31 in (90.2 x 78.7 cm).
Frick Collection, New York. The folds of the tablecloth reveal progressions of dark to lighter hues
ascending from the base to the tabletop, from blue-violets to blues and grays. Similarly, the folds
of the mistress's yellow garment reveal ascending progressions from darker to lighter hues.

12.7 Stuart Davis, *New York Mural*, 1932. Oil on canvas, 84 x 48 in (213.4 x 121.9 cm). Norton Museum of Art, West Palm Beach, Florida. Purchase R.H. Norton Fund. Davis uses a number of pure hues and sharp-edged shapes to convey the excitement of New York City on a bright day. A white wavelength predominates in the sky around noon, and the amount of white showing in the "sky," against the buildings, and in the foreground suggests that this is the time of day.

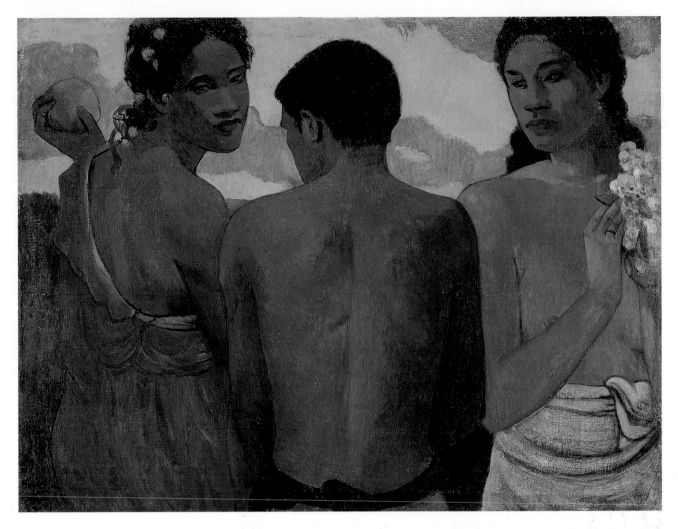

12.8 Paul Gauguin, *Three Tahitians*, 1898. Oil on canvas, 28¾ x 36⅝ in (73 x 93 cm). National Gallery of Scotland, Edinburgh. The yellow background suggests that this is a hot, dry day on Tahiti. The warm violet and red hues contribute further to that feeling of timeless luxuriance emanating from Gauguin's Tahitian paintings.

of the warm colors that Gauguin used in many of his Tahitian works.

Conditions of time and the weather change as the earth spins on its axis round the sun. The angle of the sun causes certain wavelengths to predominate depending on the time of day. Blue is dominant in the morning, going to white at noon and red in the late afternoon. Thus at dawn green and blue appear first, then a pale red appears, progressing to full-noon sun that pales colors and causes them to take on a white tonality. At dusk the blue and violet rays are weaker and red and yellow predominate, causing the clouds and sun to appear red or yellow. This in turn causes yellow-green objects to take on an orange tonality because they are reflecting the red and yellow rays. Blue and violet objects, on the other hand, appear to be darker and duller because they do not reflect the red or yellow

rays. As time moves on to sunset, red becomes the dominant hue. These changes in wavelength dominance affect the surface colors we see (**fig. 12.9**). We must be careful not to let our memory take over and say simply, "The barn is red." We must observe what happens to the red barn in morning light, at noon, and in the late afternoon. In the morning the barn will be a bluish red, at noon a lighter red, and in the late afternoon red. Remember—these conditions apply in clear daylight. You must also take into account clouds, rain, smog, and so on. Tonality plays a very important role in conveying your message.

Color is best seen in sunlight. But that is clear sunlight without any dust, smog, pollution, or water droplets (rain or snow) disturbing the light rays. This beautiful clear sunlight is probably what attracted Georgia O'Keeffe to the Southwest—colors remained

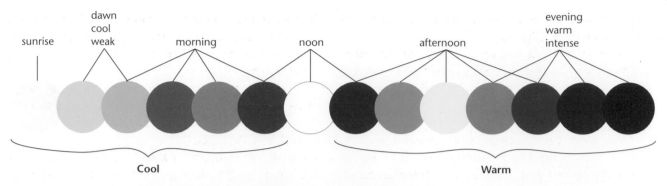

12.9 Light rays related to the time of day. Cooler green-blue colors predominate in the mornings, but warmer orange-red colors feature in the late afternoons and early evenings.

vibrant, undisturbed, and true in this unpolluted atmosphere (**fig. 12.10**). Azure (blue) and violet—both short wavelengths—are absorbed by the dust and smoke in the atmosphere, making them difficult to see in a pollution-laden sky; whereas snow will reflect these two hues, making them highly visible. Therefore, a snowy sky will have a predominance of blue and violet in it. We find that an azure blue sky is the result of little or no water present in the air and a predominance of blue and violet rays. Large particles of moisture reflect

12.10 Georgia O'Keeffe, *In the Patio I*, 1946. Oil on paper attached to board, 29¾ x 23¾ in (75.6 x 60.3 cm). San Diego Museum of Art. Gift of Mr. And Mrs. Norton S. Walbridge. O'Keeffe painted a brilliant azure-blue sky immediately over the patio and large areas of near complementary orange-brown and plain, creamy off-white throughout the painting. She emphasizes clean, geometric shapes, especially within the inner window area. The combination of flat areas of color and geometric forms convey a feeling of both atmospheric and spiritual clarity inspired by the arid Southwest.

white light, which results in the sky becoming a very pale or light-value blue sky.

Optimum daylight is not bright sunlight but rather a slightly gray day. Full, bright sunlight tends to diminish hues and the colors fade or wash out under a whitish veil. Such changes in color brightness caused by lighting variations are known as the **Purkinje effect** or Purkinje shift. Czech physiologist Johannes Purkinje (1787–1869) stated, "in moderately bright light the red zones of an object appear lighter than the blue, but in very dim light the blue zones appear markedly lighter, although colorless, than the red, which instead becomes almost black." As the light diminishes to darkness the surface will become black. In sunlight we find that red and blue have equal intensity, but as the light or illumination fades it becomes less easy to discern whether the hue seen is red or black. Blue, on the other hand, will become more visible in the diminished light. So in evening light we find that blue

is more visible than red. Diminished light has an effect on the behavior of other hues. Bright orange becomes black, yellow becomes greenish or bluish, and violet slowly changes to black.

Film color (see page 83) is used to impart the effect of weather and atmospheric conditions on to a piece.

CHROMATIC LIGHT

While simple solutions of tonality can serve to impart the sense of the time or weather that we wish to convey, we must also be aware of how colored, or chromatic, light can affect color on a surface, especially when that surface is the complement (from the Munsell wheel) of the chromatic light. Mixing yellow and blue-violet paint results in a greenish color, but mixing yellow light and a blue-violet *surface* results in a neutral, or gray. The same applies to all the Munsell complements. **Figure 12.11** indicates roughly how the Munsell pure principal hues and secondaries are

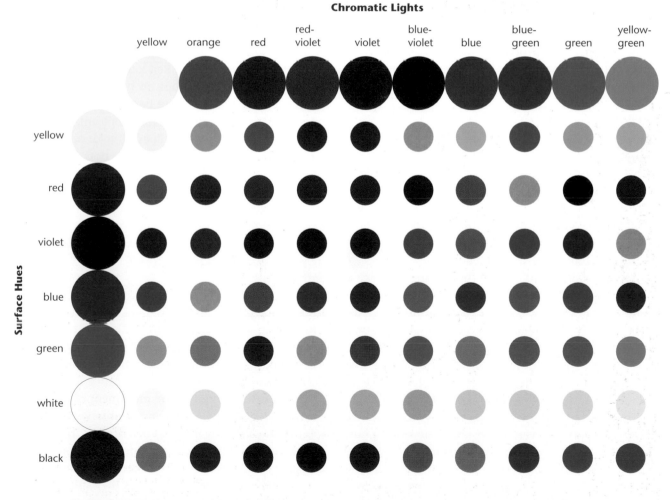

12.11 The effects of chromatic lights on different surface hues. Chromatic light mixtures change most dramatically when Munsell complements are used.

changed by various chromatic lights. It is most advantageous to make notes on how a surface color will be affected by chromatic light prior to rendering the imagery.

Keep in mind that chromatic light may have varying degrees of strength or weakness. When the chromatic light strength is very pure (strong), the surface colors will require a very strong tonality of that chromatic light for the effect to be realistic. If the chromatic light is weakened the surface color will become more predominant.

STRUCTURAL COLOR

Structural colors tell us what materials objects are made of. The same hue may take on many forms or modes of appearance—opaque, solid, filmy, atmospheric, three-dimensional, transparent, luminous, dull, lustrous, metallic, and iridescent, to name but a few. The artist tries to fool the eye into a familiar reaction or perception—it is an attempt to freeze and control one of these kinds of changing visual effects. While it is true that these visual effects could be accomplished physically using such things as metallic foils, gems, and glass, it is not always practical or desirable to do so. Therefore, one must employ techniques that impart the visual illusions or perceptions desired.

Luminosity

Luminosity—the ability of color to give a glowing impression—might be seen as the effect of sunlight on snow; it can be seen in translucent objects, in water, sky, sunsets, in certain flesh tones, the glow of silk. The Impressionists were certainly striving for luminous effects in their works, and our studies of optical mixing showed that the technique of pointillism can often (but not always) reproduce this sensation.

Simple changes in certain hues can produce a luminous effect. We find that the addition of black or white to red does not alter the fact that it is red. The same is true of blue—blue has little luminosity by itself and even the addition of a lot of white causes the blue to stay blue. Yellow, however, which is the lightest of the hues, does change its character when white is added—it becomes more luminous and radiant.

The luminous quality of a hue can be accomplished in several ways—one can, for example, surround a hue with dark values, or with its complement. Dark or black outlining can add a glowing, luminous quality to an object (see fig. 10.13). Side-by-side complementary hues intensify and produce luminosity. Luminosity works with discord when the hues are the same value.

We also find that to be luminous, areas need to be brighter than their surroundings. So contrasts between dull (less intense color) and pure hues will produce luminous effects. This should have become apparent from your broken hue compositions. We can set out the following method for achieving luminosity in a composition:

1 The area to be luminous must be smaller in size than its surroundings.

2 The area must be done in lighter values than those of its surroundings.

3 The highlight is the lightest value in the composition and the area is graduated in value from the lightest value.

4 None of the values used in the luminous area should be in great contrast to each other. Deep values should be avoided.

5 The tonality of the area must appear to pervade the whole composition, as though such a light were casting its sheen upon the whole of it (**figs. 12.12–12.13**).

White weakens the luminosity of adjacent hues and makes them appear darker. Red looks darker on a white ground, warm and luminous on black. Blue on white appears darker and the white becomes brighter, while blue on black makes the blue more brilliant.

When, as in divisionism, lines of color abut and/or intersect, and when, as in pointillism, dots of color are placed on or near each other, we should view them from a distance to obtain the correct reactions. The colors resulting from this type of optical mixing will have a luminous quality. The mechanics of this form of luminosity have been explained above (see pages 97–101 and figs. 11.6, 11.7, 11.8, 11.9, 11.10, and 11.11).

Iridescence

Iridescence—a shimmering impression—is the second of the structural effects that we will explore. We think of iridescence in terms of opals, mother-of-pearl, soap bubbles, and butterfly wings. Iridescence involves the play of colors triggered by the movement of the object being viewed or by a change in the observer's position. It is usually caused by **interference of light**, but also by **refraction** and **diffraction**. An iridescent color appears to glitter with different colors according to the angle of vision, whereas standard colors look the same from any angle. In fact iridescence results from layers of color, and glazing can therefore be used to accomplish this effect.

Luminosity with Neutrals	**Luminosity with a Single Hue**	**Luminosity with Multiple Hues**

12.12 Achieving luminosity with neutrals, a single hue, and multiple hues. By graduating the gray and blue values from dark to light in versions (a) and (b), and by contrasting a bright but small area (white) with a dark but big one (dark-gray; dark-blue), the white circle and its nearest values become luminous. In version (c), although the small yellow area and the large green one constitute analogous hues, there is luminosity at the center through the strength of the yellow-white combination.

12.13 Claude Monet, *Le Soleil dans le Brouillard*, 1904. Oil on canvas, 25 x 36 in (63.5 x 91.4 cm). Lefevre Gallery, London. Monet achieves luminosity by contrasting the intensity and lightness of orange with its darker and less intense complement, blue; rendering the sun and its reflections much smaller than the surrounding sky and sea; graduating the values of the sunlight from yellow-orange through to red-violet; and spreading the violet effects of the sunlight throughout the sky and sea.

12.14 Iridescence in nature. The artist achieves a sense of iridescence by employing a gray–light blue–dark blue background; outlining the butterfly in gray; highlighting its lightest areas in whites or off-whites; and silhouetting it against the darkest values in the background. Courtesy Deborah Scott.

The largest challenge facing the artist is to reproduce this shimmering effect within a static framework.

Hues must have white added to them to achieve iridescence. The resulting tints, or so-called pastels, are associated with this effect, but require a gray field in order to work. The gray field is necessary because gray can (and often does) intensify a hue. (White is too strong and offers little contrast to pastels; black is too weak and offers too much contrast.) The largest area of the composition should impart an illusion of mist, which is accomplished by lightening and graying color. The hues placed on the field must be fairly close in value so that no great contrast exists. Using adjacent or analogous hues will further enhance the iridescent effect. Think of the green, blue, and purple hues in peacock feathers; and red hummingbirds that flash orange and violet. Broken hues generally do not achieve this effect.

One formula for accomplishing iridescence is as follows:

1 the background is light gray or a hue equivalent in value;

2 the light area of the object is pure white or a very light value of a hue;

3 the object is outlined in mid-value gray or a hue equivalent in value;

4 the area within the object is graduated in value from white to mid-gray or equivalent hue values (**fig. 12.14**).

Luster

Luster is the impression given by subdued light. The effect of luster can be seen by comparing various materials—silver is more lustrous than pewter, silk or satin is more lustrous than felt, polished wood is more lustrous than unfinished wood. To achieve this effect the artist needs to employ a dark field. When a dark field is used, the colors on top must appear to be very bright. Our previous study of color has shown us that when a hue is pure (when nothing is added) it is at its brightest. Luster can be easily created by contrasting pure hues with dark fields, which will make the hues appear brighter than normal. The effect becomes even more pronounced when the pure hues are surrounded by darker tints (pure hues with black added). In this situation the pure hues will appear to be brighter than they actually are and can take on a shiny, metallic quality. Luster also becomes more pronounced when the lustrous area comprises a relatively small part of the composition.

An arrangement of values that would result in luster could be similar to the following:

12.15 Bruce Nauman, *The True Artist Helps the World by Revealing Mystic Truths*, 1967. Neon window or wall sign, 59 x 55⅛ in (150 x 140 cm). Kröller-Müller Museum, Otterlo, The Netherlands. Nauman achieves luster by employing the pure hues of red, orange, and blue against the black background, and by allowing the properties of neon to reflect the hues off the wall so that they take on graduated light-dark values. The effect is one of tension between color trapped within a black vortex yet simultaneously defying and illuminating it.

1 the background is medium dark gray;

2 the highlight is pure white;

3 the object is outlined in black;

4 the area within the object is graded in value from white to black (**fig. 12.15**).

CONCEPTS TO REMEMBER

☐ Shadows define the space of a composition and are capable of turning a flat shape into a three-dimensional object. There are various types of shadows: cast shadows, perspective shadows, texture shadows, and fabric/fold shadows. Shadows should contain the complementary (Munsell) colors of the object casting the shadow. The source of the light hitting an object influences the shading of an object, and the resulting shadows should be plotted to produce convincing results.

☐ An object's color does not remain constant; it is affected by time of day and weather. These conditions must be conveyed to the viewer of any work to provide the desired message. As the time of day progresses, the tonality of color added to the imagery's surface color also changes—cool in the morning, warm in late afternoon and evening.

☐ Chromatic or colored light is imparted by using a color mixture that changes the surface color of an image.

☐ Luminosity imparts a glowing effect or impression. This can be accomplished in a number of ways, for example by surrounding a hue with darker values, or with its complement.

☐ Iridescence imparts a glittering, shimmering impression. This effect can be accomplished in a number of ways, such as glazing, layering, using pastel colors on a gray field, or grading the area in value.

☐ Luster imparts the impression of subdued light by contrasting brightness against a dark field, and by grading the object in value.

Exercises

1 Do a composition involving volume shading and shadows.

2 Choose an object and render it under five different conditions. These may be five different times of day, different types of light, or varying weather conditions. Label each.

3 Do a composition that imparts a time condition.

4 Do a composition that imparts a weather condition.

5 Using the same composition, render it under three different chromatic light conditions. Refer to figure 12.11.

6 Using the same composition, render one achromatically and one chromatically imparting the sensation of luminosity.

7 Using the same composition, render one achromatically and one chromatically imparting the sensation of iridescence.

8 Using the same composition, render one achromatically and one chromatically imparting the sensation of luster.

Part IV The Influence of Color

Color's most important functions are to
provide visual and psychological information,
and to generate reactions from a viewer.
To this end, the artist, architect, or designer
can provoke various responses and so become
the controller of what that viewer perceives.

Man has historically represented intangible
aspects to life with tangible imagery. An artist
can influence a viewer's response very strongly
through the use of color symbolism in religious
imagery and in imagery reflecting nationalistic
or cultural concerns.

Technological progress has accustomed us
to superior color imagery wherever we look.
We want to like what we see and technological
breakthroughs have provided us with a visual
utopia to match our dreams and desires.

Opposite: Childe Hassam, *Allies Day, May 1917*,
detail, 1917 (see also fig. 13.7).

CHAPTER 13
Color Symbolism

A woman is wearing white for a special occasion. Where is she going? In a Western country, she'd be the bride at a wedding; in Korea, she'd be at a funeral. In China, brides wear red. The bride in Jan van Eyck's Renaissance painting *The Arnolfini Wedding* (see fig. 14.5) wears green—a symbol of her fertility. Color provides both visual and psychological information. But in different cultures, colors can have different meanings. Artists and designers can control what the viewer perceives, but must always be aware that they could sometimes be sending the wrong messages.

Some colors seem to convey universal truths, and have been codified by organizations such as the Occupational Safety and Health Administration (OSHA) of the US Department of Labor. Yellow, for example is a very visible color, which is why it is used on school buses. OSHA regulations designate yellow for caution and for marking (usually with a yellow and black chevron) physical hazards you might trip over. Red, for danger, is the color used for identifying fire protection equipment and emergency stop buttons on dangerous machinery (though in some states yellow is replacing red for these functions). In many Middle Eastern countries, blue is viewed as a protective color: front doors are painted blue to ward off evil spirits. In some communities of the Southeast, too, front porch ceilings are painted blue to keep ghosts at bay; in the Southwest, many Native Americans also paint their doors blue, again to keep the bad spirits away.

Colors can change their meanings over time with fashion and changing social awareness. Green used to be an unpopular color for automobiles—it was an unlucky color. This probably dates back to the nineteenth century when Paris Green became a fashionable emerald shade until it was discovered that this arsenic-based pigment had caused several deaths (it was aptly renamed Poison Green). Now green is back in fashion, along with greater environmental awareness. The names of colors, too, can have an influence on the perception of the color. In 1962, Binney & Smith renamed the Crayola color Flesh as the less culturally charged Peach, and in 1992 introduced so-called "multicultural" crayons in many subtle variations of brown.

We often use colors to describe our emotions and feelings: "I was so angry, I saw red," we say, or "I'm feeling blue," or "I was green with envy." "Paint it black," sang the unhappy Rolling Stones. Red, orange, yellow, and brown hues are often perceived as "warm"—inducing such emotions as excitement, cheerfulness, stimulation, and aggression—while the blues, greens, and grays are "cool"—implying security, calm, and peace, or sadness, depression, and melancholy. A cross-cultural study has shown, however, that in Japan blue and green hues are perceived to be "good" and the red–purple range as "bad." In the USA, by contrast, the red–yellow–green range is considered "good," with oranges and red–purples "bad." We must be aware, therefore, that color associations are often specific to particular cultures.

Colors are not the same for everyone. Some languages do not contain separate words for green and blue, or for yellow and orange. The Inuit are supposed to have seventeen different words for white, as modified by different snow conditions. All languages, however, have words for black and white. If a third hue is distinguished, it is red. Next comes yellow or green (i.e. the two hues can't be distinguished), and then both yellow and green. Blue is the sixth color named, and brown is the seventh. Finally, in no particular sequence, the colors gray, orange, pink, and purple are given names.

COLOR ASSOCIATIONS IN LANGUAGE AND EMOTION

So what associations can all the different colors have for us?

Black, White, and Gray

These are the achromatic or neutral colors. Black is as dark as a color can get. It is also the absence of color (light) and all the colors combined (pigment) (**fig. 13.1**).

- Black's positive connotations include: sophistication (in fashion), power, sexuality, and being in credit (in business).

- Black's negative connotations include: death, emptiness, depression (things are looking black), disapproval (black mark), and bad luck. Black is used in the following expressions: black economy,

13.1 The power of black. Black attire often signifies sophistication and high fashion. The contrasting colored confetti here reinforces the black still further.

black magic, blacklist, black sheep, blackball, black comedy, and black market.

White is the ultimate in lightness. It is all the colors combined (light) and, in watercolor painting, the absence of color, the color of the paper showing through.

- White's positive connotations include: purity, birth, cleanliness, sterility, innocence, peacefulness, and empowerment. White is used in the following expressions: white lies, white magic, white-collar worker.

- White's negative connotations include: surrender (white flag), cowardliness (white feather), cover-up, and perversion of justice (whitewash).

Black and white together equals authority and truth (written in black and white).

Gray is neither positive nor negative, and implies confusion, loss of distinction (it's a gray area), age (cobwebs, dust, gray hair), intelligence (gray matter of brain), technology, and work (men in gray suits).

Red and Pink

Red is one of the oldest color names, is the first to be seen in a rainbow, and has the greatest emotional impact of all.

- Red's positive connotations include: love (red roses, red hearts), luck, passion (red-blooded), sexiness (red lipstick, red sports cars), festivity (Santa's clothing), and things that are memorable (red-letter day, from the red letters on calendars denoting holidays), important (red carpet),

compassionate (Red Cross), and new (such as red-hot news).

- Red's negative connotations include: war (red uniforms disguised the presence of blood from wounds), revolution and anarchy (red flag), prostitution (red-light district), the devil, danger (traffic lights), fire, debt (in business), and bureaucracy (red tape).

Pink's connotations are mostly positive: healthy (in the pink), pretty, feminine, sweet, and babyish. Sometimes pink is used disparagingly to describe a person of left-wing, but not necessarily extreme, political views (see red above).

Orange and Brown

Orange is present in nature, in the setting sun, fall leaves, fruit, and flowers. It stands out well and creates a sense of warmth.

- Orange's positive connotations include: warmth, fruitfulness, brightness, cheerfulness, and spice.

- Orange's negative connotations include: brashness, danger (OSHA coding).

Brown equals earth, wood, coffee/chocolate, comfort and security, gloom, melancholy, and boredom.

Yellow

Yellow is the most easily perceived of hues, with the highest luminosity rating after white. It is seen before other colors, especially when placed against black. This combination is often used as a warning sign—in nature

13.2 Monarch butterfly. This insect displays the yellow-and-black markings that serve as warnings to potential predators to keep their distance.

eeriness, nausea (green around the gills), rawness, sourness, and the alien (little green Martians).

Blue

In many cultures, blue is the color of spirituality. It means immortality in China, holiness in Judaism, Krishna in Hinduism.

- Blue's positive connotations include: royalty and aristocracy (blue blood), the best (blue ribbon, blue-chip stocks), heaven, coolness, truth, tranquility, conservatism, loyality and dependability (true blue), security, high-technology (IBM is known as Big Blue), and things nautical (Navy blue uniforms).

- Blue's negative connotations include: introversion, sadness, depression (the winter blues) (**fig. 13.3**), and things that are cold (blue with cold), wintery, unexpected (out of the blue), low class (blue-collar worker), indecent (blue jokes), and censorious (blue pencil).

by insects such as bees, and in industry to signal hazardous situations (**fig. 13.2**).

- Yellow's positive connotations include: cheerfulness, sun, gold, happiness, vitality, hope, and optimism (yellow ribbon).

- Yellow's negative connotations include: caution (traffic light), sickness (jaundice), betrayal, and cowardice (yellow streak, yellow-bellied).

Green

Green is the largest color family discernible to the human eye, which is why our feeling toward green can be so varied.

- Green's positive connotations include: environment, growth and renewal in spring, fertility (green man), freshness, nature (green thumbs), youth, health, peace and calm (green room in theater or television studio), things that are cool and refreshing, and wealth (greenbacks).

- Green's negative connotations include: poison, envy, inexperience and gullibility, immaturity,

13.3 Pablo Picasso, *The Old Guitarist*, 1903. Oil on panel, 48²/₅ x 32¹/₂ in (123 x 83 cm). Art Institute of Chicago. Helen Birch Bartlett Memorial Collection. The predominantly blue tonality of this painting gives the subject its melancholy feeling.

Purple, Violet, and Indigo

Purple is the hardest color for the eye to discriminate. It was originally made from a rare Mediterranean snail, hence cloth-dyed purple was expensive and could be afforded only by priests and the aristocracy.

- Purple's positive connotations include: bravery (purple heart), aristocracy, spirituality, mystery.
- Purple's negative connotations include: conceit, pomposity, mourning, death, and rage.

INFLUENCES OF THE DIMENSIONS OF COLOR

Just as specific colors or hues have different associations and emotional effects, so do the other dimensions of color—value, intensity, and temperature—affect the viewer in different ways. Contrast in value produces an effect of precision and objectivity. Using close values in proximity, however, results in haziness, vagueness, and introspection. Dark compositions give feelings of night, mystery, and fear. Dark values can increase an object's size, implying space and a feeling of infinity. Light compositions, however, project clarity and optimism.

Middle values seem relaxed and less demanding. High intensities attract, and impart feelings of activity.

Warm colors—reds, oranges, and yellows—stimulate the senses (**fig. 13.4**); cool colors—blues and greens—produce calm. Warm colors can raise blood pressure and increase body temperature; cool colors can have a relaxing effect. Warm colors advance toward the viewer; cool colors retreat into the distance. Warm colors appear to advance toward the eye, because they seem nearer than they actually are. A sofa in an intense red fabric will generally appear larger than the same piece in a cool color, such as blue. If the walls of a room are painted the same intense red, the walls will appear closer, decreasing the apparent size of the room. However, a very intense, bright cool color will seem to advance, but a dull warm color will recede.

RELIGIOUS AND CULTURAL SYMBOLISM

Among various peoples and in different religions some basic colors have had at times different and sometimes opposite meanings. White, for example, may signify joy and festivity, or death and sadness. Red has the most pronounced symbolical value: it refers to both life and

13.4 Room interior. The warm temperatures of this room—reds, oranges, and yellows—and the contrasts between diverse fabric patterns and a flatly painted wall surface stimulate a feeling of luxuriance and harmony.

death. In Christianity, the color symbolism of liturgical dress and drapery is associated with events in the sacred year; in Buddhism, with the picture of the universe, the regions of which are classified according to particular colors; and in the religion of the Maya of Mexico and Central America with the four compass directions—east (red), north (white), west (black), and south (yellow).

Christianity

Early Christians banned green because it had been used in pagan ceremonies. Yellow, too, was unpopular, as Greek gods were often depicted with yellow hair and robes. Until the fourth century, white was the only liturgical color in use. Other colors were introduced by Pope Innocent III (reg. 1198–1216): red, green, and black for general use, with violet reserved for some special occasions. Innocent's symbolism was based upon allegorical interpretations of colors and flowers mentioned in Scripture, especially in the Song of Solomon. Between the twelfth and sixteenth centuries, blue and yellow were also in favor.

Since the time of Pope Pius V (reg. 1566–1572), however, five colors have been prescribed in the Roman Catholic church: white, red, green, violet, and black. Each has symbolic significance (**fig. 13.5**). For example, red, the language of fire and blood, indicates burning, charity, and the sacrifice of martyrs. It is used at Pentecost, recalling the fiery tongues that descended upon the Apostles when they received the Holy Spirit.

The Anglican and Lutheran churches have generally followed the Roman Catholic array, although some Anglican churches have restored the thirteenth- and fourteenth-century colors white, red, and blue, with unbleached cloth in Lent, changing to deep red during the two weeks before Easter. Since World War II, the sequences and symbolism inherited from the Middle Ages are being abandoned, and a greater freedom is evident in vestments and hangings, with increasing variety and combinations of colors.

Judaism

Early priests (the tribe of Levi) used red, white, and two hues of purple. The Israeli flag uses the colors from the traditional Jewish prayer shawl (the *tallit*): sky blue and white, symbolic of heaven and earth. In the nineteenth century, both cantor (*hazzan*) and rabbi wore the black gown and round black hat, a practice still observed in some congregations.

On Yom Kippur (Day of Atonement), it is the custom for participants to wear a completely white garment, symbolizing purity.

Islam

Because Islam does not recognize a priesthood set apart, "clerical" functions are discharged by the *ulama* ("the learned in the Law"), whose insignia is the *imamah* (a scarf or turban). Green is the color of Islam. A green turban usually denotes a *sharif*, or descendant of the Prophet Muhammad. Religious dress also serves a memorial function, as in the case of the religious leaders (mullahs) of the Shi'ites (Muslim members of the party of Ali), whose black gowns allude to the sufferings of Husayn (Ali's son by Fatimah, Muhammad's only surviving daughter), who was martyred at Karbala, in modern Iraq, in 680 C.E.

Many of the mystical dervish orders wear distinctive robes. The dervishes wear a black robe (*khirqah*) over all other garments, which symbolizes the grave, and a tall camel's hair hat (*sikke*) representing the headstone. Underneath are the white "dancing" robes consisting of a very wide, pleated frock (*tannur*), over which fits a short jacket. On arising to participate in the ritual dance, the dervish casts off the blackness of the grave and appears radiant in the white shroud of resurrection. The head of the order wears a green scarf of office wound around the base of his *sikke*.

Buddhism

To avoid the primary colors, Buddhist robes are of mixed colors, such as orange or brown. A common term for the robe, *kasaya*, originally referred to the color saffron. Buddhist robes in China followed Indian tradition fairly closely, though they were noted under the Tang dynasty (618–907 C.E.) for being black in color. Taoist robes, in contrast, were yellow. In Japan, devotees of the Shugen-do tradition (famous for its *yamabushi*, or mountain priests) wear white robes during purification ceremonies and similar rituals, symbolizing purity.

Hinduism

There is little distinction between ordinary dress and religious dress in Hinduism. However, colors still have religious associations. For example, Krishna, the eighth avatar (incarnation) of Vishnu, is usually blue in color and often wears yellow-orange clothes. Blue is the color of the infinite, the sky, and the ocean. The color yellow represents earth. When sand is introduced in a

13.5 William Holman-Hunt, *A Converted British Family Sheltering a Christian Missionary from the Persecution of the Druids.* Oil on canvas, 43¾ x 55½ in (111 x 141 cm). Ashmolean Museum, Oxford, England. The white of the missionary's robe suggests purity while the red signifies potential martyrdom. His Christ-like associations are also suggested by the blue robe of the older woman, evoking the Virgin Mary, and by the woman removing thorns from his feet, an echo of Mary Magdalene. The green top of the third woman holding a bowl of water and the lush green vegetation surrounding the hut are symbols of hope.

colorless flame, the flame turns yellow. The blue form of Krishna clothed in yellow-orange suggests the transcendent, infinite reality reduced to a finite being (**fig. 13.6**).

During Holi, the festival of colors, revellers carrying *gulal* (colored powder) go from house to house smearing the mixture on the faces of friends and acquaintances while children armed with *pichkaris* (water sprinklers) roam the streets squirting colored water on passers-by.

FLAGS AND HERALDRY

Flags are probably the most potent examples of abstract color symbolism. They have a huge impact today as emblems of national and regional pride. Most European designs have their roots in heraldry. Heraldry originated when most people were illiterate but could easily recognize a bold, striking, and simple design. In medieval warfare, combatants could distinguish one chainmail-clad knight from another by the designs on their shields and thus know friend from foe.

13.6 Bhanudatta, *Rasamanjari*, 1685. British Library, London. This painting employs arbitrary color in the figure of Krishna. The blue face and body of Krishna define his infinite being; yellow-orange clothes represent his finite, human nature.

Much heraldic terminology is in a quasi-French, archaic language. The field or ground of the shield is one of three kinds: a color, a metal, or a fur (pattern). There are five main colors (known as tinctures): azure (blue), gules (red), sable (black), vert (green), and purpure (purple). In English heraldry, there is also murrey (sanguine, a tint between gules and purpure). The metals are or (gold) and argent (silver, usually depicted as white). The word "proper" is used to denote something shown in its natural colors or natural form. It is considered bad practice to put a color upon a color, a metal upon a metal, or a fur upon a fur.

The colors and designs of national flags always stem from the history, culture, or religion of a particular country. The oldest European flags display the Christian cross, which was first extensively used in the Crusades to the Holy Land. The British Union Jack is perhaps best known, but Norway, Sweden, Finland, Denmark, Greece, and Switzerland also all have their flags with crosses.

Among the most influential of Europe's striped flags was the red–white–blue flag of the Netherlands. Because of its use in that country's war of independence from Spain, the flag and its colors became associated with the concepts of liberty and a republican form of government. This association was reinforced by France's adoption of the same colors, following the French Revolution of 1789, but with vertical instead of horizontal stripes. Italy also adopted the Tricolor, but changed the blue for green. These colors have come to symbolize the three cardinal virtues: green for hope, white for faith, and red for charity, as explained in Dante's *Divine Comedy*.

The red, white, and blue for the stars and stripes of the US flag were based on the colors of the Union Jack (**fig. 13.7**). The first Flag Act passed by the Continental Congress on June 14, 1777 resolved that: "the flag of the United States be made of thirteen stripes [the number of states in the union], alternate red and white; that the union be thirteen stars, white in a blue field,

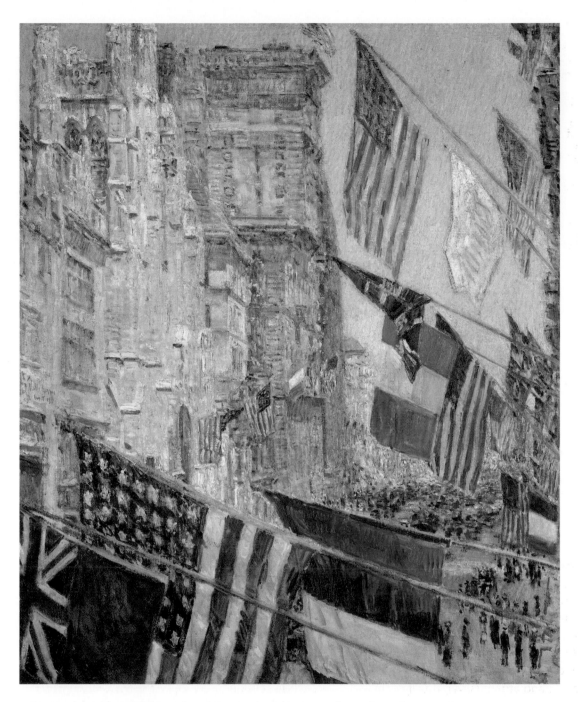

13.7 Childe Hassam, *Allies Day, May 1917*, 1917. Oil on canvas, 36½ x 30¼ in (92.7 x 76.8 cm). National Gallery of Art, Washington D.C. Gift of Ethelyn McKinney. Red, white, and blue hues can be seen in the Union Jack, Stars and Stripes, and Tricolor flags throughout the composition, suggesting a constellation of alliances between the three countries. Blue also suffuses the rest of the painting, perhaps suggesting the truth of the Allied cause.

representing a new Constellation." The colors in the Great Seal (adopted in 1782) did have specific meanings: white signified purity and innocence; red was for hardiness and valor; and blue for vigilance, perseverance, and justice.

It is said that the founder of the Chou dynasty in China (1169–255 B.C.E.) had a white flag carried before him. Indian flags were often triangular in shape and scarlet or green in color, with a figure embroidered in gold and a gold fringe. Indian and Chinese usage

13.8 This polar bear is almost perfectly camouflaged by its natural habitat. At its peril, a seal might mistake the bear for a snowbank. There could also be a second polar bear behind the first one, but so artful is the disguise that it is difficult to be sure.

charities, and other interest groups. Flags also serve as warnings or other signals. The black flag in days gone by was the symbol of the pirate. All over the world a yellow flag is the signal of infectious illness. A ship hoists it to denote that there are some on board suffering from yellow fever, cholera, or some other infectious disease. White flags have been used as a signal for a truce since at least the sixteenth century.

COLOR AND THE ENVIRONMENT

In nature, color can be used both to attract and to disguise. Birds and fish use bright colors to attract mates or to say, "This territory is mine." Flowers use colors to attract bees and other insects to help in pollination—taking pollen from flower to flower.

Snakes and lizards use colors that give prior warning to predators that they may be in for an unpleasant surprise if they try to eat them. Other animals use camouflage to match their color to their living quarters, so they can hide from things that would like to eat them. Camouflage, from the French word *camoufler* (to disguise), is the art of concealment. Baby birds, for example, are often born with drab colors that match their nests of twigs and dried leaves so that they can stay safe. Similarly, a white polar bear is hard to see in ice and snow (**fig. 13.8**). The zebra has markings that run off its edges into the background, allowing it to fade into the background so successfully that it is difficult to see its overall shape. A chameleon can change color to blend in with its environment. Soldiers often wear camouflage clothing and smear drab colors on their faces at night to become less visible.

Complementary combinations in nature help in our survival: bright red tomatoes are easy to find against green foliage. Red-hued foods seem more flavorsome, which is why supermarkets use red-hued lighting. Pink foods imply sweetness. Blue, as a food color, is rarely found in nature, possibly as a protection against potentially poisonous or putrid foods, although some varieties, such as blue potatoes, seem to be becoming fashionable. If food is colored blue artificially, however, or placed under blue light, it can dramatically suppress the appetite.

Color has been shown to affect human moods, physiological responses, and perceptions of temperature, size, and ambiance. Colored light is used to treat some illnesses, and to soothe patients in hospitals and institutions. Warm colors (particularly red) increase human attraction to external stimuli, induce states of excitement, produce higher arousal levels, quicken muscular responses, and increase grip strength. In

spread to Burma, Siam, and southeastern Asia and was probably transmitted to Europe by the Saracens. Medieval Islamic flags appear to have been plain black or white or red. Black was supposed to have been the color of Muhammad's banner—the color of vengeance. A black flag was used by the Abbasid dynasty, the Umayyads choosing white by contrast and the Khawarij red. Green was the color of the Fatimid dynasty and eventually became the color of Islam.

In the Middle East, therefore, the predominance of Islam has generally limited the choice of flag colors to the four traditional Muslim colours of red, white, green, and black. The flags of most Arab states use one or several of these colors in a tricolor format, although the star and crescent motif is present in the flags of Turkey, Algeria, and Tunisia.

The flags of the former French colonies tend to have vertical tricolors and are generally green–yellow–red, while the flags of the British Commonwealth members have horizontal tricolors and often include green, blue, black, and white. Some African-Americans celebrate their heritage by wearing clothes that feature the black, red, yellow, and green that can be found in many African flags.

Flags do not indicate nationality alone. They are sometimes hoisted aloft in parades by local clubs,

contrast, cool colors (particularly green) reduce anxiety states, and are associated with extremely calm and tranquilizing moods.

Architects and designers use color psychology to modify our behavior. Fast-food restaurants and coffee shops are often painted in orange or pink colors to induce excitement. They excite you to come in, eat quickly, then vacate the table for the next set of excited customers. Better restaurants do this more subtly using colors like burgundy. Blue is rarely used in restaurants, because it is a relaxing color. Once in the restaurant, the customers will be so relaxed that they won't want to leave. Hospitals used to be painted green to soothe patients. Pink can be energizing or calming. Prisons are painted pink to cheer up those who work there and subdue the prisoners.

A cosmetics company once gave its offices a clean, fresh new look in white, expecting that the staff would be energized and excited by the changes. Instead, absenteeism became a problem, and employees complained of not feeling well—or *looking* well. In the cosmetics industry, red is the overriding color. The complement to red is green, so after viewing all those variations of red, when the employees looked up at the walls (and each other's complexions) everything had a decided greenish tinge. After redecorating in a blue-green teal to neutralize the greenish afterimage, the staff became happier and productivity began to rise. Green-blue is also used in operating theaters—once a pristine hygienic white—not only to reduce stress, but also to reduce the afterimage effects of red (**fig. 13.9**).

COLOR AND HEALTH CARE

Color has a significant effect on both our minds and bodies. Young children are attracted more by color than shape. As we mature, we will often become more form-dominant; however, creative people often remain color-dominant throughout their lives. Eye-tracking studies of infants indicate that, regardless of sex, red and blue are the most preferred colors.

Some psychologists believe that analyzing an individual's uses of and responses to color can reveal information about his or her physiological and psychological condition. It has even been suggested that specific colors can have a therapeutic effect on physical and mental disabilities. Newborn babies with jaundice, for example, can benefit from a blue environment. Dyslexic children have been helped in their reading by placing a colored transparent sheet over the stark black-and-white page.

There are also many complementary therapies based on using color, including **chromotherapy**, auras, color breathing, and colorpuncture. Chromotherapy can involve wearing the prescribed color, or using a lamp that bathes you in the required color. According to color therapists, you can also cover a glass bottle with colored cellophane and fill the bottle with water. When you drink the water, you will be receiving the "vibrations" of that color. The powers that colors have follow conventional color symbolism. People who are depressed, lonely, or lacking in motivation, for example, can benefit from having orange around them. It is said to be good for gallstones, chest conditions, arthritis, and repressed creativity. Beware of overdosing on orange, however: it can turn liveliness into restlessness.

Some therapists claim to see colored auras around people, which can be used as a diagnostic tool. Red relates to the reproductive system, orange to the adrenal glands, yellow to the spleen and life force, green to the thymus and the immune system, blue to the thyroid and metabolism, and violet to the pineal and pituitary glands.

Color breathing is imagining oneself surrounded by a cloud of a desired color, breathing deeply, and

13.9 Blue-green is the color used by doctors and nurses in hospital operating rooms.

imagining the color filling the lungs and flowing throughout the body or to a particular spot. Color projection involves the passage of sunlight or artificial light through filters: light passing through a red filter purportedly increases hemoglobin formation, and light passing through a blue filter allegedly eliminates or reduces fever. Colorpuncture is the application of colored light to acupuncture points using a device that resembles a penlight.

The ability to see color exists in only a few animals: humans and the other primates, fish, amphibians, some reptiles, some birds, bees, and butterflies. **Color blindness** is the inability to distinguish one or more of the three colors red, green, and blue. In the United States alone, approximately 19 million people have some form of color blindness. While they are not technically blind, some colors may be inaccessible to them, appearing as a confusing blend of grays. Blindness to red is called **protanopia**; to green, **deuteranopia**; and to blue, **tritanopia**. Red-blind people are unable to distinguish between red and green, while green-blind people have reduced sensitivity to the green part of the spectrum. Blue-blind people cannot distinguish between blue and yellow. Color blindness, which affects about twenty times as many males as females, is a gender-linked recessive characteristic. A woman must inherit the trait from both parents to be color-blind.

Designers must be ever aware of the problems of those who are color blind, have age- or illness-related degenerative vision, or who have limited sight. Elderly people see colors differently, but are not color blind in the usual sense of the term. Vision declines with age, with yellowing and darkening of the lens and cornea, and a shrinking pupil size. Yellowing selectively blocks short wavelength light, so blues look darker. Moreover, the elderly have difficulty in discriminating colors that differ in their blue content: blue-whites, blue-grays, green-blue-greens, and red-purples. Ageing also reduces the amount of light reaching the photoreceptors. All colors will be dimmer and visual resolution will be lower—a moderately bright yellow may appear brownish, and dimmer blues will appear black. When designing for elderly people, use bright colors and make sure that brightness contrast is especially high.

People with schizophrenia can have abnormal color perception. A decrease of color discrimination can indicate the onset of various conditions, such as multiple sclerosis, pernicious anemia, diabetes, and brain tumors. Loss of color vision can also be the result of coming into contact with industrial toxins, or of alcohol or tobacco abuse.

CONCEPTS TO REMEMBER

☐ Color provides both visual and psychological information, although colors can have different meanings in different cultures. These meanings can also change over time.

☐ Different colors have a wide range of different associations, with both positive and negative connotations.

☐ Colors affect the viewer differently according to their value, intensity, and temperature.

☐ Some basic colors have had, and still have, symbolic significance in different religions.

☐ Flags are important examples of abstract color symbolism.

☐ We have significant psychological reactions to colors, which are important to consider when we design restaurants, hospitals, etc.

☐ Our reactions to colors can be used as diagnostic tools in some therapies.

Exercises

1 Design a milk carton for a school lunch room—use color to attract children to select milk rather than soda.

2 Collect nature pictures showing camouflage.

CHAPTER 14
Putting Color to Use—Then and Now

Color is—and always has been—all around us: in the blue of the sky, the green of the grass, the turquoise of the oceans, the reds and oranges of fire, the bright plumage of birds, the exotic colors of reptiles and insects, the beauty of flowers. From the earliest times, humans have strived to reproduce the colors we see everywhere in permanent pigments for painting, in dyes to color clothing, in inks for printing, and in glazes to decorate pottery. Thanks to advances in chemistry, the range of colors has ever expanded: from the meager handful of earth colors and plant dyes available to prehistoric cave dwellers to the thousands of colors viewable on a computer screen.

Pigments and dyes have been found in the strangest places: blue woad and indigo from plants, purple from marine snails and sepia from squid ink. Indian yellow has been found from the very earliest times to the present day.

COLOR IN THE FINE ARTS

Paleolithic Painting
Paintings in the Chauvet cave at Vallon-Pont-d'Arc in southeastern France, discovered in 1994, constitute some of the oldest known uses of color. More than just daubs of black and red iron ocher, they display hitherto unsuspected skill and dexterity. Carbon dating reveals that a buffalo and two rhinoceri were painted about

31,000 years ago. These Paleolithic painters used fewer colors than in the better known and later Lascaux caves, but Chauvet does rival Lascaux in the sheer number, diversity, originality, beauty, and state of conservation of its works of art. Rhinoceros pictures, never before seen in the Ardèche region, dominate. Next come lions, mammoths, horses (two of which are yellow ocher, the only instance of this coloring), bison, bears, reindeer, aurochs, ibexes, stags, a red hyena and a panther (**fig. 14.1**), and an engraved owl. There are many instances of large red dots painted singly or in groups, forming geometric figures, and negative stencilled images of hands (obtained by blowing paint onto the hand placed against the wall).

Attempts to replicate scenes in the French cave of Pech-Merle (around 18,000 years old) have shown that the hunter–painters had probably used their mouths to spray liquified pigment—powdered red ocher and black manganese dioxide mixed with water—onto the walls of the cave, just as Australian Aboriginal artists still do today. Using their arms and fingers the way that a house painter uses masking tape, they were able to create sharply defined lines, such as those forming horses' necks and backs. In other caves it is possible that they used chunks of red and yellow ocher for drawing, and ground these same ochers into powders for painting. These powders they blew onto the walls or mixed with some medium, such as animal fat, before

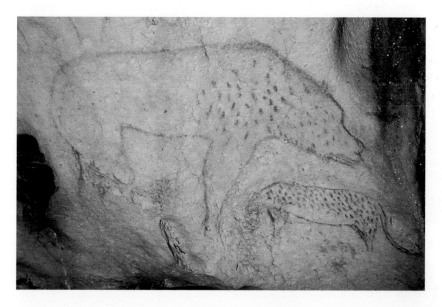

14.1 Hyena and panther, Chauvet cave, Ardèche Valley, France, c. 29,000 B.C.E. Red ocher on limestone wall. Courtesy J. Clottes, Regional Office of Cultural Affairs, Rhône-Alpes, and the Ministry of Culture and Communication. Cave artists either applied their pigments directly to damp walls or blended them with a binder, such as animal fat, vegetable juice, water, or blood. They achieved a very realistic sense of form, given minimal shading and a simple red or black outline. Perhaps the swelling rock helps to mimic the animals' bulk.

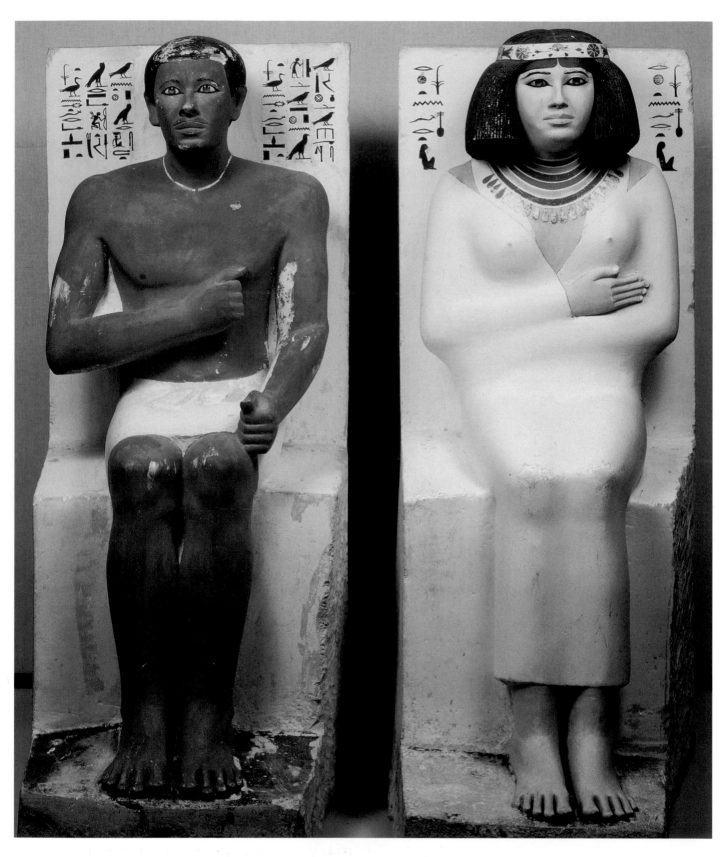

14.2 Prince Rahotep and his wife Nofret, c. 2610 B.C. Painted limestone, 47¼ in (122 cm) high. Egyptian Museum, Cairo. The well-preserved paint is indicative of the ancient Egyptians' skill in the preparation of pigments and their application to limestone. In traditional style, Rahotep's skin is painted in a dull-red color and Nofret's in creamy yellow. Their eyes have been outlined in black. The queen's necklace has traces of Egyptian blue.

applying. Other colors included carbon black and white from chalk.

Ancient Egypt

The ancient Egyptians made considerable use of paints for decorative purposes, adding mineral colors to the prehistoric palette of earth ochers. The challenge was to make a medium that was more permanent. By 1300 B.C.E., colors were being obtained from finely ground minerals, such as green malachite (copper carbonate), mixed with a tempera base prepared from glue, gum, gelatin, or egg albumen. The ancient Egyptians also used encaustic painting, later perfected by the Romans, by mixing hot beeswax into the pigment. The Egyptians discovered a way of mixing dyes made from plants and insects onto inert substances such as chalk to form insoluble lakes. All lakes, or pigments made from dyes, are prone to fading, however. Naples yellow (lead antimonate) was first used in Egypt around 1570–1293 B.C.E.

The Egyptians can also be credited with introducing the first blue into the palette. Egyptian blue (also known as cuprorivaite, or Alexandrian, Pompeian, Pozzuoli, or Vestorian blue) can be dated back to 3000 B.C.E. It is a **frit** or glass color made by roasting an ore with other ingredients.

Buon fresco, dissolving pigments in lime water and painting them onto a freshly plastered wall, so that the paints become an integral part of the ground, was first used by the Egyptians. The technique was later used extensively by the Romans, was perfected by Giotto (?1267–1337) in the thirteenth century, and was revived in the twentieth century by mural artists such as Diego Rivera (1886–1957). Not all pigments could be used with the wet plaster—some colors had to be painted afterwards, *a secco* (i.e. done on dry plaster), in tempera.

Despite their expanded color palette, ancient Egyptian artists were constrained by artistic conventions. For example, during the Old Kingdom period, male figures were depicted with dull red skin, while females were shown with yellow complexions (**fig. 14.2**). Portrait sculptures and paintings also indicate that cosmetics were in full swing by this time. Skin tones were warmed with primitive rouge, and eyes were outlined with black (kohl) and green (malachite).

Ancient Greece

The ancient Greeks developed white lead (lead carbonate), verdigris, and vermilion. Verdigris ("the green of Greece") is hydrated copper acetate—a gray-green or bluish patina formed on copper, brass, or bronze surfaces. It tended to be impermanent, being affected by other pigments and the atmosphere. Distilled verdigris was purified using vinegar. Vermilion is produced from natural cinnabar and is chemically known as mercuric sulfide. According to the fourth-century B.C.E Greek philosopher Theophrastus, it was obtained from inaccessible cliffs by shooting arrows to dislodge it. Vermilion is also found in relics of Assyrian and other early cultures.

Tyrian purple, the imperial purple of the Romans, was first used by the Greeks. As Plato makes clear in the *Republic*, it was used by the ancients for major rites of passage, such as births, deaths, and marriages, and regarded by them as the most beautiful color of all, in part because it was held to contain equal proportions of dark and light. It was prepared from the shellfish *Murex trunculis* and *Murex brandaris*. According to Pliny the Elder's first-century C.E. *Natural History*, the most desirable shades of murex purple varied from the reddish or pinkish to the bluish or violet, according to the fashion of the times.

Greek statues such as the Elgin marbles, which once formed the frieze around the Parthenon in Greece, were not the pristine white you now see in museums but were often painted using a bold palette of white, yellow, red, and black.

For critics in ancient times, color in art had a deeply ambiguous status. On the one hand, it was seen as false, as decorative trickery—but on the other hand, it lent pictures a truthful appearance. Aristotle captures the antithesis in his *Poetics*: "the chalk outline of a portrait will give more pleasure than the most beautiful colors laid on confusedly."

Ancient Rome

The Romans perfected the techniques of encaustic painting on wooden panels, as seen in portraits from the Fayum in Egypt (325–350 C.E.) and *buon fresco* as seen at Pompeii. The style of interior decoration at Pompeii was not to hang paintings, but instead to paint them directly onto the walls (**fig. 14.3**). The themes of the murals are varied and include mythology, landscape, patterns, brightly colored imitation marble, and porticos. Some artists achieved unqualified excellence, such as an unknown artist from Campania in the first century B.C.E. who painted the frieze of the Dionysiac mysteries, discovered in 1930. The deep red background of the paintings is still fresh after two thousand years.

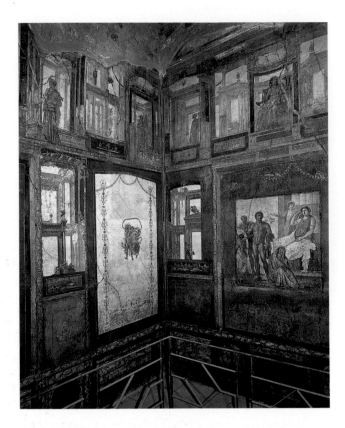

14.3 Ixion Room, House of the Vetii, Pompeii, A.D 63–79. The ash and mud that buried Pompeii after the catastrophic eruption of Mount Vesuvius in A.D. 79 acted as a preservative. Many wall paintings look as though they have been freshly executed, so brilliant remain their blue and red pigments.

The Romans added colors to the palette. Brown ocher is a dull variety of yellow ocher, which the Romans called "sil," with the finest grade Attic sil coming from Greece. Saffron is a bright yellow color obtained from *Crocus sativus*—it fades badly in daylight. Lampblack, called "atramentum" by the early Romans, is a very fine, greasy powder derived from the soot produced by the burning of lamp oil. Color was implicated in the Roman class system: high-ranking officials wore togas decorated with gold and purple, the two most precious pigments.

Experts have identified as many as twenty-nine different pigments employed at Pompeii, including ten reds. Certainly, one of the distinguishing features of later Roman art is its increasingly garish and extravagant color palette. But luster was seemingly just as important to the Romans. Painted walls at Pompeii were burnished until they shone like mirrors, and the pavements of conquered Pergamon (in modern-day Turkey) were ground smooth, waxed, and polished so that they became highly reflective.

The Middle Ages

Artists of the early Christian Church used mosaic brilliantly at sites such as churches in Ravenna, Italy, to inject drama into their stories of salvation. Bright colors, including gold, were fused into little glass cubes called *tesserae*. These could be set at angles to catch the light as the spectator moved—particularly effective for focal points such as saints' haloes. Red *tesserae* were randomly scattered to give warmth to flesh tones.

In many later medieval churches, no surface was left uncolored. The sumptuous effect was supplied by Bible stories in fresco, imitation mosaic, painted ornament, and even hanging cloths of gold that were really painted illusions.

Stained glass, translucent colored glass cut to form a window design, became an integral part of religious architecture in the medieval period (see fig. 10.15). It retained its importance for four centuries. Stained glass was an awe-inspiring medium that was effective in teaching the poor and illiterate about the lives of the saints, Jesus, and the Virgin Mary. The colored glass is created by mixing metallic oxides with molten glass. It is then cut to size and the pieces are joined together by strips of lead. The technique meant that Gothic cathedrals were suffused with soft light and radiant color. As can be seen at Chartres, northern France, the predominant palette of stained glass was red and blue, which in combination produces a violet light.

Using a nondestructive technique called Raman microscopy, researchers have been able to name the pigments used in medieval illuminated manuscripts. The technique shines a laser through a microscope at single grains of pigment and the spectrum scattered back identifies the pigments precisely. Examining a Byzantine/Syriac Gospel lectionary (1216–1220 C.E.) from Mosul in modern Iraq, now in the British Library, researchers discovered red vermilion, blue lapis lazuli, yellow orpiment, and a golden-yellow pigment called pararealgar, a form of arsenic sulfide that can be created by sun shining on realgar, an orange-red pigment also found in the illustrations. Until then, chemists had assumed the yellow pigment in old manuscripts always to be orpiment, another sulfide of arsenic.

The white pigment on the manuscript was identified as basic lead carbonate, commonly known as white lead or flake white. White lead's dominance as a white pigment was not broken until zinc oxide was introduced in the nineteenth century. It has a good record for permanence and is unaffected by light, if mixed with an oil medium or covered with a coat of

varnish. The most serious conservation problem is blackening, caused by hydrogen sulfide pollution from coal fires and the town-gas lighting of Victorian times, which formed the compound lead sulfide. The sole blue pigment identified on the lectionary was lazurite, the sulfur-containing sodium aluminum silicate that can be extracted from lapis lazuli. Although this pigment is rare and would have been expensive, it was used widely throughout the manuscript.

Egg tempera was the standard medium of painting until the fifteenth century: pigments, including calcined earths such as raw and burnt sienna and umber, were mixed into an emulsion with egg yolk or gum, using a technique of tiny hatched strokes of color to give the impression of shading.

The Bayeux Tapestry, one of the masterpieces of the medieval era, was made by stitching colored wool onto bleached linen. It is over 230 feet long and depicts the Norman invasion of England in 1066. Single threads were used not only for waves, ropes, and strands of horses' hair, but also to outline each section of color (**fig. 14.4**). The craftspeople used five predominant hues: terra-cotta, old gold (brownish yellow), a grayed blue-green, deep blue tinged with green, and olive

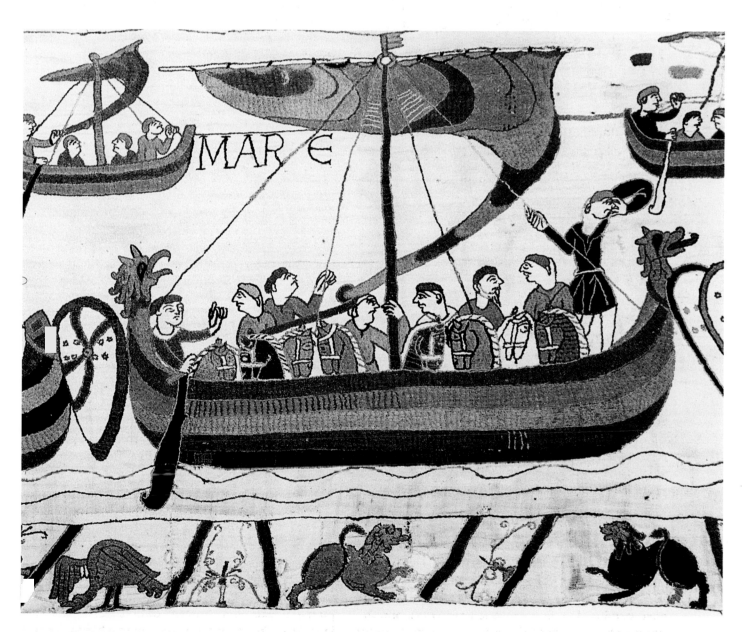

14.4 The Bayeux Tapestry, detail of Viking ships, c. 1070–80. Now light brown with age, the tapestry contains some seventy scenes from the Norman Conquest of England, embroidered in worsteds of many colors.

green. Additional colors included sage green, dark blue, yellow, red, and green. The golden age of English embroidery was 1100–1350, when it was known as *opus anglicanum* ("English work").

The Renaissance and the Baroque

Since the brightest dyestuffs of the Renaissance also cost the most money, sometimes they took on spiritual connotations. The robe of the Virgin Mary, the most venerated of spiritual figures, was traditionally picked out in lapis lazuli, the rarest and most expensive of blue pigments.

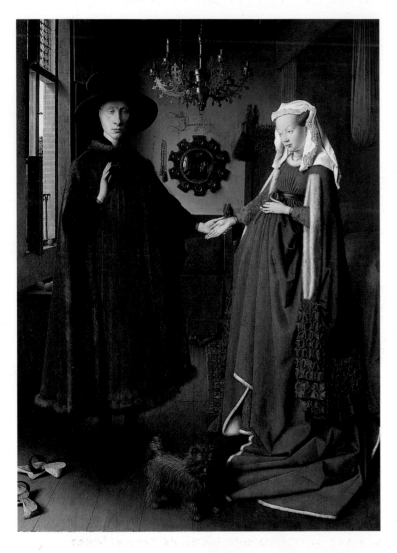

14.5 Jan van Eyck, *The Arnolfini Wedding*, 1434. Oil on wood, 32¼ x 23½ in (81.9 x 59.7 cm). National Gallery, London. Despite the stylized appearance of the figures and the stretched perspective, van Eyck's great skill with color makes this room a real space. His brilliant rendering of shadows and reflective surfaces, such as the brass candelabrum, makes us aware of the even flow of light. The bride's green dress (and the dog) are symbols of fidelity.

In the eleventh century, a monk called Theophilus developed a recipe for adding mineral pigments to a varnish, made from dissolving resins such as amber and copal in linseed, castor, or fish oil. As early as the thirteenth century oil was used for painting details over tempera pictures. Oil paint, as it became known, became more widespread during the Renaissance, with drying and semi-drying oils such as walnut, poppy, and safflower being used. Drying time was further decreased by adding metallic oxides such as litharge (lead monoxide—a heavy, yellowish powder) or white lead.

By the fifteenth century, Italy and Flanders (the latter now Belgium and The Netherlands) were the twin centers of European art. The procedures involved in making a usefully fluid medium with which to paint entire panels in great detail were perfected by the Flemish artist Jan van Eyck (c. 1390–1441). His palette comprised a green-brown verdaccio for underpainting, red madder, red ocher (sinopia), ultramarine, yellow ocher, green terre verte, yellow orpiment, and black (**fig. 14.5**). The new methods were taken to Italy by Antonella da Messina where they were received with enthusiasm. By the early sixteenth century, oil paint was the preferred medium for easel painting in Europe.

Oil paint is easily handled, can be blended, and can be applied as a transparent glaze. The color is the same when dry as it is when wet. Artists using quick-drying tempera had to work quickly, but those using oil could build up a picture slowly. Early pigments, however, caused many problems for the painters: fading or darkening, difficulty in mixing certain colors together, or in their toxicity, not to mention the artists' labors in purifying and preparing each pigment by hand.

Techniques of painting, as well as the media, were changing too. In the thirteenth century, artists such as Giotto had produced shading by using darker and lighter values of the same hue. Leonardo da Vinci was a great innovator (although his attempt to improve on the fresco technique in the *Last Supper* was not very successful). He introduced to the artist's repertoire *chiaroscuro*, using light and dark to model forms; *sfumato*, the soft blending of colors; and he perfected aerial perspective, using cool colors in the background to induce a feeling of great distance (see figs. 4.6 and 7.6).

Rembrandt Harmensz van Rijn (1609–69) epitomizes Baroque use of color in his unparalleled ability to create a mood of drama, mystery, spirituality, and introspection (see fig. 6.13). In his portraits, figures emerge from a dark, resonant background, in which all

the nuances of light and shade (*chiaroscuro*) have been carefully delineated. This helps to make the white highlights and the patches of reds, yellows, golds, and oranges in the foreground all the more brilliant.

Baroque Flemish painters such as Peter Paul Rubens (1577–1640) used a technique called *imprimatura*. They painted thinly on a colored ground—Rubens preferred a light gray—on a wood panel sealed to make it non-absorbent. A drawing was transferred, then shadows were painted in brown transparent glazes, then light tones were built up with white. In this thin, transparent method of painting, grounds of verdigris and umber are discouraged because they kill the colors that are applied over them, the Flemish tending always toward warm shadows. Later painters employed a dusky priming, serving as a middle tint for the shadows rather than the lights. Colors used included white lead, black, red ocher, and sometimes a little umber. Only a few paintings survive by Jan Vermeer (1632–1675), but their bright and luminous, predominantly blue and yellow compositions betray an awareness of optics and the subtlety of interpenetrating reflected colors.

Color in Non-Western Art

Wall paintings in India, in the Buddhist rock-cut temples at Ajanta (c. 600–700 C.E.), were made using a method akin to fresco: walls were coated with lime kept moist to absorb pigment, outlines were drawn in red, then filled with color and burnished to a lustrous gloss. Fresco-like wall paintings are also found in Mesoamerica, in Aztec Teotihuacán (c. 600 C.E.), in which blood-letting is depicted in shades of red with touches of green and blue. The finest surviving Mesoamerican paintings are Mixtec, dating from c.1400–1500. Cartoon-like figures are painted in black outline filled with brilliant color on long strips of parchment or prepared deerskin.

Rock paintings in Australia are some of the oldest in the world, dating from 40,000 B.C.E up until the 1960s. They express a view of the world that is neither secular nor sacred, natural nor supernatural, past nor present. All members of the community learn to paint as part of their initiation into its mysteries. Recently, synthetic pigments have been successfully adopted, increasing the traditional range of red and yellow ochers, black charcoal, and white kaolin, to be applied to bark, composition board, canvas, or paper by artists such as Tim Leurah Tjapaltjarri (c. 1939–1984). Heat-haze landscapes, painted in the round, on the ground, in dots of smoky gray, olive green, yellow, violet, red ocher, and umber are traversed by footprints, symbols of weapons, and animals.

The Chinese of the Chou dynasty (1169–255 B.C.E) developed lacquer work in black and vermilion red using the sap of the lac tree. This technique was perfected during the Ming dynasty (1368–1644) and spread to Japan. Like the paintings of the Greeks, early Chinese paintings on scrolls have been lost and are known only through later copies. A tenth-century copy of "Admonitions of the instructress to the court ladies" is believed to be after the portrait painter Gu Kaizhi (344–406 C.E.), who worked at the court of Nanjing.

By the fourth century, the Chinese had developed calligraphy and began to paint expressively using a flexible brush, describing volumes with a superb economy of line. The oldest surviving illustrated printed book is the Diamond Sutra (868 C.E.). It was the Chan sect (Zen in Japan) that introduced spontaneous paintings of plants, imaginary portraits, and landscapes, to meditate on (520 C.E.). Chinese landscape painting—*shanshui* or mountain-water—evolved in the tenth century. Artists such as Li Cheng (fl. 940–67 C.E.) shunned bright colors in favor of subtle shades of ink.

Some of the earliest purely decorative Japanese paintings are found on fans of the twelfth century. Painting was secularized around the eleventh century, when works of fiction were illustrated. These were called *Yamato-e* ("Japanese paintings") and differed from Chinese in format (longer but narrower) and subject matter. Pigment was applied thickly, with much use of gold and jade colors. The arrival of Europeans in the mid-sixteenth century was vividly recorded by Japanese artists on screens in bright, clear colors.

In the late seventeenth century, Chinese painters such as Hua Yan (1682–c. 1762) became obsessed with technique; subject matter was restricted to color-washed mountains and misty trees, painted in the "boneless" manner (without outlines). The Japanese *Ukiyo-e* ("painting of the floating world," i.e. modern) prints of the late eighteenth-century Edo period that inspired such Western artists as Van Gogh and Whistler would not have been considered art at all in China. In these prints, outlines were black, and forms were indicated by firm, consistent lines. As many as fifteen wood blocks were brushed with water-soluble pigment and rubbed into paper. The best-known master of *Ukiyo-e* was Katsushika Hokusai (1760–1849), who later in life signed himself "Manji, old man mad about painting." His vividly colored views of Mount Fuji reveal

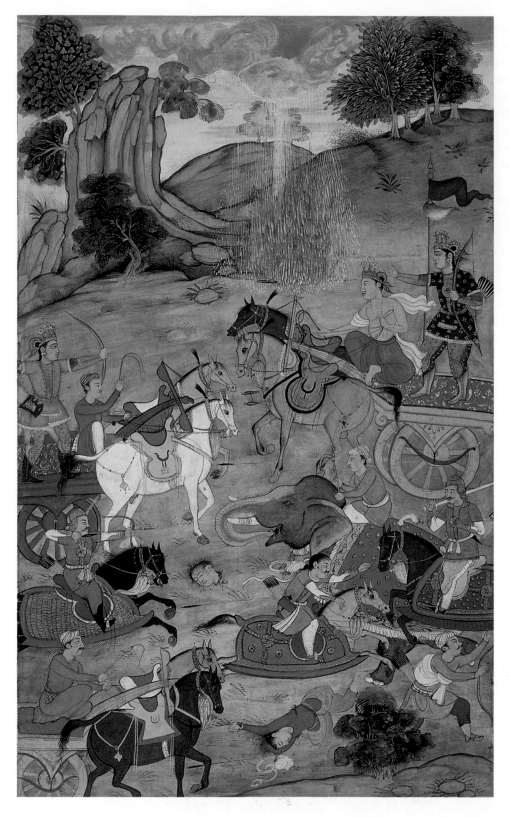

14.6 Ahmad Kashmiri, Mughal School, scene from the *Mahabharata*, 1598. Illuminated manuscript, detail. British Library, London. A rich pageant of daring color contrasts and juxtapositions can be seen, for example, in the pink saddle on the distant blue-green horse, or in the yellow and red saddle on the foreground black horse. Colors are rendered in a predominantly flat, decorative style with little shading.

a genius for decorative pattern-making which characterizes Japanese art.

Some Muslims believe that Muhammad condemned figurative painting. The Koran, however, mentions neither painting nor sculpture, and Muslim attitudes to painting are open to interpretation. Iranian miniature painting developed from Mesopotamian roots and the influence of Chinese Buddhist art introduced by the Mongols in the thirteenth century, to blossom in the sixteenth century with much use of gold and lapis lazuli,

and flat color with hatching, but no shading. Miniatures were introduced into India by the Mongols, but the bold contrasts of red, blue, green, and yellow in these narrative paintings owe more to Hindu heritage (**fig. 14.6**), and the depiction of distance by diminution of scale is taken from European art. These miniatures developed in the early seventeenth century into album paintings—of animals, flowers, and genre scenes—by artists such as the Mughal princess Sahifa Banu.

Romanticism and Impressionism

Advances in chemistry meant that many synthetic colors were introduced during the eighteenth and nineteenth centuries: cobalt blue in 1775, cobalt green in 1780, chrome yellow in 1809, emerald green in 1814, cerulean blue in 1821, zinc white in 1834, viridian in 1838, cobalt yellow in 1861, and alizarin crimson in 1869. Also in the eighteenth century, terra di colonia, or Cassel earth, was renamed Van Dyke brown after the great painter who loved this dark transparent color. Cadmium yellow, a favorite of Claude Monet, was introduced in 1819, replacing the toxic chrome yellows. One bizarre color of the nineteenth century was mummy brown, made from bone ash and asphaltum (or bitumen), obtained by grinding up Egyptian mummies. The color actually came from the asphaltum with which the bodies were embalmed. This grisly color is no longer available.

The period after the French Revolution was also one of revolution in science, industry, and philosophy. Eugène Delacroix (1798–1863), who was known as a great colorist, developed a daring use of color applied with great energy (**fig. 14.7**). He recreated color effects seen everywhere in nature, such as the color in shadows, often by juxtaposing complementary colors for the eye to combine at a distance.

The English painter Joseph Mallord William Turner (1775–1851) was often ridiculed for his free, violent, and energetic use of color. A critic described his 1840 painting *The Slave Ship* as "a passionate extravagance

14.7 Eugène Delacroix, *Liberty Leading the People*, 1830. Oil on canvas, 102 x 127 in (259 x 323 cm). Louvre, Paris. The political manifesto of the French Revolution (Liberty, Equality, Fraternity) is illustrated in the red, white, and blue colors of the Tricolor and reinforced throughout the composition. The various shades of blue in the sky, in the waistcoats, jackets, and uniforms of the falling and fallen victims, and in the dead man's sock—all play off against their darker, richer hue in the flag. The reds and off-whites dispersed throughout the painting also subtly resonate with the stronger hues in the flag.

14.8 Claude Monet, *Rouen Cathedral*, west portal, 1894. Oil on canvas, 35½ x 24½ cm (90.2 x 62.2 cm). Musée d'Orsay, Paris. Along with the other Impressionists, Monet abandoned the idea that things "possessed" certain colors and set about capturing the fleeting effects of changing light, time of day, season, and weather. This painting is one of a series of twenty canvases, all subtly different.

of marigold and pomegranate colored sea." Turner used pure color to catch the fleeting effects of light and often used mist, storms, and sunsets as a starting point to create almost abstract expressions of art for art's sake. More than once, his admirer John Ruskin came to his defense. Ruskin's writings inspired the Pre-Raphaelite Brotherhood, a group of artists including William Holman Hunt (1827–1910), John Everett Millais (1829–1896), and Dante Gabriel Rossetti (1828–1882), who reacted against academic art and vowed to go "back to nature". Their technique involved "tenderly" painting transparent and semi-transparent colors into a wet coating of white lead thin enough to show the drawing underneath, rather like fresco.

Impression—Sunrise by Claude Monet (1840–1926) gave the French movement its (originally sarcastic) name, when it caused an uproar amongst critics in an 1874 exhibition. Monet produced a composition in color alone: rather than using contrasting light and dark tones, he set off blues and greens with yellows and orange. Atmosphere had become everything. This can be observed twenty years later in *Rouen Cathedral* (**fig. 14.8**), where the palette sets off blues with yellows and orange to render an even hazier effect. He once said: "Try to forget what object you have before you—a tree, a house, a field, or whatever. Merely think, here is a square of blue, here an oblong of pink, here a streak of yellow, and paint it just as it looks to you."

The availability of ready-prepared colors in tubes, and the theories of physicist Michel-Eugène Chevreul, were both instrumental in the development of Impressionism. A typical Impressionist painting is a small landscape, usually painted on the spot, using a high-toned palette of clear, bright colors applied with varied, broken brushwork onto a canvas primed white. Pointillism was a term given to the Neo-Impressionist system of representing the shimmer of atmospheric light with unblended dabs of colored pigment by artists such as Georges Seurat (1859–1891). The dots of pure color are mixed by the eye, rather like the dots of process inks in color printing.

Vincent van Gogh (1853–1890) was unique. Painting in clashing contrasts of red, malachite green, and yellow, in agitated swirling brushstrokes, he attempted in such paintings as *The Night Café* (1888) to express "the terrible passions of humanity." His friend Paul Gauguin (1848–1903), in his South Seas paintings, preferred poetic and dreamlike, arbitrary colors rather than the "real" colors of nature. Gauguin is notable not simply for his rich, exotic color palette of gold, emerald green, and purples—but because he was one of the first

14.9 Vassily Kandinsky, *Several Circles, Number 323*, 1926. Oil on canvas, 55⅛ x 55⅛ in (140 x 140 cm). Guggenheim Museum, New York. Despite the overall effect of apparently arbitrary colors in this abstract, metaphysical, even sensual composition, the circle clusters demonstrate Kandinsky's careful choice of analogous and complementary colors. Kandinsky believed that there was a close affinity between harmony in color and in music.

artists to use color in an expressive, luxuriant way to heighten the mood of his work.

The paintings of Paul Cézanne (1839–1906) were the result of prolonged meditation in front of nature and demonstrated that subtle changes in the surface of a form and its spatial relationship to others could be expressed primarily in facets of color, modulated by varying degrees of tone, intensity, and temperature and by the introduction of complementary color accents. After 1882, he began to paint thinly, with a restricted palette of pale greens, earth colors, and blues.

Modernism

In 1905 a group of young painters including Henri Matisse (1869–1954) and André Derain (1880–1954) exhibited works with such "naive" bright colors that they were dubbed Les Fauves ("wild beasts"). The Fauves were an example of artists using arbitrary color.

Vassily Kandinsky (1866–1944) was a "spiritual" painter who took the expressiveness of Fauve colors into pure abstraction (**fig. 14.9**). He claimed that he

14.10 Helen Frankenthaler, *The Bay*, 1963. Acrylic on canvas, 6 ft 8¾ in x 6 ft 9¾ in (2.05 x 2.12 m). Detroit Institute of Arts. Gift of Dr. and Mrs. Hilbert H. DeLawter. For this color field painting, Frankenthaler initially thinned her paint and then poured it onto the canvas in veils of color. The advantage of acrylic is that different layers will not blend even when wet. The blue, especially, leaks like water into other areas of the picture plane but does not blend with them. The overall effect is reflective, even poetic.

experienced music in terms of color and vice versa, and that certain colors produce physical effects, such as taste, scent, touch (some colors are smooth, others prickly), and hearing (dark madder, he said, is like a soprano voice). He was also influenced by a religion called theosophy, which believes in colored auras and "thought forms": yellow forms, for example, are said to communicate intellectual fortitude, or mental strength and courage.

Another follower of theosophy, Piet Mondrian (1872–1944), became an abstract painter with an economical palette—not the earth colors of primitive peoples, but the primaries red, yellow, and blue (along with black and white), which he arranged into regular rectilinear shapes in his search for universal harmony.

Late Twentieth-Century Art

The introduction of permanent synthetic organic pigments such as phthalocyanine blue and green from around 1935 and the development of versatile acrylic paint in the 1950s made a full-spectrum range of pigments available to artists and allowed color to become a primary expressive element. Mark Rothko (1903–1970) was the master of a branch of abstract expressionism called "color field." Rothko's large, somber paintings contain soft, cloudy forms with frayed edges **scumbled** onto thinly painted, almost

dyed, fields of color producing a luminous grandeur that elicits a metaphysical or religious experience from the viewer.

In the early 1950s Helen Frankenthaler (b. 1928) inspired a new movement with her original technique of staining unprepared canvas by pouring acrylic paint on it (**fig. 14.10**). The color field school, as it was known, which included artists such as Kenneth Noland (b. 1924) and Morris Louis (1912–62), employed broad swathes of color, typically calm in mood and inward-looking.

Despite the ubiquity of conceptual art, there were still artists who took a delight in color and paint: the sublime flower studies of Georgia O'Keeffe (1887–1986), the vibrant fluency of Howard Hodgkin (b. 1932) and the sensual sheen of Gary Hume (b. 1962), who uses household gloss paints on aluminum. Artists of the late twentieth century went beyond pigment, using transmitted light, neon, or video to create works of art. In the light installations of James Turrell (b. 1943), especially his magical Skyspace structures around the world, he uses the sky itself to color the insides of white painted "rooms" (**fig. 14.11**). Says Turrell: "The sky is no longer out there, but it is right on the edge of the space you are in. The sense of color is generated inside you. If you then go outside you will see a different colored sky. You color the sky."

14.11 James Turrell, *Daygo*, 1990. Barbara Gladstone Gallery, New York. The boldness of the blue against its complementary orange is accentuated when the viewer discovers upon closer inspection that this is not in fact a blue surface on the wall but a hole in the wall through which blue light is shining.

COLOR IN THE APPLIED ARTS

Architecture and Interior Design

Color is a characteristic of all building materials. However, building materials are usually selected for their structural properties, so other colored materials are added to the surface as pigments, which preserve the texture of the original surface, or as claddings of stone, wood, or manufactured products that alter the surface character.

Color is often impermanent. It changes with the weathering and staining of materials (the once white Gothic cathedrals are now deep gray), or, if it is superficial, it can easily be altered or removed (as the colored stucco veneers of ancient Greek temples or the bright marble facing on Roman brickwork).

As in painting, the qualities associated with color are independent of materials and forms, and give the architect an added range of expression: colors that reflect light appear to advance toward the viewer; those that absorb light appear to recede. Thus the degree of projection and recession of architectural forms may be altered, emphasized, or subdued by the colors of their surfaces.

The Assyrians and Babylonians decorated their buildings with glazed tiles and bricks in the ninth century B.C.E. The Persians made luster and mosaic tiles from the thirteenth century onward. Throughout the

14.12 Charles W. Moore and William Hersey, Piazza d'Italia, New Orleans, 1978–79. The garish neon lights attract the eye to the imposing turquoise central entablature and its rounded arch, and to the rosy red Corinthian columns. The curved colonnades alternate red and yellow colors. This is kitsch classicism—a temple executed in a fairground style.

Middle Ages, church buildings were conceived as tangible symbols of heaven. Their architectural ornament, no matter how varied or lavish, was designed to promote this symbolism—whether by the use of gilt, stained glass windows, the brilliance of fresco colors, the awe-inspiring shape and size of the spaces, or the excellence of the craftsmanship. Mosques too are often decorated with colorful mosaics, tiles, and carvings.

Before post-modernism in the 1970s, color in architecture was usually very subtle and restrained (with the exceptions of the Mondrian-inspired buildings of the de Stijl group and the colorful façades of Art Deco buildings), but that all changed when architects such as Charles W. Moore (1925–93), Robert Venturi (b. 1925), and Michael Graves (b. 1934) went wild with color and ornament, often in a jokey and self-referential way (**fig. 14.12**). Viennese artist and

architect Friedensreich Hundertwasser (1928–2000) used buildings like huge canvases and decorated them with wacky colors. High-tech architects use color too, such as Richard Rogers' (b. 1933) color coding of the service ducts around the inside-out Pompidou Center in Paris.

Buildings can either blend or contrast with their surroundings. Frank Lloyd Wright's famous private houses, such as Fallingwater in Pennsylvania, have become one with nature. By contrast, there has always been a use of strong color on everyday buildings, especially in hot countries such as India, the West Indies, and in the Ndebele houses in South Africa. In some communities, fishermen painted their cottages in bright colors so they might more easily find their way home.

The paint industry dates back to the end of the eighteenth century—before that, craftspeople were responsible for preparing their own materials. Varnish factories were established in England in the 1790s and in Germany and France some thirty years later. Water-based paints—water and whitewash mixed with milk curds (calcium caseinate) as a binder—were used from the time of the Egyptians and Hebrews until the 1800s. At the end of the nineteenth century, powder paints consisted of glue-bound clays or whitings, with inorganic pigments added. Synthetic alkyd resins were developed in the 1920s and latex resins were introduced in the 1940s. Acrylic and polyvinyl acetate resins are now widely used.

Some pigments, such as red lead, inhibit corrosion and are used as primers on metalwork. Fillers and extenders, such as chalk, clays, and talc, determine the gloss or flatness of paint.

The surface of a building affects how it and its color are perceived. The rougher a texture is, the darker it will appear to be. Contrast also affects our perception of architecture. Light/dark contrasts can create three-dimensional effects on flat planes. The more a surface is broken up the smaller it appears, and smooth, flat surfaces can appear larger. Intelligent color use is capable of reversing these effects. A building containing many (dark) windows embedded in a white grid or surface will appear smaller than the same-sized building with blue-tinted windows set into a steel wall.

The color used on a building or its parts, such as the roof, has environmental impact. White reflects heat, while dark colors absorb heat and retain warmth. Therefore, a dark blue building will conserve energy, while appearing to be cooler and larger than it actually is. A building's color also affects the surrounding landscape. Shrubbery surrounding a traditional brick building can be either warm or cool green. If warm green, the foliage and the building will share a degree of yellow tonality—the orange of the brick and the yellow-green of the plants both contain yellow. However, if cool-green shrubbery is used, the effect will be complementary—the orange brick and the blue-green foliage. The landscape artist must thus make conscious, well-thought-out color decisions in order to produce the desired effect.

In interior design, lighting plays an important part in how colors are perceived: cool fluorescent lights emphasize the blue end of the spectrum; warm incandescent light gives a yellow-red cast. Color schemes are dictated by shifting tastes in fashion and personal preference but, as discussed in Chapter 13, the choice of color scheme can influence consumer habits in retail and restaurant environments, and psychological well-being in institutions and public spaces.

Furniture and Other Arts

Furniture and product design were also liberated by post-modernism, particularly by the Milan-based Memphis group, founded in 1980 by Ettore Sottsass (b. 1917). The crazy colors and kitsch textures had a retro 1950s feel and made extensive use of plastics and plastic laminates. Sottsass had previously co-designed a famous red Olivetti typewriter. Recently, the mainly beige (or sometimes black) world of computers has been turned upside-down by Jonathan Ive's (b. 1967) translucent iMac designs. Bondi blue was the first iMac color, followed by the "flavors": strawberry, blueberry, grape, tangerine, and lime.

Color forecasts for consumer items are discussed and predicted by international color committees, and new fashion trends trickle down, from fabric and women's clothing to home interiors, then to automobiles, and finally to architecture, depending on the lead times involved. Car colors have come a long way from Henry Ford's black Model T. But beware: research shows that silver cars have the happiest drivers, while the owners of pastel-colored cars are the most depressed. Drivers of white vehicles are least likely to be involved in an accident, and drivers are most at risk of one in a yellow car.

Ceramics have always been among the most colorful of household artifacts (**fig. 14.13**), from the orange and black vases of the Greeks, to the blue and white porcelain of the Ming dynasty in China (the blue Iran cobalt oxide color was introduced by the Mongols,

14.13 Elizabeth Fritsch, Stoneware bottle vase, early 1970s. Fritsch paints rectangular, crossed shapes on a blue background. Her matt colors and repeated shapes are often influenced by musical rhythms.

temperature. Glazes were produced by trial and error until the early twentieth century, when scientific tests and a greater understanding of chemistry perfected many new colors and effects.

Jewelry has long relied on the matching of colored precious and semi-precious stones with metals such as copper, gold, silver, and platinum. How a stone is cut will affect its color—smooth cuts will enhance a color's depth and faceted cuts will heighten brilliance (fire). Enameling—basically melted glass—is also used to add color to a design. For instance, a red ruby becomes redder when outlined with blue-green enamel, because it is a complementary pairing. Since the 1920s, plastics have opened up the range of colors to the jeweler at little expense, first imitating tortoiseshell and jet, but later coming into their own as versatile materials. Acrylics are now available in a huge range of colors and can be machined and treated to produce a wide range of finishes.

Fiber Arts

The most common forms of fiber art are embroidery, weaving and tapestry, quilting, and batik. Embroidery is the art of decorating textile fabric by means of a needle and thread (and sometimes fine wire). Ancient Egyptian tomb paintings show that clothes, couch covers, hangings, and tents were so decorated. People depicted on Greek vases from the seventh and sixth centuries B.C.E. are shown dressed in embroidered garments. Quilting was known to the ancient Persians and quilted garments were worn as armor.

The earliest surviving embroideries are Scythian, dated to between the fifth and third centuries B.C.E. Ancient Chinese embroideries have been found dating from the Tang dynasty (618–907 C.E.), but the most famous extant Chinese examples are the imperial silk robes of the Ching dynasty (1644–1911/12). Indian embroidery from the Mughal period (from 1556) found its way to Europe from the late seventeenth to the early eighteenth century through the East India trade, influencing English embroidery.

Northern European embroidery was, until the Renaissance, mostly ecclesiastical. The tenth-century stole of St Cuthbert, embroidered in gold thread, preserved in Durham Cathedral, is the earliest surviving English embroidery.

During the late medieval period known as Gothic, tapestry flourished. The Unicorn tapestries (1495–1505) employed a typical palette of dyes: madder (red), weld (yellow), and woad (blue). The weavers could extend their palette of colors by mixing them with various

who also introduced the technique of cloisonné enameling), to the bright but highly toxic orange uranium glazes of the 1920s. A glaze is a mixture of silicates that when applied to pottery and melted by the heat of the kiln combines with the clay body into hard glassy color. Medieval green and yellow pottery was produced by dusting the clay with powdered lead ore which was fired at low temperature. This both hardened the clay and coated it with lead oxide in one operation. Salt-glaze stoneware was produced when wet salt was thrown into the kiln at a higher

mordants, or color fixatives. In the sixteenth century, embroidery became an amateur craft associated with women. Samplers, used to record stitches and designs, became mainly decorative after the introduction of pattern books.

By the early nineteenth century, almost all types of embroidery in England and North America were superseded by a type of needlepoint known as Berlin woolwork. A later fashion, influenced by the Arts and Crafts movement and the Glasgow School, was "art needlework": embroidery done on coarse, natural-colored linen.

The native people of Central America produced a type of embroidery known as featherwork, and tribes of North America developed quillwork, embroidering skins and bark with dyed porcupine quills. Embroidery is also still used as an embellishment in western Africa and the Congo.

The modern-day embroiderer must be aware of how the background textile affects the overall color of a work. This is especially true for the technique known as blackwork. The student should refer to the legibility criteria on p. 87 and Appendix V to see how textile and thread colors should be combined in patterns. All embroidery makes use of optical mixing and value-order effects.

Some of the most vibrant colors are found in batik and silk painting (**fig. 14.14**). Batik is a wax-resist fiber art producing a characteristic white outline. Hot wax is applied to fabric serving as a resist, preventing the dye from reaching the fabric. The wax cracks during handling, allowing some dye to reach the fabric. Batik masters employ the process of repeated waxing and tub dyeing to achieve the final result. This method involves an understanding of color mixing and overdyeing, as each layer of dye is applied over the last, producing a new color. In silk painting, wax is applied to outlines and other portions of the design that are to remain white. Dye is then painted into areas inside the waxed lines, fixed by steaming or ironing, and the fabric is washed and dried.

Graphic Design and Printing

Trends in graphic design are often informed by the cutting edge of fine art, but are constrained by the limitations of the printing process. Graphic design was once concerned only with print; now designers may be using their expertise to produce websites or CD-roms. Designers may also have to coordinate corporate colors across a range of applications, in art-directing the promotion of a line of sportswear, for example: labeling (on clothes and delivery vans), packaging (on different substrates), and advertising (in various media). Color is perhaps the most important element in graphic design. Color is the first thing a consumer notices about a product, and companies take great pains to protect their logos: the red of Coca-Cola, the yellow of Crayola are instantly recognizable.

A single color used as a design element in a layout is called **flat color**, or sometimes match or spot color. In theory, you could use any number of different colors in a design. In practice, however, most printing presses are designed to to handle two, four, or even six colors in one printing.

Printers can match almost any color—from a color chart, a piece of printed work, or any swatch of color. But if you need consistency, between jobs and other related printed items, you have to be more methodical. The Pantone Matching System (PMS) is an industry-standard collection of numbered colors that printers recognize and are comfortable using (see fig. 4.8).

14.14 Jacqueline Guille, *Acrobats in Cairo (detail)*, 1991. Silk painting, 40 x 34 in (101.6 x 86.4 cm). The artist reserves her most vibrant colors for the suffused dyes of the acrobat in motion and the surrounding frame.

Color guides, in the form of fan charts or swatch books, are available that show all the shades, along with the formulas for mixing the ink. They also show the effect of colors printed on both coated and uncoated paper. Any color chosen from the Pantone range is made from a mixture of two or more from a set of nine basic colors: yellow, warm red, rubine red, rhodamine red, purple, violet, reflex blue, process blue, and green, supplemented by transparent white and black. Flat color can be printed solid or as a percentage tint.

However, if a job contains more than two colors (including black), it is neither economic nor practical to mix up ink and print every individual color to be found in a piece of artwork or color photograph, so another method has to be used. The secondary colors of transmitted light—yellow, magenta (process red), and cyan (process blue)—are used by printers to reproduce full color work. Colored filters were once used to produce separation negatives. The red filter allows only the blue and green components through, creating cyan. The green filter allows through only red and blue, creating magenta. And the blue filter lets through only the red and green, creating the yellow. The negatives taken through these filters were screened (converted into halftone dots) and the positives were used to make

plates to be printed in sequence and in register (correct alignment) in the process colors of cyan, magenta, and yellow. This is now all done by an electronic scanner and imagesetter.

In theory, all the colors added together should produce black, but in practice printing ink will never produce a pure enough black. So a fourth color—black—is added to deepen the dark areas and increase contrast. This makes the scheme a four-color process. In print jargon, black is referred to as "key," so the system is known as **CMYK**.

The screens are laid out at different angles, so that the dots are kept separate—the "mixing" of the colors is done by the eye—and in a pattern designed to eliminate moiré effects, when two patterns are visually superimposed to produce an unwanted new pattern. The screens of the main colors are oriented 30° to each other, with the stronger colors at 45°, 75°, and 105°, and the less intrusive yellow at the "difficult" angle of 90°.

Hexachrome, or hifi, printing uses six colors, adding orange and green to CMYK to increase the range of colors (the gamut) that can be reproduced. Prestigious print jobs, such as quality magazine covers, may also add extra Pantone colors (if the exact color of a logo, for example, demands it), metallic colors,

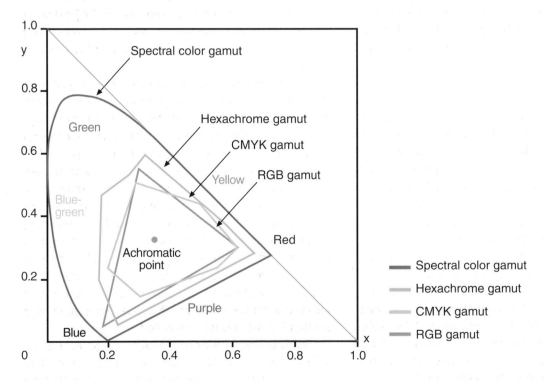

14.15 RGB versus CMYK color gamuts. The gamuts are plotted in a C.I.E. standard color space diagram (see page 18). RGB displays about 70%, and CMYK 30%, of colors detectable by the eye. The two extra colors (orange, green) added to CMYK by hexachrome printing increases a CMYK gamut dramatically.

or varnishes to increase the overall quality of color reproduction.

Computer Technology and the Internet

Most computer displays are based on the cathode-ray tube (CRT). The CRT functions due to substances called phosphors: electrically active materials that luminesce when bombarded by electrons. The electron gun at the back of the CRT scans the whole screen in horizontal lines, top to bottom, usually sixty times a second (60Hz). Each scan line is chopped into chunks called pixels (picture elements). The resolution (fineness) of a display is measured as the number of pixels horizontally by the number of scan lines vertically. Liquid crystal displays, found in laptop computers and increasingly in studio-sized displays, produce flicker-free slimline monitors.

Color-display systems come in two parts: the color screen itself, and the graphics card that drives it. Traditional tubes work in **RGB**—they have three electron guns, one each for the red, green, and blue dots on the screen (**fig. 14.15**). On their way to the screen, the beams are synchronized by a shadowmask—a metal mask with precisely placed holes through which the beams pass.

The number of colors a monitor can display is dependent on the amount of VRAM (video random access memory) on the graphics card. It comprises several layers or planes, with one bit (a 1 or a 0) stored for each pixel on each plane. The number of planes, and hence the number of bits allocated to each pixel, determines how many colors can be displayed. A mono screen (rare these days), without grayscales, has 1 bit per pixel. An 8-plane system can handle 2 to the power of 8, that is 256 different colors or grayscales. A 24-plane system can display 16.7 million colors. Each color—red, green, and blue—is allocated an 8-bit value, to drive the red, green, and blue electron guns in the tube.

However, even assuming that a computer is creating 16.7 million different spectral compositions (sets of wavelengths), it does not follow that the computer produces 16.7 million distinguishably different colors. Under best conditions, humans can distinguish only about one million colors—combinations of hue, saturation, and brightness. Furthermore, a CRT monitor can't produce all of the million colors that the eye can distinguish, specifically the most saturated colors. Ambient light falling on the screen further lowers saturation and shrinks the number of colors the display can produce.

The color coming from a color monitor, being transmitted light, will never be the same as the color reflected from a printed page. This is a problem for designers working on a computer. Using image manipulation software such as Adobe Photoshop, a designer will work in RGB and at the last moment convert to CMYK, being aware that the lower gamut of print will not be able to produce all the colors seen on screen. Color management systems such as ColorSync aim to prevent surprises by coordinating all the devices in the production stream: from display screen, to proofing printer, to the finished print job.

Color printer technologies range from the common inkjet found in most desktop printers to dye sublimation, producing near photographic quality. Inkjet printers spray jets of microscopic electrically charged droplets of ink onto a moving roll of paper. These jets of ink are deflected by electromagnets—just like the electron beam in a television tube—to build up the image. Bubblejet printers have an array of thin nozzles in the print head, each of which is full of ink, held there by surface tension. A small heating element causes a bubble to form which forces the ink out of the nozzle and onto the page. Another variation is the thermo-jet plotter, which sprays melted plastic onto the paper.

Giclée printers (from the French for "spraying" or "spreading") are medium to large-format inkjet devices printing onto substrates such as watercolor paper using archival ink. Output is specifically targeted to creating fine-art prints.

Thermal-transfer plotters use an inked-roll cartridge sandwiched between the mechanism and the drawing. It acts like carbon paper, "ironing" the image onto clay-coated paper. The three process colors (and sometimes black) are applied, one at a time, by melting a dot of wax onto the paper or acetate. The machines are cleaner and dryer than inkjets, but consumables are more expensive. Dye-sublimation printers mix ink vapor on treated paper without using dots, producing a high-quality image. Sublimation is the phenomenon whereby certain substances go directly from solid to a gaseous form, without the usual intermediate liquid stage. The thermal head on a dye-sublimation printer varies the temperature so that the amount of dye emitted is continuously controlled.

Website designers work in RGB all the time, and at a screen resolution of 72 dpi (dots per inch), so what they see on the screen will be the same as in the finished product. There are slight differences, however, in the way Macs and PCs display colors, and how browsers,

such as Netscape and Explorer, parse the color information. Most people are assumed to have at least a 256-color monitor, and taking into account the slightly different palettes of the two main browsers, we arrive at 216 "web-safe" colors, which will be displayed without resorting to optically mixing two or more colors. Thus white is FFFFFF and black is 000000.

Web colors are described using three sets of hexadecimal numbers (i.e. base 16), one each for red, green, and blue. Some web creators prefer to specify colors by name rather than by hexadecimal value. There are 136 standard colors with names that are recognized by most browsers. Many of these colors are not among the 216 web-safe colors and may be dithered. These include such exotic names as Blanched Almond (FFEBCD), Chocolate (D2691E), Dodger Blue (1E90FF), Fuchsia (FF00FF), Old Lace (FDF5E6), Thistle (D8BFDB), and Tomato (FF6347).

This whistlestop tour of color applications in fine and applied art is intended to inspire readers to give their own imaginations free rein. Though we have been able only to scratch the surface, it is clear that history provides an almost limitless variety of examples of how humans have used color through time—to heighten realism, dramatize artists' feelings, beautify the human form, blend in with the environment, or match the human eye's powers of discrimination.

Exercises

1 Find examples of compositions using complementary and analogous colors from the history of art.

2 Compare portraits by van Eyck (fig. 14.5), Rembrandt (fig. 6.13) and van Gogh (fig. 10.12). How does their different color use affect our reading of these pictures and the people depicted in them?

Coloring Agents—Dry Binders

Medium/Material	Binder
Pencil	Graphite
Chalk	Non-fat clay, kaolin
Crayon	Fatty or greasy—wax
Conté crayon	Oil
Oil pastel (Craypas)	Linseed oil and solids (wax)
Colored pencil	Wax
Litho crayon	Greasy solid

Medium/Material	Binder
Graphite	Greasy, dark-gray form of carbon mixed with clay to make lead powdered form. May be used as dry pigment or in paints
Pastel	Powdered pigment or chalk pressed into stick form. Hardness determined by amount of binder used. Chalk controls depth of color

Coloring Agents—Liquid Binders

Medium/Material	Binder
Ink	Liquid
Oil paint	Linseed oil (vegetable based oil). Serves as a natural polymer. Will not warp a surface but can rot fibers. Slow drying. Darkens as it dries
Encaustic	Hot beeswax. Used in early painting, preceded oil paints
Fresco	Water. Water paint is painted on fresh lime plaster and the two substances fuse together
Egg tempera	Egg yolk and linseed oil or water. Transparent, dries quickly. Does not blend well
Acrylic	Acrylic polymer. Quick drying and flexible. Comes in matte or glossy form.
Watercolor	Gum arabic, glycerine and/or honey. Transparent
Gouache (designer colors)	Opaque white plus watercolor

Medium/Material	Binder
Distemper (poster paint)	Water soluble glue or gum, opaque, inexpensive
Lithography ink	Oil based ink
Ceramic glaze	Made of three basic ingredients: silica, flux and alumina as well as pigments. Can be either transparent or opaque. Matte glaze—dull surface when fired. Fritted glazes—contain water soluble chemicals to enhance color clarity; two types are "f-series"—semi-opaque, brilliant colors, used with pottery clays; "high fire glazes"—porcelain, stoneware, have matte, textured and transparent gloss glazes. May also contain lead
Casein	Milk-derived polymer
Stained glass	Metal-based pigment in liquid molten glass
Enamel	Pigment plus powdered glass. Fused to metal by heat

APPENDIX 3

Coloring Agents—Pigment Origins and Characteristics of Common Colors

Alizarin: originally a vegetable dye from madder, highly fast, brilliant red, transparent
Aureolin: transparent
Blue: indigo plant
Burnt sienna: heated clay from Sienna, Italy, mineral, transparent
Burnt umber: mineral
Cadmium: opaque
Cadmium yellow: greenokite, permanent but dulls quickly
Carmine: organic, vegetable
Chrome yellow: turns green or greenish black in time

Cinnabar red: sulphide of mercury
Cobalt blue: opaque
Earth colors: browns, low intensity earth pigments such as iron oxide or clays, common names are raw sienna, raw umber, burnt sienna, burnt umber, yellow ochre
Flake white: mineral, pure white lead
Green: malachite
Indigo: organic, vegetable
Lead white: mineral, slightly gray
Mars yellow: transparent
Prussian blue: transparent
Raw sienna: pure ground clay from Sienna, Italy, mineral, transparent

Red: cochineal (insects)
Rose madder: organic from roots
Royal purple: sea snails' mucus
Sap green: organic, vegetable
Sepia: organic, animal
Titanium white: mineral, slightly pink
Ultramarine blue: mineral, deep blue pigment, transparent, historically was powdered lapis lazuli
Umber: clay from Umbria, Italy
Vermillion: opaque
Yellow ochre: mineral, opaque
Zinc white: oxide of zinc, mineral, slightly yellow

APPENDIX 4

Hue—Various Art Media Matched to Color-Aid Paper Pure Hues

Luma Water Color Formulas
The numbers indicate the number of drops required. When mixing be precise and do not add excess water. Make sure the brush is cleaned thoroughly after each color. Make sure the color is painted evenly and solidly without streaking or allowing the white paper to show through.

YELLOW: sunshine yellow
YELLOW-ORANGE-YELLOW: 22 sunshine yellow, 1 permanent crimson
YELLOW-ORANGE: 14 sunshine yellow, 1 permanent crimson
ORANGE-YELLOW-ORANGE: 8 sunshine yellow, 1 permanent crimson
ORANGE: 4 sunshine yellow, 1 permanent crimson
ORANGE-RED-ORANGE: 2 sunshine yellow, 1 permanent crimson
RED-ORANGE: 1 permanent crimson, 1 sunshine yellow
RED-ORANGE-RED: 2 permanent crimson, 1 sunshine yellow
RED: permanent crimson
RED-VIOLET-RED: 1 permanent violet, 1 permanent crimson

RED-VIOLET: permanent violet
VIOLET-RED-VIOLET: 2 permanent violet, 2 permanent crimson, 1 permanent blue
VIOLET: 3 permanent violet, 1 permanent blue
VIOLET-BLUE-VIOLET: 2 permanent violet, 2 permanent blue
BLUE-VIOLET: 3 permanent blue, 2 permanent violet
BLUE-VIOLET-BLUE: 3 permanent blue, 1 permanent violet
BLUE: 9 permanent blue, 1 permanent crimson
BLUE-GREEN-BLUE: 10 permanent blue, 2 permanent green, 1 permanent crimson
BLUE-GREEN: 4 permanent green, 17 permanent blue
GREEN-BLUE-GREEN: 4 permanent green, 7 permanent blue
GREEN: 3 permanent green, 1 permanent blue
GREEN-YELLOW-GREEN: 1 sunshine yellow, 6 permanent green, 1 permanent blue
YELLOW-GREEN: permanent green
YELLOW-GREEN-YELLOW: 2 sunshine yellow, 1 permanent green
CYAN: 10 permanent blue, 4 permanent green
MAGENTA: 12 permanent violet, 3 permanent crimson

Windsor & Newton Designer Colors
The numbers indicate the number of drops required.

YELLOW: spectrum yellow
YELLOW-ORANGE-YELLOW: 1 spectrum yellow, 1 marigold
YELLOW-ORANGE: marigold
ORANGE-YELLOW-ORANGE: 2 winsor orange, 1 marigold
ORANGE: winsor orange
ORANGE-RED-ORANGE: 1 scarlet, 2 winsor orange
RED-ORANGE: scarlet
RED-ORANGE-RED: 1 scarlet, 1 crimson
RED: crimson
RED-VIOLET: 1 quinacridone red, 3 quinacridone violet
VIOLET-RED-VIOLET: quinacridone violet
VIOLET: 2 quinacridone violet, 1 dioxazine violet
VIOLET-BLUE-VIOLET: dioxazine violet

BLUE-VIOLET: 1 dioxazine violet, 1 ultramarine
BLUE-VIOLET-BLUE: 1 dioxazine violet, 4 ultramarine
BLUE: ultramarine
BLUE-GREEN-BLUE: 1 turquoise green, 3 ultramarine
BLUE-GREEN: turquoise green
GREEN-BLUE-GREEN: 4 turquoise green, 1 brilliant green
GREEN: 1 turquoise green, 1 brilliant green
GREEN-YELLOW-GREEN: 1 turquoise green, 4 brilliant green
YELLOW-GREEN: 1 spectrum yellow, 2 brilliant green
YELLOW-GREEN-YELLOW: 2 spectrum yellow, 1 brilliant green
CYAN: process cyan
MAGENTA: process magenta

Rotring Colors

The numbers indicate the number of drops required.

YELLOW: 1 lemon yellow, 1 yellow gold
YELLOW-ORANGE-YELLOW: 1 orange, 6 lemon yellow
YELLOW-ORANGE: 1 orange, 2 lemon yellow
ORANGE-YELLOW-ORANGE: 1 orange, 1 yellow gold
ORANGE: orange
ORANGE-RED-ORANGE: 2 orange, 1 red
RED-ORANGE: 1 red, 1 orange
RED-ORANGE-RED: 2 red, 1 orange
RED: red
RED-VIOLET-RED: 1 purple, 1 red
RED-VIOLET: purple
VIOLET-RED-VIOLET: 1 blue violet, 1 purple
VIOLET: blue violet
VIOLET-BLUE-VIOLET: 1 blue, 2 blue violet
BLUE-VIOLET: 1 blue, 4 blue violet
BLUE-VIOLET-BLUE: 1 blue, 1 blue violet
BLUE: blue
BLUE-GREEN-BLUE: 1 turquoise, 1 blue
BLUE-GREEN: turquoise
GREEN-BLUE-GREEN: 1 green, 1 turquoise
GREEN: green
GREEN-YELLOW-GREEN: 2 green, 1 lemon yellow
YELLOW-GREEN: 1 green, 1 lemon yellow

YELLOW-GREEN-YELLOW: 1 green, 4 lemon yellow
CYAN: none
MAGENTA: none

Liquitex Acrylic Paints

YELLOW: yellow medium Azo or cadmium yellow light
YELLOW-ORANGE-YELLOW: none
YELLOW-ORANGE: brilliant orange/cadmium orange hue
ORANGE-YELLOW-ORANGE: none
ORANGE: none
ORANGE-RED-ORANGE: scarlet red/cadmium red light hue
RED-ORANGE: naphthol red light
RED-ORANGE-RED: none
RED: acra violet
RED-VIOLET-RED: deep magenta
RED-VIOLET: none
VIOLET-RED-VIOLET: prism violet
VIOLET: dioxazine purple
VIOLET-BLUE-VIOLET: none
BLUE-VIOLET: none
BLUE-VIOLET-BLUE: none
BLUE: brilliant blue purple
BLUE-GREEN-BLUE: cerulean blue hue (ultramarine blue)
BLUE-GREEN: none
GREEN-BLUE-GREEN: phthalocyanine green
GREEN: permanent green deep
GREEN-YELLOW-GREEN: none
YELLOW-GREEN: permanent green
YELLOW-GREEN-YELLOW: vivid lime green
CYAN: none
MAGENTA: none

Liquitex Concentrated Artist Colors

YELLOW: brilliant yellow
YELLOW-ORANGE-YELLOW: none
YELLOW-ORANGE: brilliant orange
ORANGE-YELLOW-ORANGE: none
ORANGE: none
ORANGE-RED-ORANGE: scarlet
RED-ORANGE: none
RED-ORANGE-RED: lacquer red
RED: naphthol crimson
RED-VIOLET-RED: raspberry
RED-VIOLET: none
VIOLET-RED-VIOLET: none
VIOLET: prism violet
VIOLET-BLUE-VIOLET: none
BLUE-VIOLET: twilight
BLUE-VIOLET-BLUE: none
BLUE: none

BLUE-GREEN-BLUE: swedish blue
BLUE-GREEN: none
GREEN-BLUE-GREEN: none
GREEN: none
GREEN-YELLOW-GREEN: christmas green
YELLOW-GREEN: green
YELLOW-GREEN-YELLOW: none
CYAN: brilliant blue
MAGENTA: none

PrismaColor Markers

Hues are created by layering colors in the order shown. The first number is laid down first with the second number on top of it to create the hue.

YELLOW: PM 19
YELLOW-ORANGE-YELLOW: PM 15
YELLOW-ORANGE: PM 16
ORANGE-YELLOW-ORANGE: PM 13
ORANGE: PM 14, PM 13
ORANGE-RED-ORANGE: PM 13, PM 5
RED-ORANGE: PM 6, PM 4, PM 6
RED-ORANGE-RED: PM 4
RED: PM 5, PM 4, PM7
RED-VIOLET-RED: PM 53, PM 7
RED-VIOLET: PM 53, PM 51, PM 53
VIOLET-RED-VIOLET: PM 53, PM 51
VIOLET: PM 51, PM 168
VIOLET-BLUE-VIOLET: PM 168, PM 45
BLUE-VIOLET: PM 45
BLUE-VIOLET-BLUE: PM 42, PM 44
BLUE: PM 42, PM 44, PM 48
BLUE-GREEN-BLUE: PM 40, PM 48
BLUE-GREEN: PM 125, PM 37
GREEN-BLUE-GREEN: PM 185
GREEN: PM 186, PM 185
GREEN-YELLOW-GREEN: PM 165, PM 167
YELLOW-GREEN: PM 165, PM 167, PM 24
YELLOW-GREEN-YELLOW: PM 167, PM 24
CYAN: PM 39
MAGENTA: PM 53

PrismaColor Pencils

YELLOW: 916 canary yellow
YELLOW-ORANGE-YELLOW: 917 yellow orange
YELLOW-ORANGE: 918 orange
ORANGE-YELLOW-ORANGE: 921 vermillion red
ORANGE: none
ORANGE-RED-ORANGE: 922 scarlet red

RED-ORANGE: 924 crimson red
RED-ORANGE-RED: 923 scarlet lake
RED: none
RED-VIOLET-RED: none
RED-VIOLET: 931 purple
VIOLET-RED-VIOLET: none
VIOLET: 932 violet
VIOLET-BLUE-VIOLET: none
BLUE-VIOLET: none
BLUE-VIOLET-BLUE: 933 blue violet
BLUE: 902 ultramarine
BLUE-GREEN-BLUE: 906 copenhagen
 blue
BLUE-GREEN: 908 dark green
GREEN-BLUE-GREEN: 907 peacock
 green
GREEN: 909 grass green
GREEN-YELLOW-GREEN: none
YELLOW-GREEN: none
YELLOW-GREEN-YELLOW: 912 apple
 green
CYAN: 903 true blue
MAGENTA: 930 magenta

Duncan Gloss Ceramic Glazes

YELLOW: sun yellow GL 670
YELLOW-ORANGE-YELLOW: orange
 peel GL 657
YELLOW-ORANGE: pumpkin orange
 GL 781
ORANGE-YELLOW-ORANGE: none
ORANGE: tangerine GL 632
ORANGE-RED-ORANGE: none
RED-ORANGE: none
RED-ORANGE-RED: christmas red GL
 637
RED: matador red GL 614
RED-VIOLET-RED: none
RED-VIOLET: none
VIOLET-RED-VIOLET: none
VIOLET: none
VIOLET-BLUE-VIOLET: none
BLUE-VIOLET: midnight blue GL 784
BLUE-VIOLET-BLUE: royal blue GL
 634
BLUE: aegean blue GL 676
BLUE-GREEN-BLUE: catalina blue GL
 648
BLUE-GREEN: basque blue GL 661
GREEN-BLUE-GREEN: none
GREEN: emerald green GL 609
GREEN-YELLOW-GREEN: none
YELLOW-GREEN: none
YELLOW-GREEN-YELLOW: green
 mint GL 671
CYAN: none
MAGENTA: none

D.M.C. Embroidery Floss

YELLOW: 444
YELLOW-ORANGE-YELLOW: 972
YELLOW-ORANGE: 741
ORANGE-YELLOW-ORANGE: 970
ORANGE: 946
ORANGE-RED-ORANGE: 608
RED-ORANGE: 606
RED-ORANGE-RED: 350
RED: 326
RED-VIOLET-RED: none
RED-VIOLET: 917
VIOLET-RED-VIOLET: none
VIOLET: none
VIOLET-BLUE-VIOLET: none
BLUE-VIOLET: 791
BLUE-VIOLET-BLUE: none
BLUE: 796
BLUE-GREEN-BLUE: 824
BLUE-GREEN: 806
GREEN-BLUE-GREEN: 991
GREEN: 909
GREEN-YELLOW-GREEN: 699
YELLOW-GREEN: 701
YELLOW-GREEN-YELLOW: 702
BLACK: 310
WHITE: blanc or white

Susan Bates/Anchor Embroidery Floss

YELLOW: 291
YELLOW-ORANGE-YELLOW: 303
YELLOW-ORANGE: 314
ORANGE-YELLOW-ORANGE: 324
ORANGE: 330
ORANGE-RED-ORANGE: 335
RED-ORANGE: 334
RED-ORANGE-RED: 9036
RED: 47
RED-VIOLET-RED: 65
RED-VIOLET: 94
VIOLET-RED-VIOLET: 101
VIOLET: 112
VIOLET-BLUE-VIOLET: 119
BLUE-VIOLET: 178
BLUE-VIOLET-BLUE: 941
BLUE: 132
BLUE-GREEN-BLUE: 147
BLUE-GREEN: 162
GREEN-BLUE-GREEN: 189
GREEN: 923
GREEN-YELLOW-GREEN: 228
YELLOW-GREEN: 244
YELLOW-GREEN-YELLOW: 239
BLACK: 403
WHITE: 1

Paternayan Persian Wool Yarn

YELLOW: 772
YELLOW-ORANGE-YELLOW: 770
YELLOW-ORANGE: 813
ORANGE-YELLOW-ORANGE: 811
ORANGE: 810
ORANGE-RED-ORANGE: 821
RED-ORANGE: 820
RED-ORANGE-RED: 951
RED: 941
RED-VIOLET-RED: 903
RED-VIOLET: none
VIOLET-RED-VIOLET: none
VIOLET: 311
VIOLET-BLUE-VIOLET: 330
BLUE-VIOLET: none
BLUE-VIOLET-BLUE: 340
BLUE: 541
BLUE-GREEN-BLUE: 551
BLUE-GREEN: 581
GREEN-BLUE-GREEN: 574
GREEN: 681
GREEN-YELLOW-GREEN: 620
YELLOW-GREEN: 696
YELLOW-GREEN-YELLOW: 631
BLACK: 220
WHITE: 260

Medici Wool Yarn

YELLOW: none
YELLOW-ORANGE-YELLOW: 8742
YELLOW-ORANGE: 8941
ORANGE-YELLOW-ORANGE:
 none
ORANGE: 8908
ORANGE-RED-ORANGE: none
RED-ORANGE: 8128
RED-ORANGE-RED: 8127
RED: 8103
RED-VIOLET-RED: none
RED-VIOLET: 8123
VIOLET-RED-VIOLET: none
VIOLET: 8794
VIOLET-BLUE-VIOLET: none
BLUE-VIOLET: none
BLUE-VIOLET-BLUE: none
BLUE: 8720
BLUE-GREEN-BLUE: 8993
BLUE-GREEN: 8207
GREEN-BLUE-GREEN: none
GREEN: none
GREEN-YELLOW-GREEN: none
YELLOW-GREEN: none
YELLOW-GREEN-YELLOW: none
BLACK: noir
WHITE: blanc

Appleton Crewel Wool Yarn

YELLOW: 550-3
YELLOW-ORANGE-YELLOW: none
YELLOW-ORANGE: 550-6
ORANGE-YELLOW-ORANGE: none
ORANGE: none
ORANGE-RED-ORANGE: 440-3
RED-ORANGE: 440-5
RED-ORANGE-RED: 500-1
RED: 500-2
RED-VIOLET-RED: none
RED-VIOLET: none
VIOLET-RED-VIOLET: 450-5
VIOLET: none
VIOLET-BLUE-VIOLET: none
BLUE-VIOLET: 460-5
BLUE-VIOLET-BLUE: none
BLUE: 820-3
BLUE-GREEN-BLUE: none
BLUE-GREEN: 480-6
GREEN-BLUE-GREEN: 520-7
GREEN: 430-6
GREEN-YELLOW-GREEN: 420-8
YELLOW-GREEN: none
YELLOW-GREEN-YELLOW: none
BLACK: 993
WHITE: 991

Au Ver A Soie Silk Yarn

YELLOW: 536
YELLOW-ORANGE-YELLOW: 545
YELLOW-ORANGE: 624
ORANGE-YELLOW-ORANGE: 634
ORANGE: 636
ORANGE-RED-ORANGE: 913
RED-ORANGE: 915
RED-ORANGE-RED: 941
RED: 945
RED-VIOLET-RED: 3026
RED-VIOLET: 1046
VIOLET-RED-VIOLET: 1315
VIOLET: 3315
VIOLET-BLUE-VIOLET: none
BLUE-VIOLET: 1424
BLUE-VIOLET-BLUE: 116
BLUE: 4924
BLUE-GREEN-BLUE: 115
BLUE-GREEN: 126
GREEN-BLUE-GREEN: 1825
GREEN: 216
GREEN-YELLOW-GREEN: 235
YELLOW-GREEN: 224
YELLOW-GREEN-YELLOW: 223
BLACK: noir
WHITE: blanc

D.M.C. Rayon Floss

YELLOW: none
YELLOW-ORANGE-YELLOW: none
YELLOW-ORANGE: none
ORANGE-YELLOW-ORANGE: none
ORANGE: none
ORANGE-RED-ORANGE: 30606
RED-ORANGE: none
RED-ORANGE-RED: 30666
RED: 30321
RED-VIOLET-RED: none
RED-VIOLET: 30915
VIOLET-RED-VIOLET: none
VIOLET: none
VIOLET-BLUE-VIOLET: none
BLUE-VIOLET: 30336
BLUE-VIOLET-BLUE: none
BLUE: 30797
BLUE-GREEN-BLUE: none
BLUE-GREEN: none
GREEN-BLUE-GREEN: none
GREEN: 30909
GREEN-YELLOW-GREEN: none
YELLOW-GREEN: none
YELLOW-GREEN-YELLOW: none
BLACK: 30310
WHITE: 35200

APPENDIX 5

Color Legibility Rankings

Background Color	Lettering/Line Color	Background Color	Lettering/Line Color
1 yellow	black	16 red	black
2 black	yellow	17 orange	blue
3 white	green	18 green	yellow
4 white	red	19 red	yellow
5 white	black	20 red	white
6 blue	white	21 black	red
7 yellow	blue	22 orange	white
8 white	blue	23 green	black
9 black	white	24 white	orange
10 yellow	green	25 blue	orange
11 orange	black	26 orange	yellow
12 yellow	red	27 orange	red
13 blue	orange	28 red	blue
black	orange	green	red
14 blue	yellow	29 orange	green
15 green	white		

Glossary

Achromatic: No hue present; without chroma.

Achromatic simultaneous contrast: Simultaneous contrast that concerns itself with the interactions of black, white, and grays.

Additive color: The process of mixing the colors of light together.

Afterimage: A reaction seen when the observer's brain supplies the opposite or complementary hue after the observer stares at a particular hue.

Analogous color scheme: A color scheme based on three or more hues located next to each other on the color wheel.

Analogous hues: Hues adjacent to each other on the color wheel.

Aniline dye: The first synthetic dye, based on alcohol and coal-tar derivatives.

Arbitrary color: The effect of color as produced by the artist imposing feelings on an object's color. This effect abandons natural color.

Architectural order: A sequence with the lightest value at the top and the darkest at the bottom.

Artificial light: Light created by artificial means. Three types: incandescent (warm), electric arc and fluorescent.

Asymmetrical balance: Balance that relies on non-symmetrical design components, in which both sides of the work art not the same or divisible.

Atmospheric perspective: The color reactions that occur when colors are perceived from a distance. As objects become more distant from the eye the value contrast lessens, the edges become less defined, and the hues become more neutral or dull with a bluish-gray cast.

Azo dye: A dye based on petroleum.

Balance: The overall appearance of a work that imparts unity. There are three types: symmetrical balance, asymmetrical balance, and radial balance.

Bezold effect: The effect that occurs when colors are changed by juxtaposing them with different colors. Also known as the spreading effect.

Binder: A vehicle that transforms pigments into a workable tool.

Broken hue: A color that is a combination in unequal proportions of all the primaries. Also termed broken color.

Broken tint: A broken hue with the addition of white or black. Also known as nature gray.

Cast shadow: A shadow thrown by an object onto an adjacent surface.

Chiaroscuro: The use of light and shadow effects in a painting.

Chroma: The saturation or brightness of a color. Chroma can also define the purity of a hue and describe a hue or color's strength.

Chroma strength: The degree of difference in pure hue strength. Yellow has the greatest chroma strength.

Chromatic: Having a hue.

Chromatic black: Black that is the result of mixing red, yellow, and blue together.

Chromatic grays: *See* warm grays.

Chromaticity: In lights, a measure of the combination of hue and saturation in a color.

Chromatic simultaneous contrast: Simultaneous contrast that concerns itself with hue/color changes that occur due to the influence of the surrounding hues/colors.

Chromotherapy: The use of color for healing purposes.

CMYK system: The four-color (cyan, magenta, yellow, black or "key") screen system used to reproduce color photographs.

Color blindness: Defective color vision that results in color identification confusion.

Color harmonies: *See* color schemes.

Color schemes: Partitive combinations of pure hues and their variations that are harmonious.

Color theory: The study of color that uses various types of order, observation, scientific fact, and psychology to explain color reactions and interactions.

Color wheel: A circular model showing color relationships.

Colored gray: The resulting color derived from adding a pure hue's exact value of gray.

Complementary color scheme: A color scheme built on two hues directly opposite each other on the color wheel.

Complementary hues: Hues directly across from each other on the color wheel.

Cones: Cells in the retina that are sensitive to bright light and color.

Contrast: The visual difference between colors.

Cool grays: The result of mixing white with a commercially produced black.

Cool hues: Cool hues are usually related to blue and include: yellow-green, green, blue-green, blue, blue-violet, and violet. Blue-green is the coolest hue.

Core of shadow: The most concentrated area of darkness on an object.

Deuteranopia: A form of color blindness in which sensitivity to green is reduced.

Diffraction: The breaking up of a beam of light into a series of dark or light bands or colored spectra, after hitting an obstacle.

Dimension: The property of a color. There are four: hue, value, intensity, and temperature.

Disappearing boundaries: The effect obtained when adjacent hues of the same or near value are in a partitive setting.

Discord: The effect obtained when the value of a hue is opposite to its natural order.

Dissolving boundaries: The effect obtained when equal-valued related broken colors are found in a partitive setting.

Divisionism: The optical mixing of lines, crossed lines, or dots of different colors on a ground other than white.

Double complementary color scheme: A color scheme based on two sets of complementary colors. When the hues are spaced equidistantly on the color wheel, this is known as a quadrad color scheme.

Dye: A pigment dissolved in a fluid.

Earth color: A broken hue found in nature.

Electric arc light: An artificial light that uses various gases to impart a variety of film colors to a surface.

Emphasis: The creation of areas of visual importance for the viewer to focus upon.

Equivocal space: When the eye goes in and out of space simultaneously, so that space appears to change as we view it.

False pairs: The colors resulting from the mixtures of pairs of orange, purple, and green.

Far-reaching space: Space that usually extends far beyond the picture plane.

Film color: The effect on a surface color when certain atmospheric conditions are imposed on it.

Flat color: A single solid area of color used as a design element in printing; also match or spot color.

Flat composition: A composition that relies on hue changes and does not usually have fine shading or modeling.

Fluorescent light: An artificial light that casts a blue tonality.

Focal point: An area within a composition that provides emphasis and causes the viewer to be drawn to it.

Form: A three-dimensional shape that implies volume.

Fovea: The area at the back of the retina that contains only cone cells and therefore is the area of sharpest color definition.

Frit: A glass color made by roasting an ore with other ingredients.

Gesso: A primer that provides a uniform painting surface.

Glazing: The layering of transparent colors.

Harmony: The visual agreement of all the parts of a work which results in the unity of the work.

Hexachrome: A type of printing that adds orange and green to the CMYK system to increase the range of colors.

Highlight: The lightest value on an object's surface.

Hue: The identification or name of a color.

Illusionary space: Two-dimensional space that can be created by color values.

Incandescent light: A type of artificial light that bathes the area in a yellowish glow; also called warm light.

Intensity: Saturation, or the degree of purity of a hue.

Intensity scale: An arrangement of color chips that are the result of mixtures of various quantities of pure hue pigment wheel complements.

Integral tripack: Photography film with three layers of gelatin each of which takes care of a different color.

Interaction: A color's reaction to its placement or position.

Interference of light: The color reaction caused by changing the viewer's position; the blocking of some light or illumination by another object; or a weather condition.

Intermediate hue: *See* secondary color.

Interpenetration: A color interaction that occurs along the edges of abutting areas of color.

Intervaled scale: A color scale that forms a smooth equal visual transition from one component of the scale to the next.

Iridescence: The play of colors due to a change of position that results in a glittering effect.

Irradiation: Contrasts created between an object and the ground.

Ishihara test: A test used for color blindness and color confusion diagnosis.

Kinetic effect: The effect resulting from warm/cool contrast.

Lake: A pigment that is combined with a dye to extend the pigment range.

Law of field size: The effect that illumination imposes upon a work.

Light notations: Notations as assigned by Goethe to hues, denoting their strength.

Light wheel: A color wheel arrangement of hues that are the result of projected colored lights. Its primaries are red, green, and blue, and this wheel is the basis for additive color.

Line: A continuous mark on a surface, which imparts motion and contour to images.

Linear composition: The crisp, clean delineation of forms.

Local color: The effect of color as seen in clear daylight.

Logical shading: Shading seen when no definite light source is noted.

Lost-and-found contour: The effect of shapes and forms melting or integrating with the background.

Low intensity colors: Colors that are broken or complementary mixtures (shades).

Luminance: A measure of the value (lightness or darkness) of a mixture of lights.

Luminosity: The ability of a color to give a glowing impression.

Luster: The perception that imparts the impression of subdued light.

Middle-value gray: A mixture of black and white that is neither more black nor white but visually equal.

Medium space: The depth that is conveyed by ordinary vision; also known as moderate space.

Monochromatic color scheme: The use of a single hue and its variations to impart color to a composition.

Mordant: A substance that helps fiber accept and set dyes.

Munsell wheel: A color wheel with hues arranged based on afterimaging. Its principal (primary) colors are yellow, red, violet, blue and green. This wheel is the basis for partitive color.

Natural order: Using a black background and sequencing to gray and then white, or having a white background and sequencing to gray and then white.

Natural pigments: Pigments that are derived from animal, vegetable, and mineral substances.

Negative afterimage: An afterimage that is seen as the complement of the observed color area.

Neutral: A color such as black, white, or gray that does not contain any pure hue.

Objective color: *See* local color.

Optical color: The effect of color as seen in lighting conditions other than white daylight, such as rain, sunrise, sunset, candlelight, etc.

Optical mixing: A color phenomenon based on color fusing that occurs in an eye/brain interaction. A new color is created when colors are optically fused.

Pantone Matching System: *See* PMS system.

Parent: The hue that comprises the greatest visual portion of any color.

Partitive color: The process of placing colors side by side to produce different reactions.

Pastels: Light discords of hues.

Phantom colors: Colors created as the result of color spreading and tinting neutrals with their hue.

Pictorical composition: A composition that imparts the illusion of space and depth and uses shading and modeling.

Pigment: A powder that is in a binder which covers a surface or adheres to a surface. Pigments provide color.

Pigment wheel: A color wheel arranged to facilitate working with subtractive color. Based on the mixing of pigments, its primary colors are red, yellow, and blue.

PMS system: The Pantone Matching System. This system, based on nine colors, black, and transparent white, shows the percentages of colors required to produce a particular color.

Pointillism: The optical mixing of lines, crossed lines, or dots of different colors on a white ground.

Positive afterimage: An afterimage that is the same as the color viewed.

Primary color: A hue that cannot be obtained by mixing. Mixing primary colors forms other hues and colors.

Principal color: One of the five primary hues in Munsell's color model (yellow, red, violet, blue, and green).

Process wheel: A color wheel based on primary hues of yellow, magenta, and cyan. The wheel works with subtractive color and is used for color printing, photography, and certain types of ink manufacture.

Progression: The repeating of a design element in an orderly format that imparts change and therefore motion.

Proportion: The relationship formed between one part of a design and another part, one part and the whole piece, and all the parts to each other and the whole.

Protanopia: The most common type of color blindness, which confuses red and orange with yellow and green.

Pure hue: A hue that contains no black, white, gray, or complement in its mixture.

Purkinje effect: The effect of lighting variations on color brightness; also Purkinje shift.

Quadrad color scheme: *See* double complementary color scheme.

Quaternary: The mixture of a primary hue and a tertiary hue in visually equal proportions.

Quinary: The mixture of a secondary hue and a tertiary hue in visually equal proportions.

Reflected light: Light bounced back from nearby surfaces.

Refraction: The bending of a ray of light when it enters a different material.

Repetition: The repeating or sequencing of design elements within a composition.

Retina: The light-sensitive inner lining of the back of the eye.

RGB: Red, green, and blue: the additive primaries used in color television and other color display systems.

Rhythm: A design principle that imposes order and unity using various forms of repetition.

Rods: Cells in the retina that are sensitive to dim light, but not to color.

Saturation: The relative purity of a hue. All pure hues are fully saturated.

Scale: The concept of size relationships.

Scumble: To apply a layer of opaque or semi-opaque pigment irregularly, so that some of the color underneath remains visible.

Secondary color: A hue resulting from the mixing of a primary hue and an adjacent primary hue. Also termed intermediate hue.

Sfumato: A technique in which lines are softly graded and blended to give a smoky effect.

Shade: A dull color resulting from mixing a pure hue with its complementary pigment wheel hue.

Shadow: The casting of light that results in the defining or transposition of a shape into a form.

Shallow space: Images in a barely perceptible space.

Shape: An image that conveys area.

Simultaneous contrast: A partitive color reaction when color is in a complementary setting.

Space: Space refers to the distance, void, or interval between objects.

Split complementary color scheme: A color scheme formed from any hue and the two hues at each side of its complement.

Spreading effect: *See* Bezold effect.

Stable: Easily recognized (of hues).

Structural color: An illusionary color that gives us information about the material composition of an object.

Subtractive color: The process of mixing pigments together.

Successive contrast: A color interaction based on afterimaging.

Surface color: The hue that most closely describes the color of an image or parts of an image.

Symbolism: The use of visual imagery to represent a message or concept.

Symmetrical balance: Balance that relies on a "mirror image" of design components, in which both sides of the work are equal.

Synergistic color: Color interactions developed by Arthur Hoener based on using orange, green, and violet as the primary colors.

Temperature: The warmth or coolness of a color.

Tertiary color: A hue that results from the mixing of a primary hue and an adjacent secondary hue.

Texture: The quality of surface and its relative smoothness or roughness. Texture may be actual or implied.

Tint: The color resulting from adding black or white to a hue.

Tinting strength: How a pigment's intensity reacts when mixed with white and the binder.

Tonality: The dominance of one hue in a composition.

Toning: The procedure of working a composition on a mid-value surface.

Translucent: Denotes that light can pass through the material but the material is not entirely transparent.

Transparency: When objects overlap but are still seen in their entirety.

Transparent: Denotes that light can pass through the material, and things within or behind the material can be seen clearly.

Triad color scheme: A color scheme formed by three hues that are equidistant from each other on the color wheel.

Triadic color system: A rule that there should be an equal balance between sunlight and shadows in a composition.

Tritanopia: A form of color blindness in which sensitivity to blue is reduced.

Typographical order: Sequence with the darkest value at the top and the lightest at the bottom.

Value: The lightness or darkness of a color.

Vehicle: A binding agent for pigments.

Visible spectrum: The range of colors that can be perceived by the human eye. When light is projected through a prism, the array order is: red, orange, yellow, green, blue, indigo, and violet.

Visual array: The arrangement of colors as produced by Newton in his prism experiments.

Visual vibration: The effect of pairing equal valued complementary hues in a partitive setting.

Visual wheel: A color wheel arrangement with the primaries yellow, red, blue, and green. It is based on partitive color.

Warm grays: Grays that result from mixing white with a black that is generated by mixing red, yellow, and blue together.

Warm hues: Warm hues are usually related to red and include: yellow, yellow-orange, orange, red-orange, red, and red-violet. Red-orange is the warmest hue.

Warm light: *See* incandescent light.

Wavelength: A measure of light: the distance between crests in a wave of energy.

Bibliography

Aims, Jim. *Color Theory Made Easy*. New York: Watson-Guptill, 1996

Albers, Josef. *Homage to the Square*. New York: Museum of Modern Art, 1964

Albers, Josef. *Interaction of Color*. New Haven, CT: Yale University Press, 1975

Albers, Josef. *Search versus Re-search*. Hartford, CT: Trinity College Press, 1969

Allen, Jeanne. *Designer's Guide to Color 3*. San Francisco, CA: Chronicle Books, 1986

Anderson, Sara. *Colors*. New York: E.P. Dutton, 1988

Ardley, Neil. *The Science Book of Color*. San Diego, CA: Harcourt Brace Jovanovich, 1991

Armstrong, Tim. *Colour Perception*. Stradbroke, Norfolk, UK: Tarquin Publications, 1991

Beyer, Jinny. *Jinny Beyer's Color Confidence for Quilters*. Gualala, CA: Quilt Digest Press, 1992

Birren, Faber. *Color and Human Response*. New York: Van Nostrand Reinhold, 1978

Birren, Faber. *Color and Perception in Art*. New York: Van Nostrand Reinhold, 1976 (reprinted West Chester, PA: Schiffer Publishing, 1986)

Birren, Faber. *Color: A Survey in Words and Pictures*. Secaucus, NJ: Citadel Press, 1963

Birren, Faber. *Color in Your World*. New York: Collier Books, 1978

Birren, Faber. *Creative Color*. New York: Reinhold Publishing Corporation, 1961 (reprinted West Chester, PA: Schiffer Publishing, 1987)

Birren, Karen (ed.). *A Grammar of Color*. New York: Van Nostrand Reinhold, 1969

Birren, Faber. *Light, Color and Environment*. Third edition, West Chester, PA: Schiffer Publishing, 1988

Birren, Faber. *Principles of Color*. West Chester, PA: Schiffer Publishing, 1987

Borgeson, Bet. *Color Drawing Workshop*. New York: Watson-Guptill, 1984

Brusatin, Manlio. *A History of Colors*. Boston, MA: Shambhala, 1991

Chevreul, M.E. *The Principles of Harmony and Contrast of Colors*. West Chester, PA: Schiffer Publishing, 1987

Chijiiwa, Hideaki. *Color Harmony*. Rockport, MA: Rockport Publishers, 1987

Clinch, Moira (ed.). *The Watercolor Painter's Pocket Palette*. Cincinnati, OH: North Light Books, 1991

Cook, Alton, and Fleury, Robert. *Type and Color*. Rockport, MA: Rockport Publishers, 1989

Cornell, Judith. *Drawing the Light from Within*. New York: Prentice Hall, 1990 (reprinted Wheaton, IL: Quest Books, 1997)

De Grandis, Luigina. *Theory and Use of Color*. New York: Abrams, 1986

Doyle, Michael E. *Color Drawing*. New York: Van Nostrand Reinhold, 1993

Eckstein, Helene W. *Color in the 21st Century*. New York: Watson-Guptill, 1991

Eiseman, Leatrice, and Herbert Lawrence. *The Pantone Book of Color*. New York: H.N. Abrams, 1990

Ellinger, Richard Gordon. *Color Structure and Design*. Scranton, PA: International Textbook Co., 1976 (reprinted New York: Van Nostrand Reinhold, 1980)

Emery, Richard. *Color on Color*. Rockport, MA: Rockport Publishers, 1993

Emery, Richard. *Type and Color 2*. Rockport, MA: Rockport Publishers, 1994

Fabri, Ralph. *Color*. New York: Watson-Guptill, 1967

Falk, David S., Brill, Dieter R., and Stork, David G. *Seeing the Light*. New York: Harper & Row, 1986

Felix, Monique. *The Colors*. Mankato, MN: Creative Education, 1991

Gage, John. *Color and Culture*. Boston: Little, Brown & Co., 1993

Galton, Jeremy. *Color*. Edison, NJ: Chartwell Books, 1994

Garau, Augusto. *Color Harmonies*. Chicago, IL: University of Chicago Press, 1993

Gerritsen, Frans. *Evolution in Color*. West Chester, PA: Schiffer Publishing, 1988

Gerritsen, Frans. *Theory and Practice of Color*. New York: Van Nostrand Reinhold, 1983

Gerstner, Karl. *The Forms of Color*. Cambridge, MA: MIT Press, 1986

Goethe, Johann Wolfgang von. *Theory of Colors*. Cambridge, MA: MIT Press, 1970

Guptill, Arthur. *Color in Sketching and Rendering*. New York: Reinhold Publishing, 1935

Hall, Marcia. *Color and Meaning*. New York: Cambridge University Press, 1992

Hickethier, Alfred. *Color Mixing by Numbers*. New York: Van Nostrand Reinhold, 1970

Hirsch, Robert. *Exploring Color Photography*. Madison, WI: Brown & Benchmark, 1993

Holtzchue, Linda. *Understanding Color*. New York: Van Nostrand Reinhold, 1995

Hope, Augustine, and Walch, Margaret. *The Color Compendium*. New York: Van Nostrand Reinhold, 1990

Howard, Constance. *Embroidery and Colour*. New York: Van Nostrand Reinhold, 1976

Hubbard, Hesketh. *Notes on Colour Mixing*. London: Windsor & Newton, 1955

Itten, Johannes. *The Art of Color*. New York: Van Nostrand Reinhold, 1973

Itten, Johannes. *The Color Star*. New York: Van Nostrand Reinhold, 1986

Itten, Johannes. *The Elements of Color*. New York: Van Nostrand Reinhold, 1970

Jackson, Carole. *Color Me Beautiful*. Washington, DC: Acropolis Books, 1980

Jeunesse, Gallimard, and de Bourgoing, Pascale. *Colors*. New York: Scholastic Inc., 1987

Justema, William and Justema, Doris. *Weaving and Needlecraft Color Course*. New York: Van Nostrand Reinhold, 1971

Kobayashi, Shigenobu, and Nippon Color and Design Research Institute Inc. *A Book of Colors*. Tokyo and New York: Kodansha International, 1987

Kobayashi, Shigenobu. *Color Image Scale*. Tokyo and New York: Kodansha International, 1991

Kriesberg, Irving. *Working with Color*. Upper Saddle River, NJ: Prentice Hall, 1986

Küppers, Harald. *The Basic Law of Color Theory*. Woodbury, NY: Barron's, 1982

Küppers, Harald. *Color Atlas*. Woodbury, NY: Barron's, 1982

Lamb, Trevor, and Bourriau, Janine. *Color: Art and Science*. New York: Cambridge University Press, 1995

Lambert, Patricia, Staepelaere, Barbara, and Fry, Mary. *Color and Fiber*. West Chester, PA: Schiffer Publishing, 1986

Lambert, Patricia. *Controlling Color*. New York: Design Press, 1991

Lüscher, Max. *The Lüscher Color Test*. New York: Random House, 1969

Mante, Harald. *Color Design in Photography*. New York: Van Nostrand Reinhold, 1972

Martin, Judy. *Airbrushing Shadows*. Cincinnati, OH: North Light Books, 1989

Martin, Judy. *Dynamic Color Drawing*. Cincinnati, OH: North Light Books, 1989

Martin, Judy. *High Tech Illustration*. Cincinnati, OH: North Light Books, 1989

Martin, Judy. *Rendering Highlights*. Cincinnati, OH: North Light Books, 1988

Martin, Judy. *Rendering Metals*. Cincinnati, OH: North Light Books, 1989

Martin, Judy. *Rendering Transparency*. Cincinnati, OH: North Light Books, 1989

Marx, Ellen. *Optical Color and Simultaneity*. New York: Van Nostrand Reinhold, 1983

Matthaei, Rupprecht. *Goethe's Color Theory*. New York: Van Nostrand Reinhold, 1971

Munsell, Albert. *A Color Notation*. Eleventh edition, Baltimore, MD: Munsell Color Co. Inc., 1946

Nemser, Cindy. *Benn Cunningham: A Life with Color*. Post, TX: JPL Art Publishers, 1989

Padgham, C.A., and Saunder, J.E. *The Perception of Light and Color*. New York: Academic Press, 1975

Parramon, José María. *The Book of Color*. New York: Watson-Guptill, 1993

Parramon, José María. *Color Theory*. New York: Watson-Guptill, 1988

Poling, Clark. *Bauhaus Color*. Atlanta, GA: High Museum of Art, 1975

Portmann, Adolf, et al. *Color Symbolism*. Zurich: Spring Publications, 1977

Quiller, Stephen. *Color Choices*. New York: Watson-Guptill, 1989

Quimby, Nellie Earles. *Beauty in Black and White*. Richmond, VA: Dietz Press, 1953

Rabergh, Hilkka. *Ferga Forma Forverkliga*. Västerås, Sweden: ICA, 1985

Rainwater, Clarence. *Light and Color*. New York: Golden Press, 1971

Reed, Hal. *Analogous Color Wheel*. Woodland Hills, CA: Art Video Productions, 1987

Riedy, Mark. *Airbrush Techniques: Liquids*. Cincinnati, OH: North Light Books, 1988

Riedy, Mark. *Airbrush Techniques: Reflective Surfaces*. Cincinnati, OH: North Light Books, 1988

Riedy, Mark. *Airbrush Techniques: Textured Surfaces*. Cincinnati, OH: North Light Books, 1988

Riedy, Mark. *Airbrush Techniques: Transparent/Translucent Objects*. Cincinnati, OH: North Light Books, 1988

Rogondino, Michael and Rogondino, Pat. *Computer Color*. San Francisco, CA: Chronicle Books, 1990

Rood, Ogden. *Modern Chromatics*. New York: D. Appleton & Co., 1879 (reprinted New York: Van Nostrand Reinhold, 1973)

Rossolti, Hazel. *Color*. Princeton, NJ: Princeton University Press, 1983

Sargent, Walter. *The Enjoyment and Use of Color*. New York: Dover Publications, 1964

Schwarz, Hans. *Color for the Artist*. New York: Watson-Guptill, 1968

Shibukawa, Ikuyoshi, and Takahashi, Yumi. *Designer's Guide to Color 5*. San Francisco, CA: Chronicle Books, 1991

Sidelinger, Stephen J. *Color Manual*. Upper Saddle River, NJ: Prentice Hall, 1985

Silver, Burton. *Colorfax International*. Berkeley, CA: Ten Speed Press, 1991

Smith, Charles. *Student Handbook of Color*. New York: Reinhold, 1965

Stierlin, Henri (ed.). *The Spirit of Colors*. Cambridge, MA: MIT Press, 1981

Stockton, James, et al. *Designer's Guide to Color*. San Francisco, CA: Chronicle Books, 1984

Stockton, James, et al. *Designer's Guide to Color 2*. San Francisco, CA: Chronicle Books, 1984

Swirnoff, Lois. *Dimensional Color*. Boston, MA: Birkhäuser, 1989 (reprinted New York: Van Nostrand Reinhold, 1992)

Tilton, John Kent, and Scalamandré Silks, Inc. *History of Color as used in Textiles*. New York: The Company, n.d.

Tison, Annette, and Taylor, Talus. *Adventures of Three Colors*. Columbus, OH: C.E. Merrill, 1980

Tucker, Marcia. *The Structure of Color*. New York: Whitney Museum of American Art, 1971

Verity, Enid. *Color Observed*. New York: Van Nostrand Reinhold, 1980

Walch, Margaret, and Hope, Augustine. *Living Colors*. San Francisco, CA: Chronicle Books, 1995

Weigle, Palmy. *Color Exercises for the Weaver*. New York: Watson-Guptill, 1976

Wilcox, Michael. *Blue and Yellow Don't Make Green*. Rockport, MA: Rockport Publishers, 1989 (reprinted Cincinnati, OH: North Light Books, 1994)

Wilcox, Michael. *Color Mixing System for Oil Colors*. New York: Watson-Guptill, 1983

Wilcox, Michael. *Color Mixing System for Watercolors*. New York: Watson-Guptill, 1983

Wilcox, Michael. *Color Theory for Oil Colors or Acrylics*. New York: Watson-Guptill, 1983

Wilks, Mike. *The Weather Works*. New York: Holt Rinehart and Winston, 1983

Willis, Lucy. *Light*. Cincinnati, OH: North Light Books, 1988

Wolfrom, Joen. *The Magical Effects of Color*. Lafayette, CA: C&T Publishing, 1992

Wong, Wucius. *Principles of Color Design*. New York: Van Nostrand Reinhold, 1997

Woolery, Lee. *Marker Techniques Workbook 2*. Cincinnati, OH: North Light Books, 1988

Woolery, Lee. *Marker Techniques Workbook 3*. Cincinnati, OH: North Light Books, 1988

Yenawine, Philip. *Colors*. New York: Museum of Modern Art, 1991

Zelanski, Paul, and Fisher, Mary Pat. *Color*. Englewood Cliffs, NJ: Prentice Hall, 1994

Zender, Mike. *Getting Unlimited Impact with Limited Color*. Cincinnati, OH: North Light Books, 1994

Additional publications

Metropolitan Museum of Art. *Josef Albers at the Metropolitan Museum of Art*. New York: Metropolitan Museum of Art, 1971

Montclair Art Museum. *Josef Albers: His Art and His Influence*. Montclair, NJ: Montclair Art Museum, 1981

Solomon R. Guggenheim Museum. *Josef Albers: A Retrospective*. New York: Solomon R. Guggenheim Foundation, 1988

Artist's Color Wheel, USA. New York: The Color Wheel Co., 1989

Color. New York: Leon Amiel Publisher, 1980

Color on Color Guide Volume 4, USA. New York: Wyerheuser Company, 1978

Color Fun. Laguna Hills, CA: Walter Foster Publishing, 1988

Color Harmony Workbook. Rockport, MA: Rockport Publishers, 1999

Color and Shape. Buffalo, NY: Albright-Knox Art Gallery, 1971

Color Spectrum. Philadelphia, PA: Panel Prints, 1987

Complete Process Color Finder. Rockport, MA: Rockport Publishers, 1991

The Desktop Color Book. San Diego, CA: Verbum Books, 1992

How to Mix and Use Color. Philadelphia, PA: Binny & Smith, 1989

Interchem: The Color Tree. New York: Interchemical Corp., 1965

Light. Loughborough, Leics., UK: Ladybird Science, 1987

Mix and Match Designers' Colors. New York: Van Nostrand Reinhold, 1990

Precise Color Communication. Toyko, Japan: Minolta Corporation, 1988

Sight, Light and Color. New York: Arco Publishing, 1984

Index

A

achromatic simultaneous contrast 95
achromaticity 23, 49
Acrobats in Cairo (Guille) **14.14**
acrylic paints 11, 26, 27, 140, **14.10**
acrylics 144
additive color 8, 23
aerial perspective *see* atmospheric
 perspective
afterimages 10–11, 16, 17, 94–95,
 100, **11.1**
 and simultaneous contrast 95
 and temperature 57–58, **8.3**
ageing and vision 128
Ahmad Kashmiri: scene from
 Mahabharata **14.6**
Ajanta rock-cut temples 135
Albers, Anni 20
Albers, Josef 20
 color triangle 20, **3.14**
 "Homage to the Square" series 20,
 100–101, **11.11**
alkyd resins 143
Allies Day, May 1917 (Hassam),
 116, **13.7**
analogous color schemes 75, **9.21**
analogous hues 43–44, **6.9, 8.1**
analogous rhythms 67, **9.5**
aniline dyes 25, 26
animals and color 126, **13.8**
Antonella da Messina 134
Anuszkiewicz, Richard: *Entrance to
 Green* **9.1**
arbitrary color 7, 73, **1.8**
architectural order 47, **6.12**
architecture 141–43
Ardèche Valley, France: Chauvet cave
 paintings 129, **14.1**
Aristotle: *De Coloribus* 13
 Poetics 131
Arnolfini Wedding, The (van Eyck)
 118, **14.5**
"art needlework" 145
artificial light 92
Assyrians 141
asymmetrical balance 69, **9.8, 9.9**
atmospheric (aerial) perspective 13,
 59, 78, 134, **8.6, 10.3**
Australian rock paintings 135
automobiles 118, 143, **1.7**
*Autumn Landscape with a View of Het
 Steen in the Early Morning*
 (Rubens) **8.6**
azo dyes 25

B

Babylonians 141
backgrounds 59
 and hue intensity 53

and hue repetition 67, **9.6**
and hue temperature 59
and hue values 44–45, 80,
 6.10, 10.4
metallic 62–63, **8.8**
and optical mixing 102
and shading 92
and simultaneous contrast 95–96
and spatial effects 78–80, 84,
 10.1–10.3, 10.5
balance, compositional 68
 asymmetrical 69, **9.8, 9.9**
 and complementary hues 53, **7.9**
 symmetrical 68–69, **9.9**
Banu, Sahifa 137
Baroque painting 134–35
batik 145
Battleground, The (Wyeth) **5.4**
Bauhaus School 19, 20, 51
Bay, The (Frankenthaler) **14.10**
Bayeux Tapestry 133–34, **14.4**
Berlin woolwork 145
Bezold effect 96–97, **11.5**
Bhanudatta: *Rasamanjari* **13.6**
Bierstadt, Albert: *Untitled Landscape*
 32, **6.6**
binders 23, 26, 143
birds and color 126
Birren, Faber 20–21
black 10, 11, 13, 26, 40, 118, **2.1**
 symbolism and associations 5,
 118–19, 122, **13.1**
 temperature 56, 57, **8.2**
 with white 43, **6.7, 6.8**
blue 4, 9–11, 35, 131, 133, 137,
 140, **1.4, 1.5, 2.1–2.7, 5.1, 5.3**
 symbolism and associations 118,
 120, 122, 123, 127, **1.8, 13.3,
 13.5, 13.6, 13.9**
 temperature 41, 56, 121
Blue Profile (Redon) opp. 1, **1.8**
Boccioni, Umberto: *Study for
 "Dynamic Force of a Cyclist II"* **6.8**
Bochner, Mel: *Vertigo* **4.2**
borders (of artworks) 84
boundaries, disappearing and
 dissolving 43–44, **6.9, 7.10**
brass, rendering 91, **10.20**
breathing, color 127–28
broken hues 37, **5.4–5.6**
browns 13, 118, 137
 symbolism 119
bubblejet printers 147
Buddhism: and colors 122
building materials 141–43
buon fresco 131
butterflies **12.14, 13.2**

C

Calder, Alexander 74
calligraphy, Chinese 135
camouflage 126, **13.8**

candlelight 92
Canyon (Hughto) **4.3**
cast shadows 41–42, 88, 104–106,
 6.4, 12.5
cave paintings 129, **14.1**
ceramics 23, 25, 143–44, **14.13**
 glazes 4, 144, **4.3**
Cézanne, Paul 139
 Pink Onions **8.4**
Chartres Cathedral 132
 Carpenter's Guild Signature
 window **10.15**
Chauvet cave, Ardèche Valley,
 France **14.1**
Chevreul, Michel Eugène 16, 139
chiaroscuro 13, 40–41, 47, 88–89,
 134
Chinese calligraphy 135
 and colors 120, 122, 125–26
 embroideries 144
 lacquerwork 135
 landscape painting 135
Christian Church/Christianity 122,
 132, 134, 142
chroma 17, 18, 49
chromatic simultaneous contrast 96
chromaticity 18, 23
chrome, rendering 91, **10.20**
chromotherapy 127
C.I.E. 18
 color diagram 18–19, **3.12**
Close, Chuck 97: *Lucas 1* **11.9, 11.10**
CMYK printing 146, **14.15**
Cole, Thomas: *The Course of Empire:
 The Savage State* **1.9**
color(s) 2–3
 additive 8, 23
 arbitrary 7, 73, **1.8**
 dimensions 33
 local 5, 7, 78, **1.7**
 optical 5, 7, **1.9**
 partitive 8, 10, 11, **2.4, 2.7**
 perception factors 4–5, **1.6**
 physiological factors 3, **1.2, 1.3**
 and psychology 5, 117, 126–27
 see also emotions; temperature
 purpose of 65
 subtractive 8, 9, 11, 23, **2.2,
 2.3, 2.7**
 see also color schemes; color
 wheels; hues; light
color blindness 128
color breathing 127–28
color field painting 140, **14.10**
color monitors 23, 147
color projection 128
color schemes 16, 75
 analogous 75, **9.21**
 and balance 69
 complementary 75, **9.22**
 and contrast 75–76
 double-complementary 76, **9.23**
 monochromatic 75, **9.20**

quadrad 76
split-complementary 76, **9.24**
triad 40, 76, **9.25**
Color Sphere, The (Runge) 15, **3.5**
color therapies 127–28
color wheels and other systems 8
 Albers's triangle 20, **3.14**
 Birren's circle and triangle 21
 Gerritsen's wheel 21
 Goethe's triangle and wheel 14–15,
 3.3, 3.4
 Harris's wheel 14, **3.2**
 Hering's wheel 17, **3.8**
 Itten's wheel 19–20, **3.13**
 light wheel 11, **2.6**
 Maxwell's triangle 15–16, **3.6**
 Munsell's wheel and tree 10–11,
 17–18, 35, 49, 55, **2.4, 2.5,
 3.9, 3.10**
 Newton's wheel 13–14, **3.1**
 Ostwald's solids 18, **3.11**
 pigment wheel 9, 34, **2.2**
 process wheel 9–10, 35, 37,
 2.3, 5.3
 Rood's wheel 16, **3.7**
 Runge's sphere 15, **3.5**
 visual wheel 11, **2.7**
Coloribus, De (Aristotle) 13
complementary hues 10–11, 13,
 50, **7.4**
 and balance 53, **7.9**
 equal-value 54, 72, **7.10**
 false pairs 51, **7.5**
 glazing with 52, **7.7**
 and intensity 50, 52–53, 55, **7.8**
 and optical mixing 97, 100
 and proportion 54–55, **7.11**
composition:
 balance 53, 68–69
 flat 68, **9.7**
 harmony 74
 hues 37–38, 45
 and intensity of hues 54
 pictorial 68, **9.7**
 proportion 54–55, 60–61, 69–71,
 7.11
 rhythm and hues 66–67
 scale 71–72
 and temperature of hues 59,
 60–62
 and tonality 59
 values in 43–45, 47–48
computer graphics 11, 23, 147
computer printers 23
computers, colored 143
conceptual art 140
contrast:
 and balance 53, 69
 in color schemes 75, 76
 and emotion 42
 and emphasis 72–74
 and pattern and texture 42
 of primary hues 38

simultaneous 13, 15, 16, 95–96
successive 15, 16, 94
value 43, 72, **6.7**
*Converted British Family Sheltering a
 Christian Missionary from the
 Persecution of the Druids, A*
 (Hunt) **13.5**
cool colors/hues 56–57, 79–80, 121,
 8.1–8.4
copper, rendering 91, **10.20**
core of shadow 41
cosmetics industry 127
Course of Empire: The Savage State
 (Cole) **1.9**
Credi, Lorenzo di: *Drapery for a
 Standing Man* **6.3**
Cubism 80
cultural associations 118, 121–23
cyan 9, 10, 11, 35, **2.3, 2.6, 5.3**

D
da Vinci, Leonardo *see* Vinci,
 Leonardo da
Dalex fluorescent lights 92
Davis, Stuart: *New York Mural*
 106, **12.7**
Daygo (Turrell) 140, **14.11**
definition 40, 43
Delacroix, Eugène 137
 Liberty Leading the People **14.7**
Democritus 13
depth, intensity and 54
Derain, André 139
detailing, unusual 73
deuteranopia 128
di Credi, Lorenzo
 see Credi, Lorenzo di
Diamond Sutra 135
diffraction 112
discords 40, **6.2**
distance, illusion of 79–80, **10.3**
divisionism 97, 101, 112, **11.6**
 see also pointillism
double-complementary color
 schemes 76, **9.23**
Drapery for a Standing Man
 (di Credi) **6.3**
drawing 23, 25, 39, 88, **4.2, 10.16**
dye-sublimation printers 147
dyes, fiber 23, 25, 129, 131, **4.4, 5.3**
 aniline 25, 26
 azo 25
dyslexia 127

E
earth colors 37, **5.4**
ecru 37
egg tempera 133
Egyptians, ancient 131, 144
 sculpture 131, **14.2**
electric arc lights 92

embroidery 23, 25, 27, 133–34, 144,
 145, **9.15, 14.4**
emotions:
 and hues 62, 118–21, 126–27
 and light 92
 and value 40, 42–43
Empedocles 13
emphasis, creating 40, 43, 54, 72–74
enameling 23, 25, 144
encaustic painting 131
Entrance to Green (Anuszkiewicz) **9.1**
equivocal space 80
Estes, Richard: *Woolworth's* **10.19**
Evans, Ralph M. 96
*Experiment on a Bird in an Air Pump,
 An* (J. Wright) **10.8**
Expressionists 7
Eyck, Jan van 134
 The Arnolfini Wedding 118, **14.5**
eye, human 3, 4, 21, **1.2, 1.3**

F
fabric: shadow effects 105, 106,
 6.3, 12.6
false pairs 51, **7.5**
far-reaching space 80, **10.5**
Fauves 7, 139
featherwork 145
fibers, dyeing 25, **4.4**
 see also dyes, fiber
Fighting "Téméraire", The (Turner)
 47, **6.14**
film color 83–84, 111, **10.11**
films, color 30–31, **4.9**
fixatives 23
flags 123, 124–26, **13.7**
flat compositions 68, **9.7**
Flemish painting 134, 135, **8.6, 14.5**
fluorescent lights 92, 103, 143
focal points 72, 73, **9.16–9.18**
 and outlining 86
form 88–89
form shading 89, **6.4**
form shadow 89, **6.4**
fovea (eye) 3, **1.2, 1.3**
frames 84
Frankenthaler, Helen 140
 The Bay **14.10**
frescoes 131–32, 134, **4.6, 14.3**
frits 131
Fritsch, Elizabeth: stoneware vase
 14.13
furniture 143

G
Gauguin, Paul 139
 Three Tahitians 106, 109, **12.8**
Gerritsen, Frans 21
gesso 4, 27
giclée printers 147
Giotto 131, 134

glazes 52, 112, 135, **7.6**, **7.7**
 ceramic 4, 144, **4.3**
Goethe, Johann Wolfgang von 14, 55, 60, 69, 75, **7.11**, **9.13**, **9.20–9.25**
 color triangle 14–15, **3.4**
 color wheel 14, **3.3**
Gogh, Vincent van 135, 139
 The Night Café 139
 Portrait of Père Tanguy 84, **10.12**
gold 37, 62, **8.8**, **8.9**
 rendering 91, **10.20**
Golden Cell, The (Redon) opp. 1, **1.8**
"golden rectangle" grid 72, **9.17**, **9.18**
Goodwin, John 70, 75, **9.21**, **9.22**
Gothic cathedrals 141
 see also Chartres
gouache painting 27
gradation and emphasis 73
graphic design and printing 145–47
Graves, Michael 142
grays 11, 40, 40, 49
 and adjacent colors 44–45, 95, **6.11**, **11.2**
 colored 39, 49–50, 78, **7.2**
 middle-value 39, **6.1**
 neutral 51
 sequencing and order 45, 47–48, **6.12**
 symbolism 119
 temperature 56–57, **8.2**
Greco, El: *View of Toledo* 47, **6.15**
Greeks, ancient 131, 144
green 4, 9–11, 34, 35, 137, 140, **1.4–1.6**, **2.2–2.7**, **5.1**, **5.3**
 symbolism and associations 118, 120, 122, 127, **13.5**, **14.5**
 temperature 56
grounds 26–27, 96
 see also backgrounds
Gu Kaizhi 135
Guille, Jacqueline: *Acrobats in Cairo* **14.14**

H
harmony 74–76
Harris, Moses 14
 color wheel 14, **3.2**
Hassam, Childe: *Allies Day, May 1917* 116, **13.7**
health care 126, 127–28, **13.9**
Helmholtz, Hermann 17
heraldry 123–24
Hering, Ewald 17
 color wheel 17, **3.8**
Hersey, William *see* Moore, Charles W.
hexachrome printing 146–47, **14.15**
Hickethier, Alfred 20, 35, **5.3**
hifi printing 146–47, **14.15**
highlights 40, 41, 88, 90, **6.2**, **6.4**, **10.18**

Hinduism: and colors 120, 122–23, **13.6**
Hodgkin, Howard 140
Hoener, Arthur 97, 101
Hokusai, Katsushika 135–36
"Homage to the Square" series (Albers) 100–101, **11.11**
hospitals 126, 127, **13.9**
Hua Yan 135
hues 3, 16, 17, 18, 34
 analogous 43–44, **6.9**, **8.1**
 background *see* backgrounds
 broken 37, 44, **5.4–5.6**, **6.9**
 complementary *see* complementary hues
 in compositions 37–38, 45, 54–55
 discords 40, **6.2**
 false pairs 51, **7.5**
 glazing 52, 112, 135, **7.6**, **7.7**
 intensity *see* intensity
 mixing 34–35, 37
 primary 34–35, 38
 process-wheel 35, **5.3**
 pure 34, 39, **5.1**, **5.7**
 secondary 34–35, 38, **5.7**
 tertiary 37, 38, **5.7**
 values 39–40, **6.1**
Hughto, Margie: *Canyon* **4.3**
Hume, Gary 140
Hundertwasser, Friedensreich 142–43
Hunt, William Holman 139
 A Converted British Family Sheltering a Christian Missionary from the Persecution of the Druids **13.5**

I
illnesses and color 126, 127–28
iMac colors 143
Impression—Sunrise (Monet) 139
Impressionists 27, 47, 57, 101, 112, 139
 see also Monet, Claude
imprimatura 135
In the Patio I (O'Keeffe) 109–10, **12.10**
incandescent lights 92, 143
indigo 4, **1.5**
 symbolism 121
indigo dye 25
inkjet printers 147
Inscape (Sugarman) 74, **9.19**
insects and color 119–20, 126, **13.2**
installations, light 140–41, **14.11**
intensity 49
 of complementary hues 50, 52–53, 55, **7.8**
 and composition 54–55, 84
 spatial effects 54, 71–72, 84
 and values 54, **7.10**
interior design 75, 121, 127, 128, 143, **13.4**
Internet, the 147–48

iridescence 112, 114, **12.14**
iron, rendering 91, **10.20**
irregular order 47, **6.12**
Islam 122, 126, 136
Itten, Johannes 19, 20
 color wheel 19, **3.13**
Ive, Jonathan 143

J
Japanese paintings and prints 135–36
jewelry 144
Judaism: and colors 120, 122

K
Kalf, Willem: *Still-Life with the Drinking Horn of the Saint Sebastian Archer's Guild, Lobster, and Glasses* **10.2**
Kandinsky, Vassily 20, 139–40
 Several Circles, Number 323 **14.9**
kinetic effects 61
Kitaj, Ronald: *Walter Lippmann* **9.8**
Klee, Paul 51
Kueppers, Harald 101

L
lacquerwork 135
lakes 23, 131
lapis lazuli 134
Last Supper, The (da Vinci) **4.6**
latex resins 143
Lawrence, Jacob: *The Studio* **5.2**
layering of colors 74
 see also glazes
legibility, color 87–88
Li Cheng 135
Liberty Leading the People (Delacroix) **14.7**
light/lighting 3, 4, 13–14, 91
 see also shading and shadows
 artificial 92
 chromatic 111–12, **12.11**
 and emotions 92
 and film color 83–84, **10.11**
 fluorescent 92, 103, 143
 in interior design 143
 mixing 23, **4.1**
 natural 92
 theatrical 8, 11, 23
 and time and weather 5, 7, 92, 105, 106, 109–11, 112, **12.9**
 translucency 82–83
 and values 39, 92, 103
 visible spectrum 4, 13, **1.4**, **1.5**
 see also iridescence; luminosity; luster
light installations 140–41, **14.11**
light wheel 11, 35, **2.6**
linear composition 92
lines 84, 88, **4.2**, **10.12**, **10.16**

liquid crystal displays (LCDs) 147
Liquitex acrylic paints 11
local color 5, 7
lost-and-found contour 72, 92
Louis, Morris 140
Lucas 1 (Close) **11.9**, **11.10**
Luckiesch, M. 87
luminance 18, 23
luminosity 14, 16, 112, **12.12**, **12.13**
 and discord 40
luster 114–15, 132, **12.15**

M
magenta 9, 10, 11, 35, **2.3**, **2.6**, **5.3**
Mahabharata, scene from (Ahmad
 Kashmiri) **14.6**
manuscripts, illuminated 132–33,
 136–37, **14.6**
Matisse, Henri 139
 The Red Studio **1.1**
mats/matting 84
Maxwell, J. C. 15
 color triangle 15–16, **3.6**
media and color 4
medieval use of colors 132–34
medium space 80, **10.5**
Memphis group 143
metallic lusters 114–15
metallic surfaces, rendering 90–91,
 10.20
metals 62–63, **8.8**
Millais, Sir John Everett 139
Mistress and Maid (Vermeer) **12.6**
Mixtec paintings 135
Mona Lisa (da Vinci) **7.6**
Mondrian, Piet 139, 142
Monet, Claude 97, 137
 Impression — Sunrise 139
 Rouen Cathedral 139, **14.8**
 Le Soleil dans le Brouillard 64, **12.13**
monochromatic color schemes
 75, **9.20**
monochromatic rhythms 67, **9.5**
Moore, Charles W. 142
 (with William Hersey) Piazza
 d'Italia, New Orleans **14.12**
Moore, Henry: *Sheep #43* **10.16**
mordants 23, 25
mosaics 132, 142, **8.8**
Moulin de la Galette, Le (Renoir) **12.3**
Mughals:
 embroidery 144
 painting 137, **14.6**
Munsell, Albert 10, 17
 color systems 10–11, 17–18, 35,
 49, 55, **2.4**, **2.5**, **3.9**, **3.10**
music: and color 140, **14.9**

N
Natural Color System (NCS), Swedish
 17, 33

Natural History (Pliny the Elder) 131
nature and color:
 camouflage 126, **13.8**
 flowers 126
 food 126
 warning 119–20, 126, **13.2**
Nauman, Bruce: *The True Artist Helps
 the World by Revealing Mystic
 Truths* **12.15**
Navajo blanket **4.4**
Neo-Impressionists 16, 27, 139
neutral colors 11, 56–57
New Orleans: Piazza d'Italia (C.
 Moore) **14.12**
New York Mural (Davis) 106, **12.7**
Newton, Sir Isaac 4, 13
 color wheel 13–14, **3.1**
Night Café, The (van Gogh) 139
Noland, Kenneth 140

O
ochers 37
oil painting 26, 27, 134
O'Keeffe, Georgia 140
 In the Patio I 109–10, **12.10**
Old Guitarist, The (Picasso) **13.3**
Op Art 66
optical color 5, 7, **1.9**
optical mixing 16, 97–98, 100–102,
 11.6–11.11
orange 4, 9, 10, 11, 34, 35, **1.4**, **1.5**,
 2.1–2.4, **2.7**, **5.1–5.3**
 symbolism and associations
 119, 127
 temperature 56
orders 45, 47, **6.12**, **6.16**
Ostwald, Wilhelm 17, 18
 color solid 18, **3.11**
outlining 86–87, 96, 112, **10.13**,
 10.14

P
paints 4
 acrylic 11, 26, 27, 140, **14.10**
 ancient Egyptian 131, **14.2**
 ancient Greek 131
 ancient Roman 131–32, **14.3**
 Chinese 135
 exterior 143
 medieval 132–33
 oil 26, 27, 134
 Paleolithic 129, 131, **14.1**
 synthetic 135, 137, 140
 in tubes 139
 watercolor 26, 27
Paleolithic painting 129, 131, **14.1**
Pantone Matching System (PMS) 29,
 145–46, **4.8**
Paracas (Peru) shirt **7.8**
partitive color 8, 10, 11, **2.4**, **2.7**
pastels 40, 114

patterns 40, 42, **6.5**
 and balance 69, **9.9**
 pure hue 69, **9.10**
Pech-Merle, France: cave paintings
 129, 130
perception of color 4–5, **1.6**
perspective:
 atmospheric (aerial) 13, 59, 78,
 134, **8.6**, **10.3**
 of shadows 105–106, **12.5**
pewter 114
 rendering 91, **10.20**
phantom colors 102
photography 8, 39
 black-and-white 30
 color 8, 16, 27, 30–31, **4.9**
photolithography 21
Picasso, Pablo: *The Old Guitarist*
 13.3
pictorial compositions 68, **9.7**
pigment wheel 9, 34, **2.2**
pigments 4, 8, 23, 25–26, 129, **4.5**
Pink Onions (Cézanne) **8.4**
pixels 147
plastics 144
Plato 13, 131
Pliny the Elder: *Natural History* 131
PMS *see* Pantone Matching System
Poetics (Aristotle) 131
pointillism 16, 20, 27, 97–98, 101,
 112, 139, **11.7**, **11.8**
Pompeii 131, 132, **14.3**
Portrait of Père Tanguy (van Gogh)
 84, **10.12**
Post-Impressionism 97
Pre-Raphaelite Brotherhood 139
presentation of artworks 84
primary colors 9, 10, 11, 17, **2.2–2.7**
priming canvases 27
principal colors 10
printing, color 9, 20, 29–30, 145–47,
 4.7, **4.8**
process wheel 9–10, **2.3**
 hues 35, 37, **5.3**
proportion:
 and color areas 54–55, 69–71,
 7.11, **9.11**, **9.13**
 and hue temperature 60–62,
 70, **9.12**
protanopia 128
psychological factors 5, 117, 126–27
 see also emotions; temperature
Purkinje effect 111
purple (*see also* violet) 131
 symbolism and associations
 121, 122

Q
quadrad color schemes 76
quartz halogen lights 92
quaternary colors 37
quillwork 145

quilting 144
quinary colors 37

R
Rahotep and Nofret (sculptures) **14.2**
raindrop patterns 42, **6.5**
Raman microscopy 132
Rasamanjari (Bhanudatta) **13.6**
red 3, 4, 9–11, 34, 118, **1.4–1.6,**
 2.2–2.7, 5.1, 5.3
 symbolism and associations 119,
 121, 122
 temperature 41, 56, 121
Red Studio, The (Matisse) **1.1**
Redon, Odilon: *The Golden Cell* (*Blue
 Profile*) opp. 1, **1.8**
reflected shadow 41–42, 88–89,
 6.4, 10.18
reflective surfaces 89, 90–91,
 10.18–10.20
refraction 112
religious associations 121–23
Rembrandt van Rijn 47, 134–35
 Self-Portrait on a Sill **6.13**
Renaissance, the 134
Renoir, Pierre-Auguste: *Le Moulin de la
 Galette* **12.3**
repetition, hue 66, 67, **9.2**
 and harmony 74
 and tonality 59
resins 143
restaurants 127
retina (eye) 3, **1.2, 1.3**
RGB 147
rhythms 66–67, **9.4**
 analogous 67, **9.5**
 monochromatic 67, **9.5**
Rivera, Diego 131
rock paintings, Australian 135
rods and cones (eye) 3, **1.3**
Rogers, Richard: Pompidou Center 143
Romans, ancient 131–32, **14.3**
Rood, Ogden 16
 color wheel 16, **3.7**
Rossetti, Dante Gabriel 139
Rothko, Mark 140
Rouen Cathedral (Monet) 139, **14.8**
Rubens, Peter Paul 135
 *Autumn Landscape with a View of
 Het Steen in the Early Morning* **8.6**
Runge, Philip Otto: *The Color Sphere*
 15, **3.5**
Ruskin, John 139
russet 37

S
samplers 145
Sargent, Walter 21, 87
saturation, color 11, 16, 17, **3.9**
 see also intensity
scale 71–72

schizophrenia 128
scumbling 140
seasons 106
secondary colors 9, 11, **2.2–2.7**
Self-Portrait on a Sill (Rembrandt) **6.13**
sequencing, natural and unnatural
 45, 47, **6.12**
Seurat, Georges 16, 20, 97, 139
 *Sunday Afternoon on the Island of La
 Grande Jatte* **11.7**
Several Circles, Number 323
 (Kandinsky) **14.9**
sfumato 13, 134, **7.6**
shades (color) 50, 52, 74
shading and shadows 103–104, **6.4,
 12.1–12.4**
 cast shadows 41–42, 88, 104–106,
 6.4, 12.5
 chiaroscuro 13, 40–41, 47, 88–89,
 134
 core of shadow 41, **6.4**
 on fabrics 105, 106, **6.3, 12.6**
 form shading 89, **6.4**
 form shadow 89, **6.4**
 and light sources 91–92
 logical shading 92
 reflected shadow 41–42, 88–89,
 6.4, 10.18
shallow space 80, **10.5**
shanshui 135
shape and color 88, 89
Sheep #43 (H. Moore) **10.16**
Signac, Paul 97
silk painting 145, **14.14**
silver 62, 114, **8.9**
 rendering 91, **10.20**
simultaneous contrast 13, 15, 16
 achromatic 95
 chromatic 96
size, visual:
 and color 54, 71–72, 79–80, 121
 and value contrast 43, **6.7**
Slave Ship, The (Turner) 137, 139
Soleil dans le Brouillard, Le (Monet)
 64, **12.13**
Sottsass, Ettore 143
space/spatial effects:
 of background values 78–80, 84
 equivocal space 80
 far-reaching space 80, **10.5**
 and hue intensity 54, 84, 121
 medium space 80, **10.5**
 shallow space 80, **10.5**
 see also transparency
spectrum, visible 4, **1.4, 1.5**
split-complementary color schemes
 76, **9.24**
stained glass windows 132, **10.15**
staining 140
steel, rendering 91, **10.20**
*Still-Life with the Drinking Horn of the
 Saint Sebastian Archer's Guild,
 Lobster, and Glasses* (Kalf) **10.2**

structural colors 112
Studio, The (Lawrence) **5.2**
*Study for "Dynamic Force of a Cyclist
 II"* (Boccioni) **6.8**
Study for Homage to the Square
 (Albers) **11.11**
subtractive color 8, 9, 11, **2.2, 2.3, 2.7**
 mixing 23, 37
successive contrast 15, 16, 94
Sugarman, George: *Inscape* **9.19**
*Sunday Afternoon on the Island of La
 Grande Jatte* (Seurat) **11.7**
symbolism, color 5, 65, 117, 118–21
 flags and heraldry 123–26
 religious and cultural 118, 121–23
 see also emotions
symmetry 68–69, **9.9**
synergistic color 101–102
synthetic colors/pigments 135,
 137, 140

T
tapestries 144–45
 Bayeux Tapestry 133–34, **14.4**
television 8, 23
tempera 131, 133
temperature (of hues) 41, 56–57,
 121, **8.1, 8.2, 13.4**
 effects of surrounding hues 57–59,
 62, **8.1, 8.3, 8.5**
 kinetic effects 61, **8.7**
 and proportion 60–61, 70, **9.12**
 and texture 89
Teotihuacán wall paintings 135
tertiary colors 9, 10, **2.2–2.4, 2.7**
textiles *see* fabric
texture 4, 40, 42, 89, **10.17**
 and emphasis 73
 reflective surfaces 90–91
 and shadows 106
 and temperature 89
 and viewing distance 89
theatrical lighting 8, 11, 23
Theophilus 134
Theophrastus 131
theosophy 140
therapies, complementary 127–28
thermal-transfer plotters 147
Three Tahitians (Gauguin) 106,
 109, **12.8**
time: and light 5, 7, 92, 105, 106,
 109–11, **6.14, 12.7–12.9**
tinting strength 26
tints 39
 broken 40
Tjapaltjarri, Tim Leurah 135
tonality 37, 59
 and harmony 74
toning 43
translucency 82–83, **10.9**
transparency, illusion of 80–82, 105,
 10.6–10.8, 10.19

Treatise on Painting (da Vinci) 13
triad color schemes 40, 70, 75, 76, **9.12**, **9.25**
tritanopia 128
True Artist Helps the World by Revealing Mystic Truths, The (Nauman) **12.15**
Turner, J. M. W. 137, 139
 The Fighting "Téméraire" 47, **6.14**
 The Slave Ship 137, 139
Turrell, James 140
 Daygo 140, **14.11**
typographical order 47, **6.12**

U
Ukiyo-e 135
Unicorn tapestries 144
Untitled Landscape (Bierstadt) 32, **6.6**

V
values 17, 18, 33, 39–40, **6.1**
 in compositions 43–45, 47–48
 contrasts in 42, 43, 72, **6.7**, **6.8**
 and delineation 43
 emotional effects 42–43
 and emphasis 43, 72
 and intensity 54, **7.10**
 and pattern and texture 42
 in photography 8
 sequencing and order 45, 47, **6.12**
 spatial effects 54, 78–80
 and toning 43
 and visual size 43, 71–72, **6.7**, **9.14**

see also shading and shadows
van Eyck, Jan *see* Eyck, Jan van
van Gogh, Vincent *see* Gogh, Vincent van
vat dyeing 25
vehicles (binding agents) 26
Venturi, Robert 142
verdigris 131, 135
Vermeer, Jan 135
 Mistress and Maid **12.6**
vermilion 131
Vertigo (Bochner) **4.2**
video 11, 23
View of Toledo (Greco) 47, **6.15**
viewing distances 70–71, 112
Vinci, Leonardo da 11, 13, 52, 134
 The Last Supper **4.6**
 Mona Lisa **7.6**
 Treatise on Painting 13
violet 4, 9, 10, 11, 34, 35, **1.5**, **1.6**, **2.2–2.5**, **2.7**, **5.1**, **5.3**
 discording 40
 symbolism and associations 121, 122
 temperature 56
Virgin and Child (anon.) **8.8**
visible spectrum 4, **1.4**, **1.5**
visual centers 72, **9.16**
visual vibration 100
visual wheel 11, **2.7**
volume color 83, **10.10**

W
wall paintings:
 Indian (Ajanta) 135

Mesoamerican 135
Paleolithic 129, **14.1**
Roman 131–32, **14.3**
see also frescoes
Walter Lippmann (Kitaj) **9.8**
warm colors/hues 56–57, 121, **8.1–8.3**, **13.4**
water, rendering 83, 91, 112, **6.6**, **10.10**, **12.13**
watercolor paintings 4, 26, 27, 39
weather conditions 5, 7, 42, 106, 109–11, 112, **1.9**, **6.5**, **6.6**
"web-safe" colors 148
white 11, 13, 14, 26–27, 40, 118, **2.1**
 with black 43, **6.7**, **6.8**
 symbolism and associations 5, 119, 121
 temperature 56, 57
white lead 131, 132–33, 135
white light 23, **4.1**
Woolworth's (Estes) **10.19**
Wright, Frank Lloyd 143
Wright, Joseph: *An Experiment on a Bird in an Air Pump* **10.8**
Wyeth, Andrew: *The Battleground* **5.4**

Y
Yamato-e 135
yellow 3, 4, 9–11, 132, 137, **1.3**, **1.5**, **1.6**, **2.2–2.7**, **5.1**, **5.3**
 discording 40
 symbolism and associations 118, 119–20, 122–23, **13.2**, **13.6**
 temperature 56, 57–59